GREGORY HEISLER
50 PORTRAITS

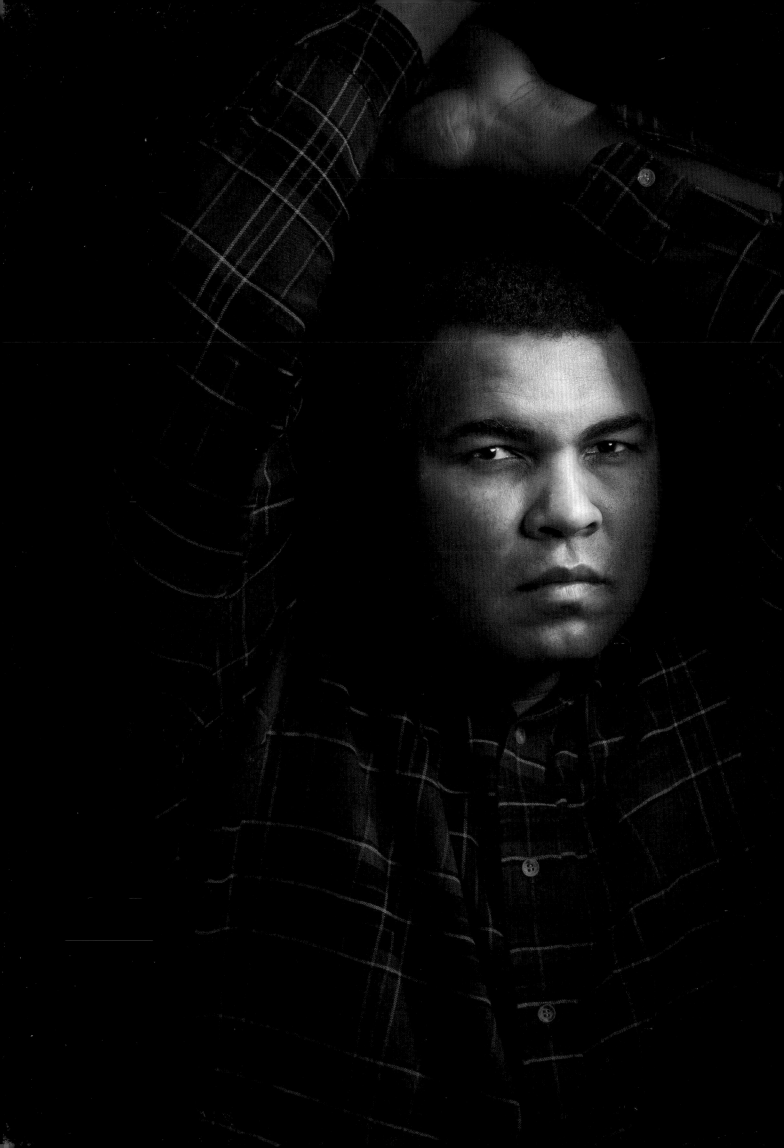

GREGORY HEISLER
50 PORTRAITS

STORIES AND TECHNIQUES FROM A PHOTOGRAPHER'S PHOTOGRAPHER

GREGORY HEISLER

FOREWORD BY MICHAEL R. BLOOMBERG

AMPHOTO BOOKS

an imprint of the Crown Publishing Group / New York

Published in the United States by Amphoto Books, an imprint of the Crown
Publishing Group, a division of Random House, Inc., New York.
www.crownpublishing.com
www.amphotobooks.com

AMPHOTO BOOKS and the Amphoto Books logo are registered trademarks of
Random House, Inc.

Library of Congress Cataloging-in-Publication Data
Heisler, Gregory.
Gregory Heisler: 50 portraits : stories and techniques from a photographer's
photographer / Gregory Heisler.
Includes bibliographical references and index.
1. Celebrities—Portraits. 2. Portrait photography. I. Title. II.
Title: Gregory Heisler: 50 portraits.
TR681.F3H46 2013
770.92—dc23
2012047795

ISBN 978-0-8230-8565-1
eISBN 978-0-8230-8566-8

Printed in China

Endpapers: The Paul Taylor Dance Company
Page 2: Muhammad Ali
Page 6: Sir Anthony Hopkins

Design by Jennifer K. Beal Davis for Ballast Design
Photographs by Gregory Heisler, unless otherwise credited
Jacket design by Jennifer K. Beal Davis
Jacket photographs by Gregory Heisler

10 9 8 7 6 5 4 3 2 1

First Edition

To Lucy and Sadie,
the lights of my life.

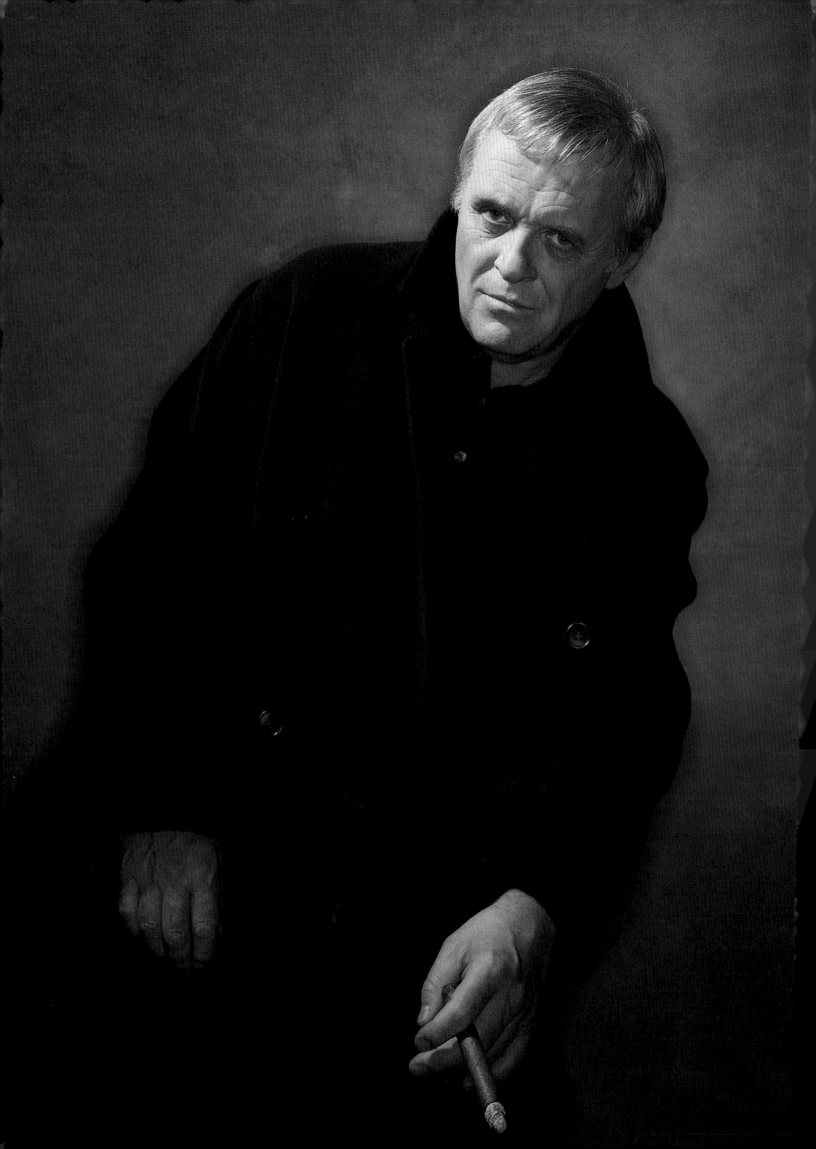

CONTENTS

FOREWORD BY MICHAEL R. BLOOMBERG

Lighting, framing, backdrop, props . . . I don't know the first thing about portrait photography. I couldn't tell an f-stop from a bus stop. And I certainly could not explain how the elements work together to make a good portrait. But from my experience, there is one element that precedes them all: trust.

Does the person sitting for the portrait trust the photographer enough not to get in the way of his or her vision—not to seek to be both the subject *and* the artist? For me, that trust comes easily, because I know what I don't know. But many people who are used to being photographed constantly—even hounded by the paparazzi—think they know best. They don't. That's not to say the subject can't have ideas. But ultimately, it is a portrait—not a self-portrait. And you have to trust the artist.

I think a big part of Gregory Heisler's success is that he is so easy to trust—and not just because he has a long history of doing incredible work, as is so clearly seen in this book.

I've known Greg for nearly two decades. He's smart and creative, with an easy way about him—a down-to-earth conversationalist with a disarming sense of humor. He puts on no airs, puts you at ease, and treats you like a friend. He photographed me for the cover of my 1997 autobiography. I was a first-time author, but I knew enough not to try to be a first-time artist, too.

The words were mine; the photo was Greg's. And when I needed my portrait taken at two sites that mean a great deal to me—the 9/11 Memorial and my alma mater, Johns Hopkins University—I called Greg.

Greg is also easy to trust because he respects your time. He works quickly, perhaps knowing that someone who is frustrated with the time it takes to get the right shot risks ruining the picture. For me, getting a portrait taken can be a distraction from whatever real work is going on that day. It feels like a self-indulgent experience without the satisfaction of, say, putting chunky peanut butter on a piece of matzoh. But Greg makes it feel quick and easy—even when it's not so quick and easy.

A few years ago, Greg came to New York's City Hall to take a portrait of me that would run in the *Time* 100 issue about our administration's environmental agenda. The plan was to take the photograph in City Hall Park. I'd walk out the door and be back at my desk in five minutes. No problem. But when he arrived, he had another idea: to put me up in a tree. You can imagine what I said when I arrived at the shoot—and if you can't, well, it can't be printed here. But I knew Greg, and I trusted him. So up in the tree I went. And he was absolutely right: it was a much more interesting and memorable photograph than me standing next to the tree or just sitting on a park bench.

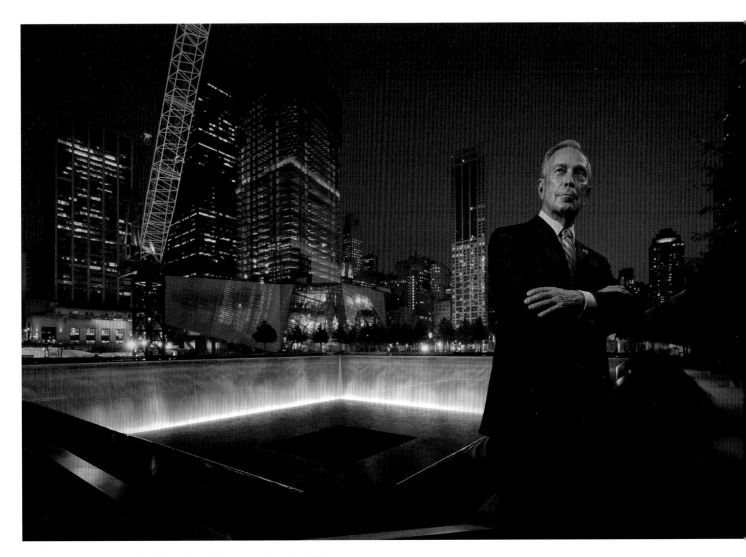

New York City mayor Michael Bloomberg photographed at the 9/11 Memorial site the week before it opened to the public.

Greg has always had a pitch-perfect sense for matching subject and setting, which gives his portraits a feeling and mood that ring true for the audience. His picture of former New York City mayor Ed Koch, which hangs in City Hall, is one of the greatest political portraits ever created. Nearly every visitor who sees it in City Hall stops to take it in—and those who lived here in the 1980s understand it in personal ways that are both poignant and profound.

The portraits in this book include some of Greg's best work, and as different as the photographs are, I think you can see a common trait in all of them: trust.

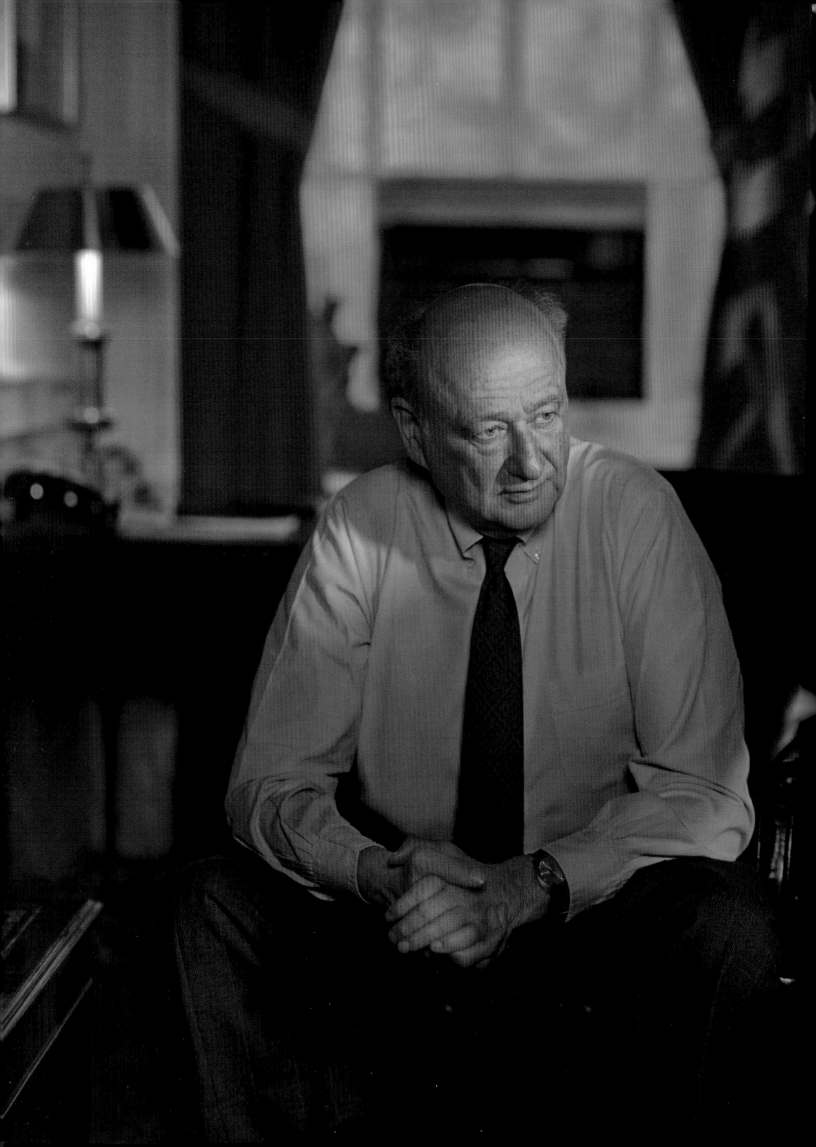

INTRODUCTION

"Premier coup" painting: The term refers to making paintings "at the first go," or in one session. . . . It requires a careful selection of materials and tools and a working procedure that will allow improvisation and spontaneity.

—Jeffrey Carr, from the foreword to *Alla Prima: A Contemporary Guide to Traditional Direct Painting*

Photography isn't just the "premier coup," it's the *only* coup. That's the very essence of photographic portraiture. Whatever happens in front of the lens stays. What's captured during the encounter is all that exists. A photographer has to bring all of his or her resources to bear on the moment of exposure. All the planning, intuition, technical prowess, and knowledge, as well as the trust and rapport you have (or haven't) established, will show up in the picture, frozen forever. It's like an interview, except there's no opportunity for a follow-up question. It triggers a classic left brain/right brain struggle: spontaneous yet calculated, emotional *and* rational. It's exciting but terrifying, thrilling when it works and heartbreaking when it doesn't.

There are many different kinds of portraits. Some isolate an insightful moment; others capture a revealing gesture. Some are just intriguing face maps, while others seem to go beneath the surface. (Richard Avedon

insisted that all he photographed was the surface and claimed that it interested him the most.) There are also those portraits that are less about capturing character than evoking it. They rely less on the sitter and more on the setting, lighting, and composition to convey a sense of the subject. This can be the preferred approach when the subject (or the photographer) is emotionally unavailable. The portrait then has to be made *around* the subject and can become more of an intellectual pursuit.

Distance is a funny thing in portraiture: it can work for you or against you. There's a bubble of intimacy, and you don't want it to burst. If you're too far from the subject, the connection is lost; if you're too close, it's threatened. And then there's the question of scale: How much of this person do we want to see? How big is this person in the frame? Do the eyes say it all? The set of the shoulders? How they sit or stand? What about their clothing? Are they better isolated or seen in context? These are just some of the many considerations that come into play, occasionally resolved in advance, but more often split-second decisions made on the fly in response to the subject, situation, or moment.

A portrait is never *not* a surprise to the sitter, accustomed to the daily scrutiny of his or her likeness in a mirror. The photograph will never match. It won't

Edward I. Koch, former mayor of New York City

look quite right. Photographic portraits are, of course, reversed, though this isn't apparent to most sitters. It's a reflection of how the world sees them, not of how they see themselves. So the making of the portrait is fraught with unease. The sitter has fears, the photographer has hopes. The sitter has anxieties; the photographer has ambitions. There is always a silent negotiation, a push and pull. The sitter doesn't want to face reality; for the photographer, that's all there is. Both contribute to the portrait, but only one—the photographer—knows what it will actually look like.

I don't seek to flatter my subjects so much as to *respect* them. I want to give them their moment, a moment in which their individuality is heightened, their uniqueness set into strong relief. A crystallizing moment in which they can be seen a little more clearly, a little more powerfully. I prefer not to impose an arbitrary approach or uniform visual style; indeed, I believe it's a disservice to do so, an insult to the human being in front of my camera. My photographs are personal, *personalized* responses to particular people, often created within the context of a specific assignment. I strive to tailor each image to its subject using the myriad tools available: different techniques, different lighting schemes, different cameras.

One thing most of my sitters share, though, is the brevity of their visit. The portraits in this book are not the result of sessions lasting hours or even many *minutes*. Most of them were made in as short a time as possible to accommodate the demanding schedules of the subjects. When commissioned by editorial clients, at least two separate portraits were made: one for the cover of a magazine, the other for the "opener" (the photograph that kicks off the story inside). The cover generally functions as a poster: bold, simple, instantly recognizable. The opener can be more nuanced, posing a question to engage the reader; it tends to have more staying power. These, for the most part, are the images that populate this book. Usually, both photographs have to be set up at the same time to be shot in quick succession. The pictures have to be worked out in advance, the lighting tweaked, the setting selected. They have to be "subjectproof" to work no matter what curveball might get thrown my way, from tardiness to grumpiness. Yet since it becomes a game of minutes, of how *fast* a successful portrait can be made, spontaneity shows up. Things inevitably go awry, so improvisation is the rule.

The other thing these people share is that they were all photographed for *jobs*. These pictures were made for editorial clients and private commissions; a few were made during advertising or corporate shoots. Yet they are very much my *personal* work. I don't screw on one head for jobs that I knock out for a buck and then screw on another for my own private work. All my pictures come from the same source; all deserve and receive the same thought, attention, creativity, discipline, and effort. I am fortunate to have been allowed tremendous creative freedom in the making of these images; not one was shot to follow a layout or mandate. I have never taken that responsibility lightly.

Each portrait assignment I receive immediately triggers a series of questions, choices, and decisions that ultimately define the photograph: Will the portrait be made in the studio or on location? Indoors or out? How will it be used? Will it be close up or pulled back? Black and white or color? What's the personality and temperament of the sitter? How much time will there be? Which camera will be used? Which lens(es)? Will I be working with a tripod? What sort of lighting will be employed? Strobes? Continuous light?

Yet a funny thing happens when I get behind the camera. I become *possessed*. No longer myself, Hyde takes over. He sees an image in his head and will do anything to get it. He cajoles and wheedles. He jokes and charms. He stalls and fumbles. He compliments and lies. He pushes. But he's always respectful, bordering on obsequious. He certainly seems sincere. My assistants have said that he invariably throws a wrench in the works at the last possible moment. They speculate that it's because he needs the extra stress and tension to force out something unusual, surprising, and fresh. Veering from the original, carefully choreographed plan, he might find a new location. Throw the lighting scheme out the window. Opt to add another shot. Outdoors. In the rain. With more lights. Many more. And a big camera. Or so I've been told. I remember none of this, of course; it was all Hyde.

As an avid reader and collector of photography books, I have often wished I could mine the mind of the artist to understand the thinking behind the images, and maybe ask a few technical questions. The essays accompanying these photographs will hopefully shed some light on this puzzling process. I've tried my best to reconstruct the thoughts and events underlying the pictures, and I apologize for any inaccuracies or unconscious embellishments incurred by my faulty (or wishful) memory.

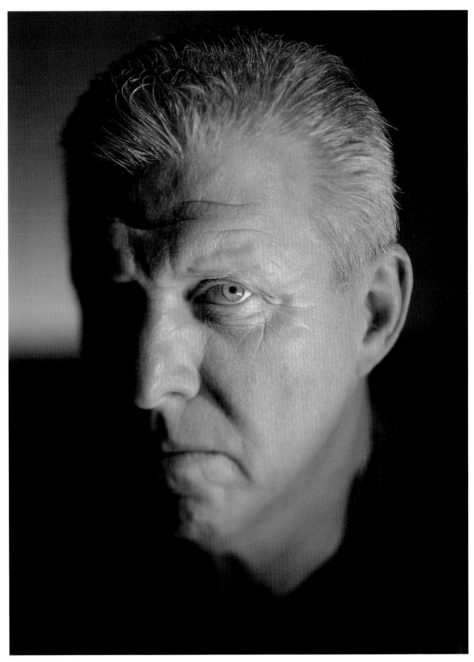

Portraiture is a peculiar pursuit. Documentary photographer Garry Winogrand once remarked that he photographed to see what something looks like photographed. Let's take that one step further: I photograph people to see what *they* look like, photographed. So that they can be held, studied. And truly appreciated.

ABOVE Bill Parcells

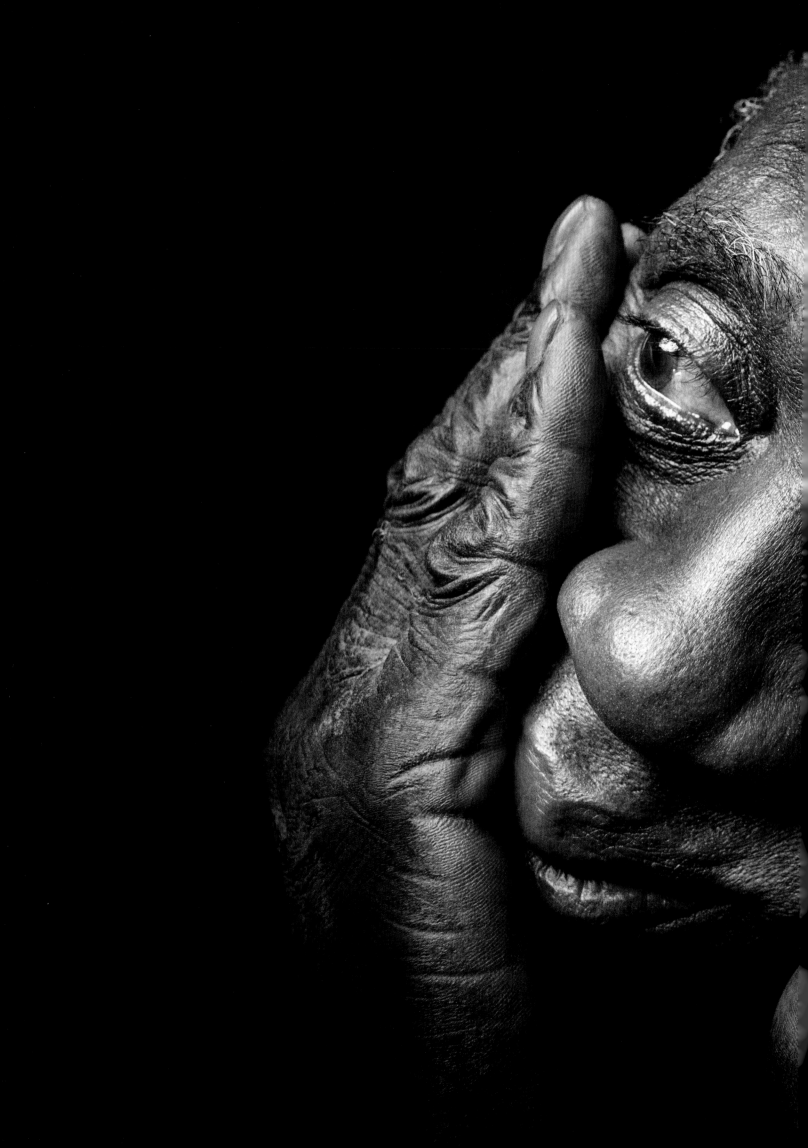

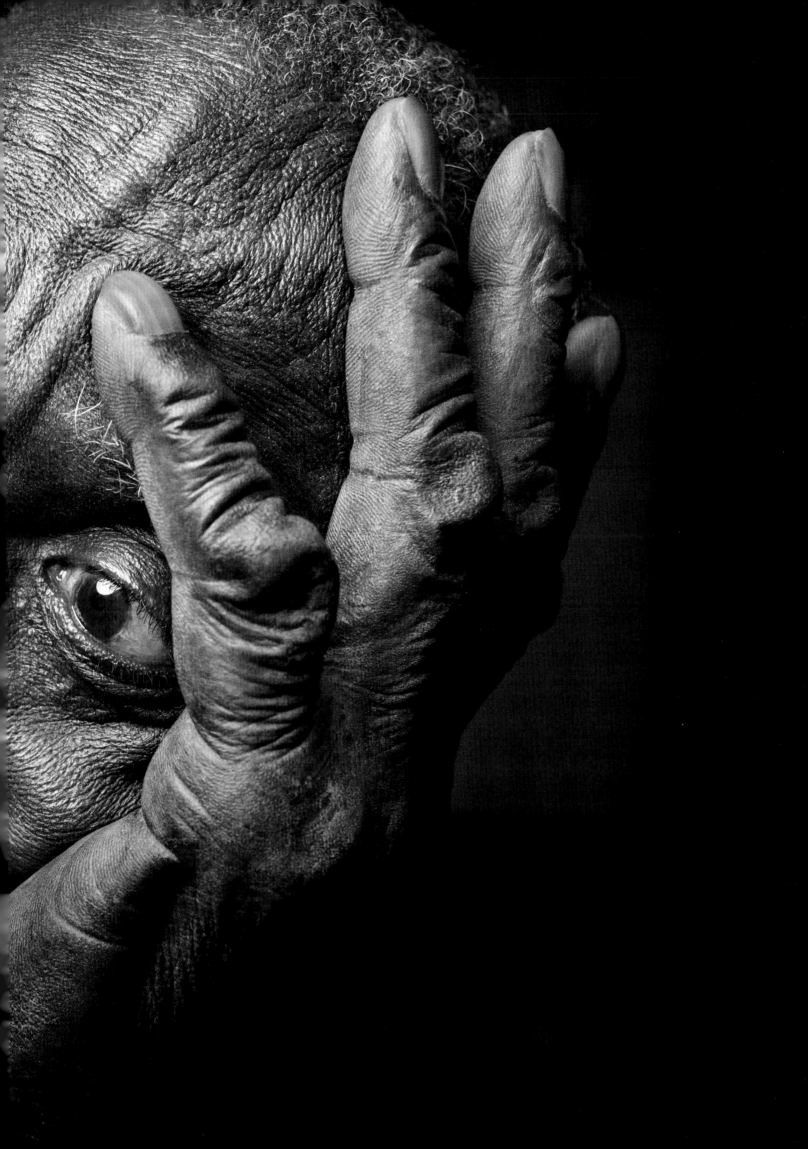

1
LUÍS SARRÍA

I stood outside a chain-link fence on a hot Miami day waiting for a response. The old wood-frame house sat on a dry, dusty, barren lot. Dogs barked from inside. They sounded like really big dogs. My assistant, Monica Buck, called out in Spanish. We had been told that our subject was expecting us and that he had agreed to have his picture taken. I had just received an assignment from Cathy Mather, the photography editor at *Sports Illustrated*, to shoot the first black-and-white essay of my professional career to accompany a story by Gary Smith profiling the seven people who had comprised Muhammad Ali's inner circle during his heyday. My subject on this day, Luís Sarría, was a very old man now and apparently quite frail. He had been Muhammad Ali's masseur, physical trainer, and cornerman for his entire professional boxing career. Though he was small and slight, Sarría was renowned for his big, strong hands that seemed to work miracles on the man.

After a long while, Monica and I looked at each other, not sure if we should stay or go. (This was in the era before cell phones, so yelling had, unbelievably, been our only option.) Just then, an older black woman appeared from the house and approached us. Monica politely explained in Spanish who we were and why we had come. She shook her head and said that her husband, Luís, was not feeling well and couldn't have his picture taken. She elaborated more specifically that his lip was terribly swollen, that he'd gotten an infection, and that he felt too embarrassed to come out. She said they were both sorry that we had come all that way for nothing.

Monica, nodding compassionately, sweetly cajoled her, painting a picture of me as the gentlest, most understanding artist, able to do wonders with my camera. The old lady listened thoughtfully, was quiet for a moment, and then went back inside. Monica and I stood outside the fence, blinking at each other in the hot sun. After a few long minutes, the woman reappeared from the house followed by a small, stooped man, who seated himself in an old metal chair on the porch. She opened the gate and introduced us to her husband, Luís. He reached out a hand that wrapped fully around mine as we greeted each other. It was leathery but soft, strong and sure yet gentle. He offered a tentative, sweet smile.

His wife hadn't exaggerated; the right side of his upper lip looked distended and painful.

They talked quietly with Monica. The old man was from Cuba and spoke very little English. I had remembered from Smith's story that while Ali was the biggest talker of his time, he and Sarría communicated like mimes, the fighter cherishing the respite of their silent sessions together. It seemed clear that the portrait was going to have to be made outside, right there, and real soon. I grabbed a small battery-powered flash from the car and taped it roughly onto a diffuser meant for a much bigger studio strobe; there was nowhere to plug in, and I felt Sarría deserved the caress offered by that particular light. I picked up my clunky camera and began to shoot as he sat uneasily in his little chair.

Because of his self-consciousness, I thought that I would try to make the portrait environmental, not so much to capture the setting as to just give him some space and minimize his swollen face. I made a few frames but wasn't happy. After all, the story wasn't about where he lived; it was about *him*. He kept bringing his hand up to cover his mouth, and I was feeling worse by the second, sure that our brief session would end at any moment. I wanted to pull him away from the house, so I smiled and motioned for him to come sit on the stoop next to me. He gently sat down, supporting his elbows on his knees. Up close, he was beautiful. Just as Monica brought our little light nearer, his hands instinctively shot up again to cover his mouth. In the camera, there they were: those incredible hands. I crouched in close and just let him be as I started to work, shooting a few quick Polaroid tests so that he could see what I was seeing. No porch, no swollen lip. He shifted slightly and cradled the lovely egg of his head in his enormous, expressive hands. I showed him the image; he relaxed and gazed back in time as I made a few final exposures.

PAGES 14–15 Luís Sarría

One of the keys to lighting isn't what you light but what you don't light.

THOUGHTS ON TECHNIQUE

The renowned photographer Robert Capa once said, "If your pictures aren't good enough, you aren't close enough." I might paraphrase this slightly as "If your picture isn't good enough, your light isn't close enough."

I often try to bring my light as close to the subject as I can. A common misconception I've heard from students is, "If you bring the light in close, won't it get *harsh*?" No, it won't get harsh; in fact, it will actually get *soft*. That might seem counterintuitive. If you get close to a fire, it feels hotter; stand close to a speaker and it sounds louder. But with lighting, it's not harshness, it's brightness. The light becomes brighter; its intensity increases the closer you get. And the fact that it gets brighter is often a plus. Because that means your subject gets brighter, too, and what it gets brighter *than* is everything else in the frame, so it stands out. But more important, the light also becomes *softer*. As it gets closer, its rays begin to strike the subject from many different angles. It begins to wrap around. Though its *intensity* gets brighter, its *quality* gets softer.

And when it comes to quality and softness, I also tend to *feather* my light. It even sounds soft. Instead of aiming the light dead-on and smacking my subjects with the center of the source, I feather it, so they just catch the softer penumbral light from the very edge. When the light is feathered, it looks like it's aiming the wrong way, missing the subject. If it's sidelight, it's often aiming halfway between the subject and me. Or if it's frontlight, it might be aiming completely at the floor. (That ends up wasting much of the light, but since it's so close, there's plenty to spare.) Feathering is another approach to achieving a softer effect, because in its own way, it causes the light to wrap around and act as its own fill. It's also a way to emphasize the subject, because when you feather the light, you're taking it off the background. In the same sense that one of the keys to composition isn't what you put in the frame but what you leave out, one of the keys to lighting isn't what you light but what you *don't* light. You have to be selective: just light what you want the viewer to notice. Let the rest go.

Sometimes less is more, especially when it comes to lighting. There have been many times when I've used many lights (maybe too many). Even then, I generally prefer to have it appear that one source is doing all the work. My goal is for the viewer to get wrapped

up in the image, not the lighting. And when it's possible (which isn't all that often), I love to work with just one light. It's simpler, easier to work and travel with, and cheaper, too. The True Secret to Lighting is this: learn to work with one light really well. It's easier to juggle just one ball. Explore and understand it; discover what it can (and can't) do. Figure out how *you* work with it.

For this image, I worked with one light. Nothing fancy: a thirdhand, beat-up, battery-powered, gaffer-taped contraption. It was the unlikely marriage of a lovely, refined studio soft light modifier and a cheap, crappy location flash. It was so jury-rigged and rickety that, fortunately, it needed to be handheld by my assistant, who was then able to position it very close and make the most delicate feathering adjustments as I photographed.

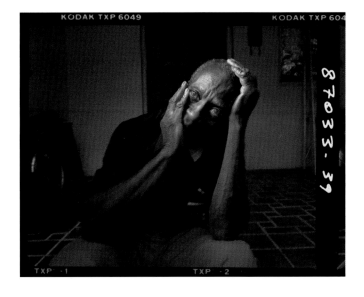

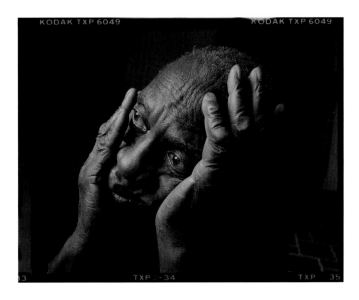

TOP The first tentative frame, made before I eased closer to eliminate the background and focus in on Sarría's beautiful face and hands.

BOTTOM A transitional frame near the end of the roll: I'm almost there.

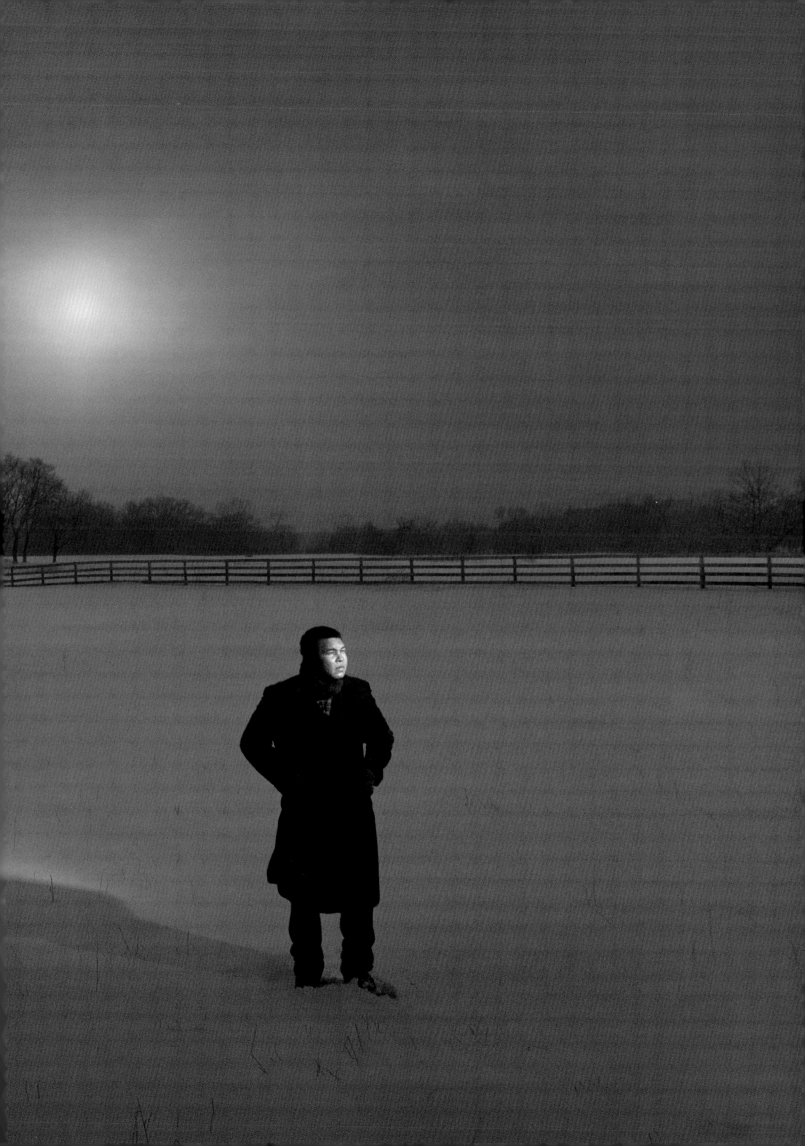

2

MUHAMMAD ALI

Ali had already been a generous host at his old farmhouse in Berrien Springs, Michigan, treating us to magic tricks and joking with us (at one point he quietly leaned his massive frame against a bathroom door, preventing the photo editor from emerging). We had just finished shooting the portrait that would ultimately run on the April 25, 1988, cover of *Sports Illustrated*. Earlier, though, he had sat silently on his sofa, seemingly in a stupor as he watched a television show while we set up our cameras. It was as if he crackled in and out of clarity like an old radio. Here was The Champ, the biggest and most gregarious figure of his era. He didn't appear unwell or unhappy, though; if anything he seemed at peace inside his own head, isolated from the world by his trauma-induced Parkinson's. It was that quiet, peaceful but powerful aloneness I wanted to somehow see in the portrait I had yet to make.

Sometimes the best you can do is to be a spectator to your own creative process as it winds itself out and wraps around an idea, a feeling. I remember walking farther and farther from the house just to get some *space.* We were frozen. My assistant, Howard Simmons, had been standing in the snow for a long time as we finessed the light. And I remember photographing Howard tight and loose, high and low, trying to find the right vantage point and framing. Mostly I remember waiting many long freezing minutes for Ali to make his way from his house to our little spot, moving incrementally in a painfully slow shuffle through the snow.

When he finally arrived, stone-cold and expressionless, he looked silently at me as I explained: there would be a tiny little spotlight shining on him; if he moved, he'd be lost to the light, so he would need to stand stock-still. I couldn't tell if he heard me; he betrayed nothing. I climbed up to the camera on its tall tripod and exposed a few rolls of film. As I watched him squinting over the snow, I thought I could see his lips begin to move. I hopped down into the snow, made my way over to him, and leaned in close. In a hoarse whisper, he was saying, "You're *crazy*, man. You're crazy." He looked right at me and smiled. "But you *love* what you do, don't you?" And with that, he abruptly wheeled around and took off at a trot for the fireplace warmth of his farmhouse.

THOUGHTS ON TECHNIQUE

It's not moonlight.

This picture was actually made in the hazy sunlight of a late afternoon. It's not digitally manipulated. The technique that creates this effect is only available to

OVERLEAF **Muhammad Ali**

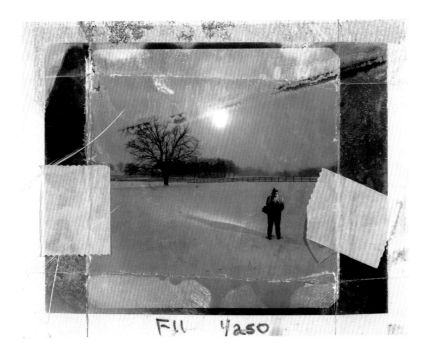

FII ¼250

still photographers because it combines flash (or strobe) illumination with daylight.

An electronic strobe emits a momentary burst of light: literally, a flash. So no matter what shutter speed your camera is set at, the strobe doesn't care; it spits out its flash of light and is done. The flash intensity or brightness is measured in f-stops. If a flash puts out f/8, then it's the same bucket of f/8 light at 1 second of exposure as it is at 1/250 sec.; the f/8 component doesn't change. It's just a flash. So when you want to control the brightness of your f/8 flash, you use your aperture. If you set it at f/11, then the flash will appear darker; at f/5.6 it will look lighter. So your f-stop camera control is like a rheostat for your flash exposure. Again, the shutter speed has no effect, because the flash is just an *instantaneous* burst of light.

The shutter speed, then, becomes a rheostat for the ambient light, independent of the flash. They are two completely separate variables. So if I have f/8 strobe light falling on my subject, the background can be at any of a wide range of shutter speeds without affecting it. If it's a sunset, f/8 for 1/60 sec. might make the sky look airy and bright, while an exposure of f/8 for 1/250 sec. might render it deep and rich. But my subject, lit by only the flash, gets f/8 either way and is unchanged. So, again, *the shutter speed acts like a rheostat for the background, while the aperture is like a rheostat for the flash.* This is powerful stuff.

For this image of Ali, my little spotlight flash is illuminating him with f/16 of strobe light. So I set my f-stop at f/16. When my shutter speed was 1/30 sec., the sky and the snow were pure white; not very dramatic. When my shutter speed was 1/125 sec., they became a light gray tone. Now it starts to get interesting. Finally, when I changed my shutter speed to 1/500 sec., the snow and sky darkened to a charcoal gray. Moonlight.

ABOVE The Polaroid test print of my assistant, moments before Ali appeared, displaying the day-for-night balance of strobe and sunlight as well as the exposure information that got us there.

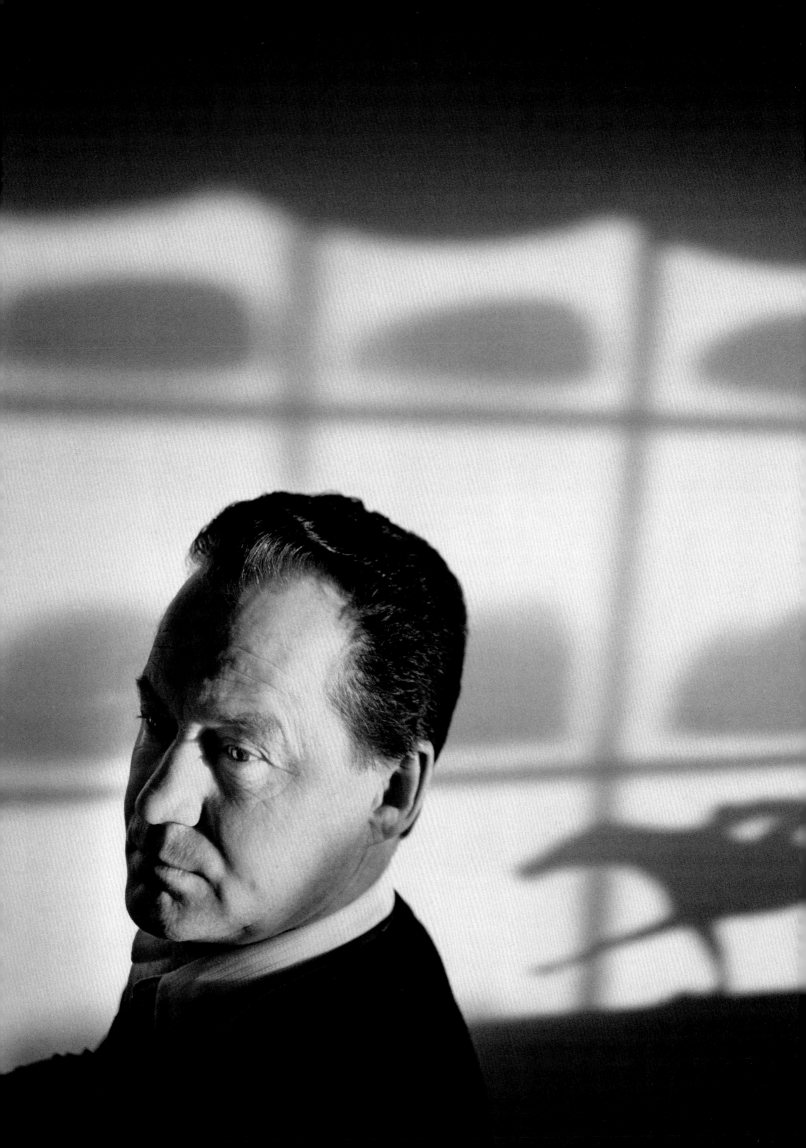

RON
TURCOTTE

Sometimes your best idea isn't. I'd been laboring for hours in the Grand Falls, New Brunswick, home of legendary racehorse jockey Ron Turcotte. I was photographing him for a *Sports Illustrated* essay on sportsmen who had been handicapped in action. Turcotte had become an international celebrity when, in 1973, he rode Secretariat to win the Triple Crown. Sadly, a career-ending fall in a 1978 race had left him a paraplegic. I'd already photographed a blinded boxer, a brain-damaged cyclist, and a quadriplegic race-car driver. Without any preconceptions, I would arrive at the home of the subject, we'd talk for a while, and then I'd formulate a game plan.

In Turcotte's modest home, photographs, articles, and trophies from his more than three thousand victories were prominently displayed, many in a large, illuminated display case. There was one terrific image of him flying along on Secretariat that I decided to use in a double exposure. (It recalled the famous sequential image by Eadweard Muybridge of a horse in full gallop, one frame showing all four feet in the air at once.) As I'd envisioned it, I would position Turcotte in silhouette against a sliding glass door; when double-exposed, he would look like a small, isolated figure reflected in the framed photograph.

It was easier said than done. I hadn't anticipated attempting a multiple exposure, and the camera I had brought was the wrong tool for the job. I had to alternately photograph Turcotte, then the framed picture, him and then the framed picture, again and again. It was tedious and time-consuming. He was far away in his wheelchair by the window while I fussed and fiddled with my camera, going back and forth. I struggled lining up the two images, trying to imagine how they'd juxtapose. Preoccupied with technical complexities, I wasn't at my bedside best, all but ignoring him as he sat alone by the door. He was getting tired.

Sometimes the picture tells you if it's working; this one was saying no. As I pushed uphill, it ground to a stop and threatened to roll right back over me. I suggested we take a short break so that I could collect my thoughts. I had arrived before lunch; it was now late afternoon. I padded through the house back to the living room to retrieve something from one of the cases I had staged there. The low sun streamed through a big window, throwing sharp shadows of the snowy panes onto the wall. A cast sculpture on a nearby table caught my eye. It was Turcotte riding Secretariat, a bronze interpretation of the very photograph I'd been shooting. I stacked a few books by the window as a makeshift plinth and placed the small statue on top. There on the wall, the shadow of the horse hung like a haunting memory.

The sun was sinking fast; we'd have only precious minutes to grab a few frames. I ran back and asked Turcotte to join me in the living room. Sensing my panic, he quickly wheeled in. As soon as he saw the wall, he understood and said, "Just tell me where to go." I quickly

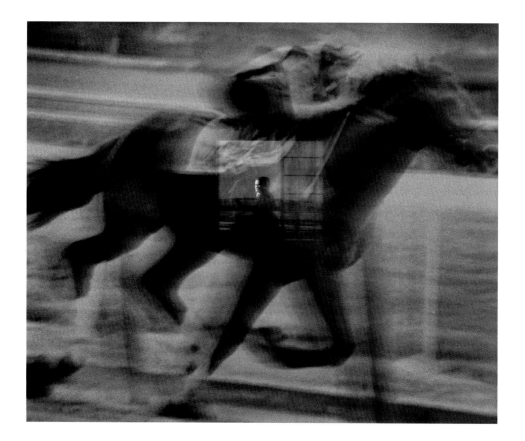

The one that didn't work. Turcotte appears twice in this double exposure. I was just trying too hard.

fired off two rolls. He shifted slightly; I responded and reframed as the shadow softened, then faded away.

THOUGHTS ON TECHNIQUE

For years, my workhorse camera was a donkey. It was boxy and clunky. Heavy. Anything but sleek. It was a single-lens reflex like a much smaller camera, and it boasted a bellows like a much larger one. It was most at home on a tripod but could be handheld, if not easily, surprisingly comfortably. It may have been a brick, but it was a well-balanced brick. Solid. Satisfying. It was the Mamiya RZ67. (Even the name's a bit of a donkey.)

The "RZ" was my equivalent of a Leica, a camera many photographers consider an extension of the eye and the brain. With it I could be nimble, if not invisible. It had a cannon-blast of a shutter release, followed by the loud grinding of the motor advancing the film. Ka-CHONK-RAWRRRRRR! Not exactly fly-on-the-wall material. It sported a 30-degree look-down prism viewfinder, equally boxy but ergonomically ideal. Unlike an eye-level finder, it didn't block your face, and unlike a 90-degree, or "chimney," finder, it didn't force you to look into your shoes. It delivered a right-side-up, unreversed, bright and crisp image. I found it to be ideal for portraits, as I could just lift my chin slightly and connect directly with my subjects. I loved it.

The camera incorporated a somewhat anachronistic bellows focusing mechanism that could turn any lens into a close-up lens. No attachments, extension tubes, or auxiliary filters required. I'd just keep on turning the knob and the lens would continue to focus closer and closer without interruption. It would be impossible for me to estimate the number of photographs I was able to capture that I would otherwise have missed or lost altogether.

And it had a rotating film back. There was no more need to turn the whole camera sideways to shoot a vertical image—what a revolutionary idea! Virtually all cameras are designed in the "landscape" format to shoot horizontal photos, presumably because our eyes are arranged horizontally, side by side in panoramic fashion. The catch is that many, if not most, commercial applications are oriented to suit the *vertical* page. So we photographers have to hold our cameras sideways to shoot vertical pictures. Our cameras hang off the side of our tripod to shoot vertically, throwing them vertiginously off-balance. Many subjects lend themselves to vertical pictures. Like, say, portraits. People are vertical (mostly). Their heads are vertical, too (mostly). This was a problem for most cameras, but not the RZ! The film was housed in a separate piece that rotated from horizontal to vertical, while the rest of the camera stayed put. I could instantly switch from a vertical magazine cover to a horizontal "opener" and back again. And there were little black croppers in the viewfinder that automatically reoriented when the film back was rotated. Ingenious.

On this particular shoot, however, I had just finished cursing the camera. I had been forcing it to make sequential double exposures, and while it was a good idea initially, its execution was bogging down the shoot. For all the camera's fine qualities, it just wasn't suited to the job. But then I saw the light, literally, on Turcotte's living room wall. I yanked the camera off the tripod and cradled it like a baby's head as I jockeyed for position, composing and squeezing off the last frames in the dwindling light.

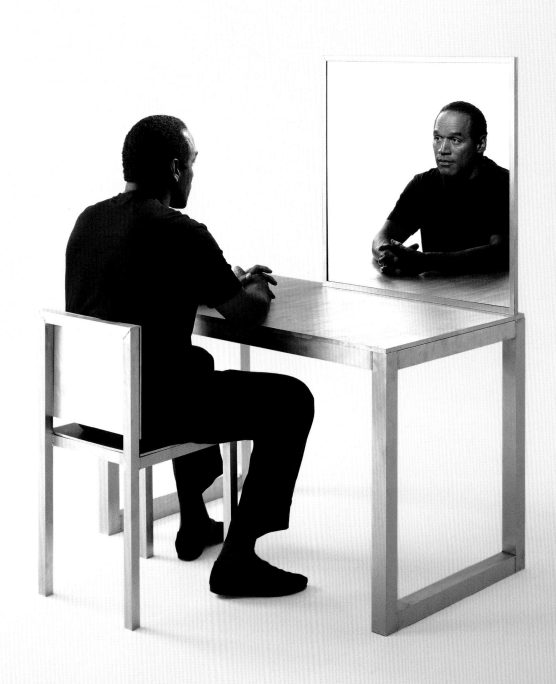

O. J. SIMPSON

"The Juice is great, man. You're gonna love him."

It was the night before the shoot. I stared at the phone receiver in disbelief. Had his agent actually said that to me?

Even after the circus of the nine-month trial and the acquittal, questions still lingered. Three years later, *Esquire* magazine scored an interview with the former athlete and, in a move they knew would generate controversy (and sales), decided to put him on the cover of their February 1998 issue. Simpson was intent on rehabilitating his public persona, and this was to be the first step. I believed that *he* believed he was being sincere, and I wanted the cover image to reflect that: to be direct, honest, and nonjudgmental. It was a simple daylight portrait. He gazed directly into the camera. He held his hand over his heart.

Did he do it or didn't he? I wanted the inside portrait to convey the sense that, in the end, only he knew his own truth. The image popped into my head fully formed; sometimes it just happens that way. It was sterile, all white. The stark, metal table at which he was sitting in a cold, straight-backed chair featured an offset mirror; from the camera's viewpoint, it would appear that he was confronting his reflection. Yet unexpectedly, the mirror also looked like a window, as if he were visiting himself in prison.

A single call to Hollywood prop and set designer Rick Elden quickly turned the idea into an elegant, perfectly realized set piece. That's the beauty of collaborative work: when the finished product is better than anything you could have imagined on your own.

Simpson showed up at the studio unaccompanied. His agent was right: the Juice was a perfectly nice, cooperative fellow. But he had a sense of resignation about him, like you couldn't possibly say or even think anything about him that hadn't already been said or thought. He was up to the task of being photographed, no questions asked. I explained that the mirror was positioned so that the camera could see his reflection. He nodded, happily sat down at the table, and patiently stared into space at . . . nothing.

I recalled his agent's unbelievable last words: "Look, man, you can't judge a guy by the worst night of his life."

THOUGHTS ON TECHNIQUE

Like a bank shot in billiards, this picture is all about working the angles. Plus, it's a picture within a picture. And it's about space, empty space.

You can almost see the dotted lines connecting Simpson to his reflection, then to the viewer, and

Did he do it or didn't he? I wanted the inside portrait to convey the sense that, in the end, only he knew his own truth.

then back again. The camera has to be at just the right height, the table at just the right angle, and both at just the right distance.

The eye is fooled. Compared to the mirror, the room looks gray, but the mind knows it's white. It knows the room is white, yet the reflection is whiter. This is a subtle lighting distinction but an important one. Normally, in a picture, the reflection in a mirror is darker than the subject the mirror is reflecting. In this case, though, it's the brightest part of the image. Your eye goes right to it, and then bounces back and forth between the reflected Simpson and the real one (if there is such a thing).

In order to accomplish this, the picture must be regarded as two separate pictures from a lighting standpoint. If a mirror reflection is typically half as bright, then it must have twice the illumination to hold its own in the photograph, or *four* times as much light to actually appear brighter. The key to this sleight of hand is the background in the reflection. If it were just the same as the rest of the room, it would look darker. But

by erecting a phony wall (or "flat," as it's called in the biz) that's not seen in the main picture, I can light it as bright as I want without affecting the rest of the picture. It's only seen behind Simpson in the mirror. We think it's the same space, but it's not. It's like having two separate little lighting worlds.

He sits solidly at the table, yet he's adrift in a void. His disembodied reflection floats before him, trapped in a little window. He's disconnected from everyone and everything, alone with his knowledge. This image is full of emptiness. We should be able to hear his thoughts as he looks at himself, but there's nothing. Just a silent understanding. He has been given space to be alone with his thoughts. He knows them; we don't. He's calm, if not relaxed. He's in no rush.

Even without the reflection, we would recognize him. The shape of his head, his brow and cheekbone. Facing away, he's unknowable. Facing us, he's a mask.

For the second inside portrait, I used the 11x14 camera, placed uncomfortably close to my subject for maximum detail and impact.

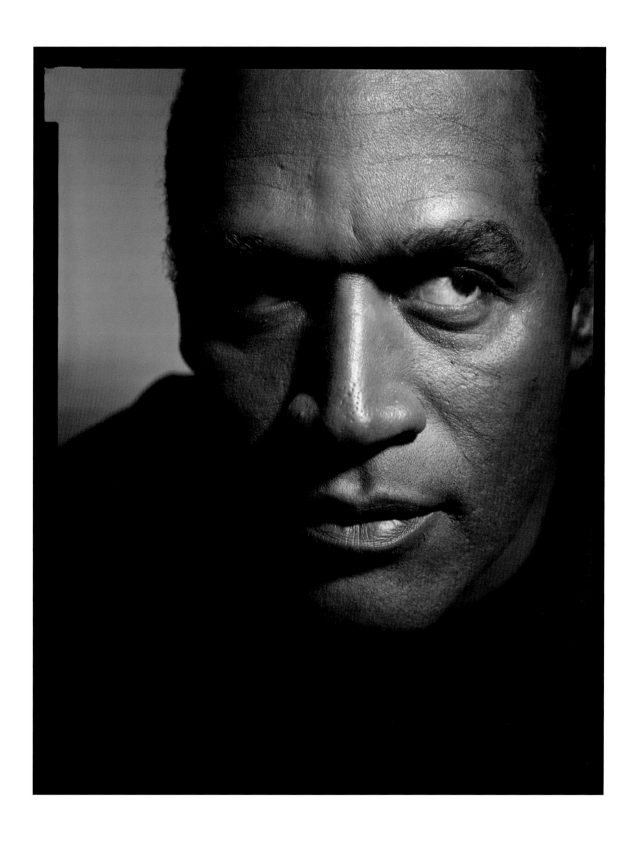

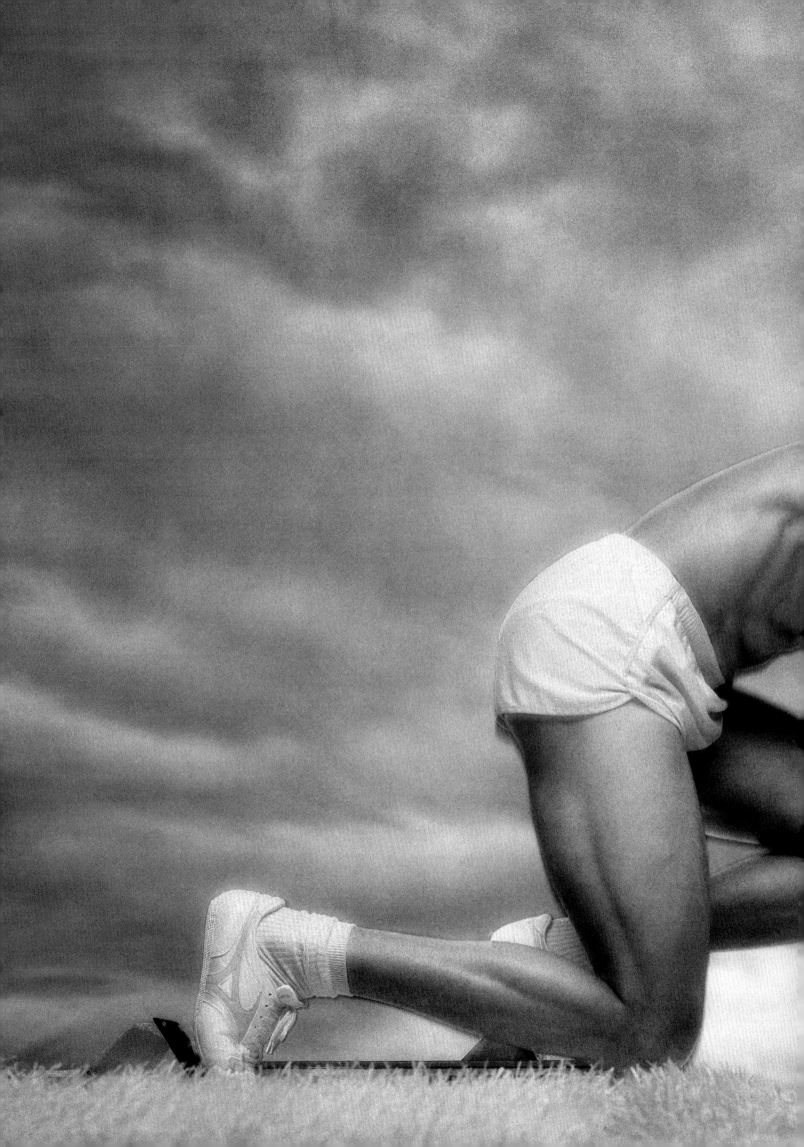

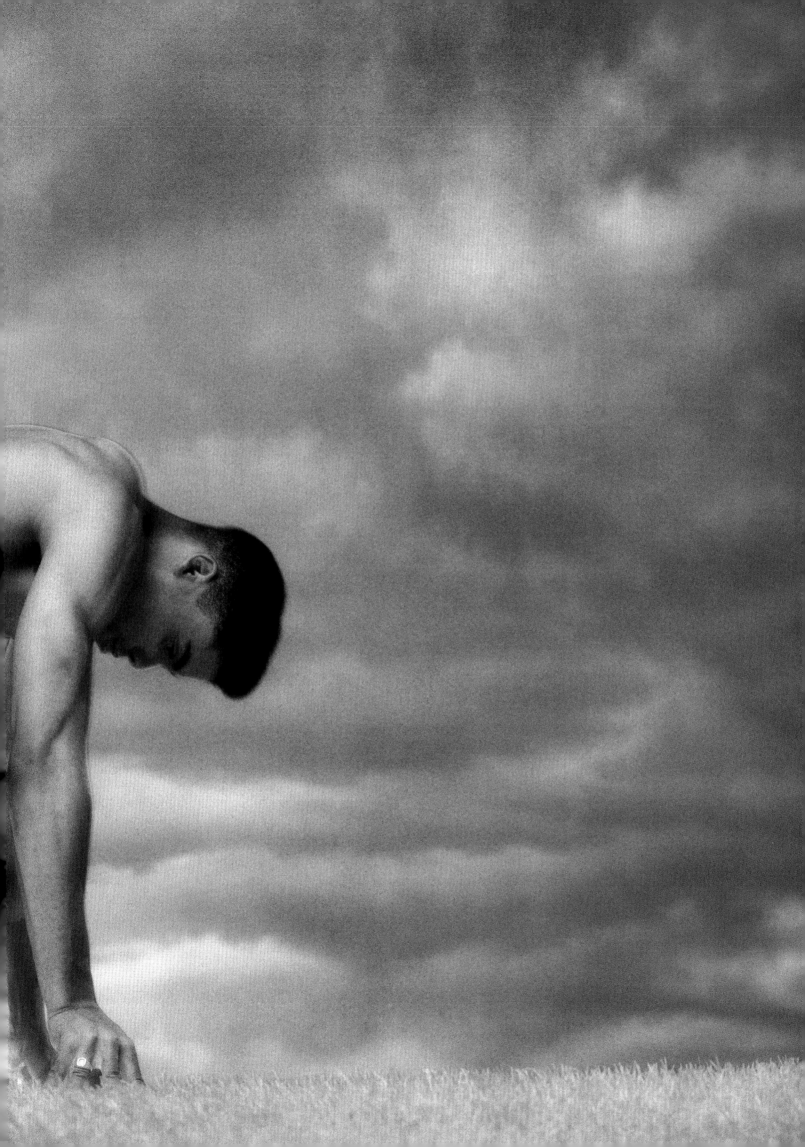

CARL LEWIS

Sometimes I already have the picture in my head, shot and printed. I know exactly how it will look: what the lighting will be, what the environment will be, even what the subject will be doing and what his expression will be. Then the reality of the actual shoot enters the mix, and more often than not, my original vision becomes a mere jumping-off point. This is not a bad thing. One of the greatest mistakes a photographer can make is to become wedded to an initial vision, no longer receptive to new opportunities along the creative path. That said, having an initial vision can prove helpful, even if it's something to work *against*, because at least it gets the juices flowing. John Loengard, the picture editor at *LIFE* magazine, would often send me off on an assignment with some initial idea as a direction, yet much as it bugged me, it at least gave me something to chew on (even if I spat it out once I got going).

For this portrait of Olympic gold medalist Carl Lewis, I was certain that I wanted a ground-level action shot of Lewis springing to life, bolting out of the starting blocks. In my mind, I could see the stretch of his body, his incredible energy unleashed. As I'm not much of a sports photographer, I elected to create this portrait under the controlled conditions of the studio. I would have him "fake" his start for my camera. The problem

was that I wasn't working with the motor-driven cameras normally used for such circumstances, which capture rapid-fire high-speed sequences of photographs. Instead, I was using an unwieldy camera that used special infrared film, lending the image an unusual tonality. The drawback was that it permitted only one shot per start. One.

Lewis and I were both crouched on the floor of the studio, he in his starting blocks and me behind my camera. I made a few Polaroid test exposures to refine my timing, giving him a countdown before each start. I shot a few test frames on film, followed by about a dozen of his starts.

Later that night at the lab, I looked at the developed negatives. While there were several strong frames of him bolting out of the blocks, I kept getting drawn to a single frame of him at rest, waiting to ready himself for the start. Even as a negative, it was striking in its stillness. It wasn't an action shot. It was a picture of potential energy, of *intention*. It was a portrait of an Olympic athlete completely focused in the moment just before the flash into action. I honestly didn't remember shooting that specific frame. It might have been one of the tests. Or it might have simply been a misfire that I accidentally exposed between starts. It was not an image I consciously made, nor was it the picture I had

OVERLEAF Carl Lewis

set out to do. It could have just as easily been ignored or even discarded. It was a complete surprise, an unexpected detour, a gift that I was open to, even in the face of my expectations.

THOUGHTS ON TECHNIQUE

The advantage to photographing primarily on location is that you learn how things in the real world actually *look*. So when you're in the studio trying to simulate a location or a quality of light, it's all grounded in the fact that you've already seen it, so you know how it *should* look. Even so, I generally prefer to work on location whenever possible. Why simulate when you can have the real thing in all its random splendor? Yet random splendor comes at a price, especially the "random" part: changing light, unpredictable weather, locations that don't pan out. These are, to me, more than offset by the infinite variety of inspirations they offer, influencing the creative process. The changing light and unpredictable weather. The next location just around the corner. And while studio sets are generally restricted to just one camera angle, there are myriad possible points of view in a 360-degree universe.

So how does one decide whether to photograph in a studio or out in the world? Well, it may come down to simple logistics. A studio may be required because the subject is only available for an hour at a specific location at a specific time. Or the weather is too changeable. Or it's the wrong season. Or the wrong country. It might be that the perfect location is unavailable or simply doesn't exist. Or going to a location might incur too much expense. In the end, it might come down to the fact that the photographer has a specific vision that is best realized within the controlled confines of a studio.

This image was created in a studio in Hollywood without the aid of photo-compositing or retouching. I'd wanted to convey a sense of pent-up power, and a stormy sky seemed like the ticket. In Hollywood, stormy skies of every size and shape are available for rental; this one came, appropriately enough, from a source called Skydrops. The foreground "grass" was actual sod secured from a garden supply. Lewis was crouched in borrowed starting blocks.

The key, though, was creating the right light: that kind of oddly glowing luminosity that occurs just before a really severe storm. It wasn't so much a technical challenge as an aesthetic one. The quality of the light on Lewis had to work with the backdrop but not match it. It had to look legit yet seem strange, with a quality you couldn't quite put your finger on. It had to have a hush, a sense of imminence. I needed the tightly controlled unreality of the studio to pull it off.

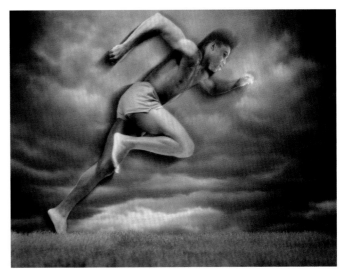

This explosive start is the image I was after, but the moment before was the winner.

GREG LOUGANIS

How far do you push someone you're photographing? Until you begin to sense their discomfort or resistance? Until they start to complain? Until they flat out say no? Or until you get what you're after? Many, if not most, professional photographers would unhesitatingly say the latter; it's their job to bring back the goods. They might say that it is, in fact, the very definition of being a professional. In my experience, it's not so simple.

When photographing much-photographed individuals, it's highly likely you won't be the last person to photograph them. In fact, you might be the next guy. I've been that guy, following in the footsteps of photographers who have grossly overstepped. Then I show up with flowers and it means nothing. The damage has been done.

One such case occurred on a squinty, sweltering Florida day. I was crouched at the apron of the outdoor pool waiting for Olympic gold medalist Greg Louganis, whom I would be photographing for an essay in *LIFE* magazine on athletes who won gold in 1984 and were aiming to do the same at the '88 games. My goal was to capture them in action but not to take "action" photographs. I was hoping instead to convey something more subjective: the unreal time-distortion athletes speak of

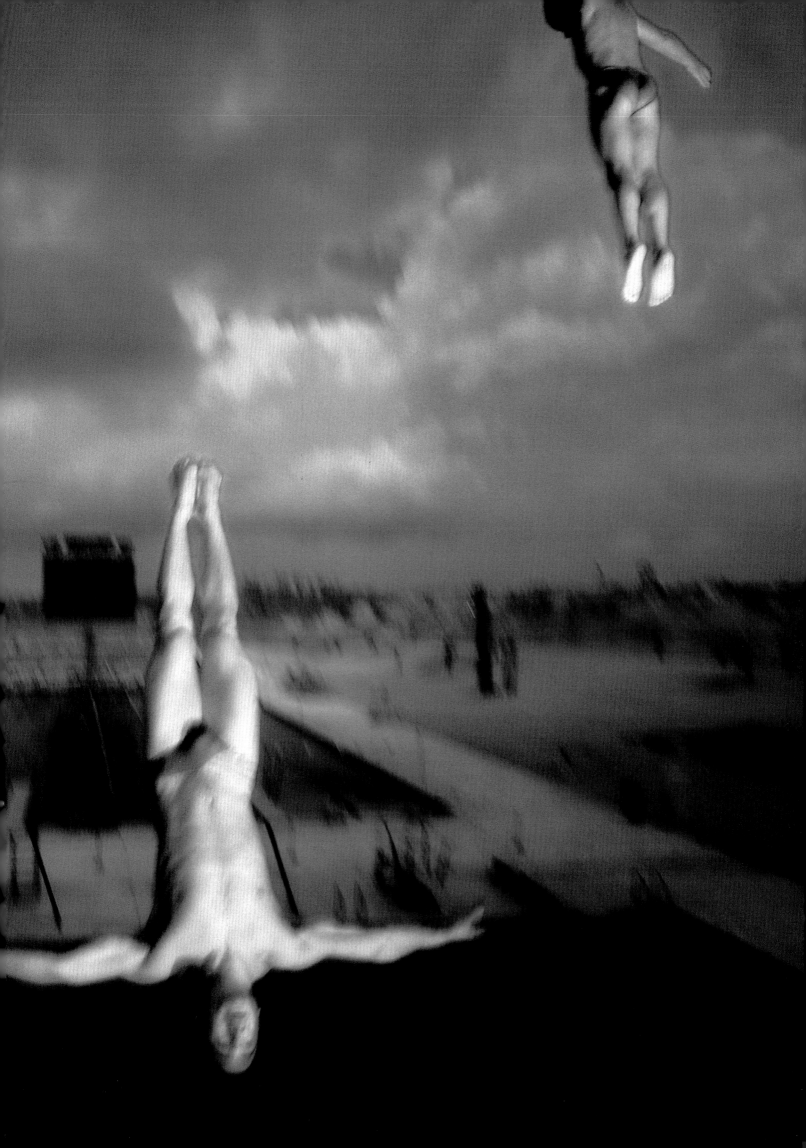

when they describe the experience of performing their event. To accomplish this, I was working with a decidedly non-sports camera. It had neither a long telephoto lens nor a motor drive for shooting rapid sequences. It was big and clunky, took only one picture at a time, and had a wide-angle lens that required me to be very close to the person I was photographing. Louganis would be in midair.

I had read that he had described the sensation of falling from the ten-meter platform as a little terrifying. So I wanted him plummeting, not flying. I figured the closest I could get was to perch on the edge of the seven-meter platform and shoot him as he whizzed past.

He appeared on deck, friendly but wary, and quietly listened as I explained the setup. I warned him that as he flew by me on his descent, he would see a bright flash when I took the one and only picture I'd be able to capture; then we'd try again on the next dive. He shook his head. "I can only give you five dives." I was stunned. He nodded as I described how I had spent the morning perfecting the picture, photographing collegiate divers training at the pool. I painted a picture of how the whole essay was shaping up and emphasized how important it was to the magazine. He shook his head. "Five dives. I'm sorry."

I didn't want to be pushy, but I continued, explaining that since my camera didn't have a viewfinder, I'd have to estimate the right time to press the shutter, but there'd be no way of knowing that I had absolutely captured him at the perfect moment, so I'd need more than a few exposures to be sure I had the shot. Not too many, but certainly more than five. He was unmoved.

I politely asked why he was being so firm. He explained that just the week before, he had been photographed for some swimwear ads and the photographer had made him do what seemed like hundreds of dives, all day long. He swore he'd never allow someone to do that to him again. He added that people don't realize how dangerous it is to dive off the ten-meter, even for someone at his level. He could hit his head on the platform (a premonition?). He could strike the water at just the wrong angle and break his neck. He could be paralyzed, even die. It wasn't fun. It wasn't flying. It was hard, scary work. And the Olympics were only weeks away. I listened and told him that I completely understood. Then I asked if he'd consider just a few more if I felt I hadn't nailed it. Not hundreds, not dozens; maybe just a few more. He said no. I walked to the diving tower as if it were a gallows. There was no plan B.

I readied myself on the seven-meter platform as he scaled the diving tower to the ten. I was nervous but felt fairly confident; the Polaroids I had done with the collegiate divers had looked promising. But there would be no Polaroids of Louganis. Every exposure had to count. He asked if I was ready, and I said yes. The next thing I knew, he flew right past me and hit the water. I never even pushed the button. It was just so . . . different from the earlier divers. He wasn't even in the same zone. He was so much closer. The focus would be different, the lighting altered. My timing, such as it was, was way off. He hollered up to see if I'd gotten it. "Yep, looks good!" That was one.

He climbed the tower again and dove, whoosh right past my nose, then the splash. I pressed the shutter just so he'd see the strobe flash. But I had completely missed it. He looked up from the pool, and I gave him a grinning thumbs-up. That was two. (It's easy to freeze a NASCAR racer going a hundred miles an hour from across the track. It's another story to stop the car streaking by five feet in front of you.) On the next

two I fared slightly better. I thought I had maybe caught his toes exiting the frame, but I couldn't be sure. As he climbed past me, he said, "Okay, last one!" I asked him to give me a one, two, three. He did, and just possibly I had my first almost-picture on film. I felt certain I could nail it with one more try. I requested just one, only one more dive.

"I'd love to help you, but that's it." I'm sure he was afraid to open that door even a crack. I felt sick. I honestly didn't think I had gotten the picture.

Just then, a little boy, dripping wet from his swim class in the pool, slap-toed up to Louganis and asked, "Can I have my picture taken with you, Mr. Louganis? Pleeease?" Louganis looked at me and said, "This is your lucky day." The two of them climbed to the top. I got the "one-two-three," and they went off together. Louganis dove, but the boy just jumped, thirty feet into the sky.

It was the only frame that worked.

THOUGHTS ON TECHNIQUE

I was searching for a way to portray Olympic athletes that hadn't been done before. The year was 1988, and they were being photographed for every magazine by all the top photographers in the country. At the time, retro-looking, black-and-white portrait photography was quite prevalent. What I wanted, though, was a kind of nonportrait portrait; a nonaction action shot that would feel like a portrait but would show the athletes "in the moment," doing what they do best. I wanted to evoke that sense of suspended time in a dream-like way that transcended the specific activity, that would convey a feeling of that moment rather than merely document it.

There is a kind of film that was almost a rite of passage for photographers when I was starting out. Because of its unique sensitivity to infrared light, black-and-white infrared film imbued everyday subjects with a strangely beautiful, dreamy tonality. Skies were dark and dramatic while trees went white within snowy-looking landscapes. It portrayed people in wonderful ways. Skin glowed, lips paled, and eyes were punctuated with pitch-black irises and pupils.

It seemed, intuitively, that these athletes expended so much energy and generated so much heat that they'd be like little infrared lightbulbs. They'd glow. Or so I fantasized. The trouble with 35mm infrared film was that it had a telltale "grainy," gritty look that I didn't much like. I decided to try out the 4x5-inch sheet version with the logic being bigger film, less grain.

It worked. The larger-format film greatly reduced the graininess while retaining the special tonal qualities of its smaller brother. The downside was that the film required heavy filtration, which reduced its effective ISO to about 12! Not only that, but light meter readings didn't necessarily correspond to the film's sensitivity, which changed drastically depending on the light source. Polaroids as a predictor were all but useless. Tungsten lighting was most effective, but strobes were needed to freeze the athletes. We rented the biggest ones we could get, veritable fire hoses, and still barely had enough of a trickle to make our exposures.

Possibly the biggest hassle, though, was the ultra-careful handling it required. Fingers fogged the film. Invisible light leaks streaked it. Heat made it unhappy. It was a nightmare to transport, load, carry, and process. But it possessed a unique, unreal quality achievable in no other way, so we tolerated its ill temperament. And in return, it delivered images conjured as if in a dream.

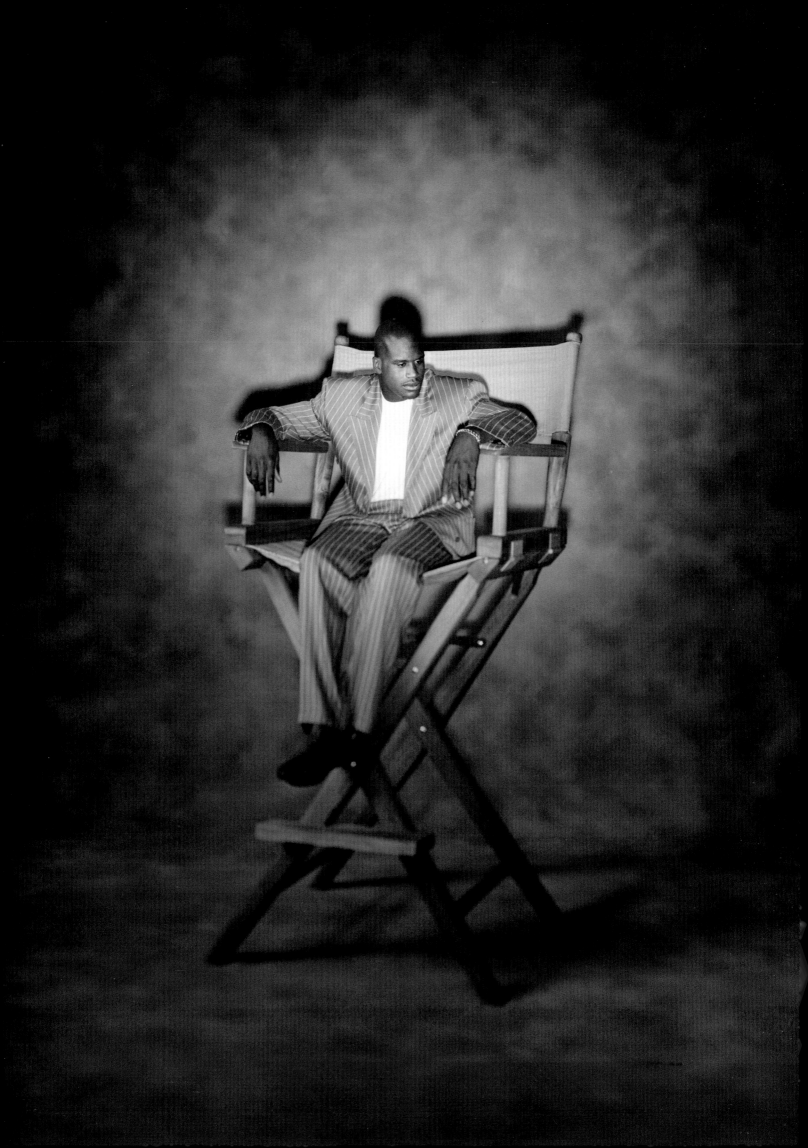

SHAQUILLE O'NEAL

"He jus' be tall."

That was the summation of basketball star Patrick Ewing's athletic gifts in the eyes of some of his envious high school teammates when I photographed him back in 1980. No matter how I prodded (Fast? Great shooter? Amazing ball handler?), all I could elicit was a grumbling, "He jus' tall." Those words echoed as I contemplated photographing the enormous new star rookie of the NBA, Shaquille O'Neal, for *GQ* magazine in 1993. He be *extremely* tall.

I felt compelled to convey his incredible stature: 7'1", 325 pounds. His huge hands could easily span the basketball like a grapefruit. And his foot was as long as *both* of mine end-to-end! The comments all season had centered on his exceptional size, a standout even in a sport of exceptionally large men.

But what if he looked incredibly small instead? I immediately thought of comedian Lily Tomlin's brilliant creation, the character "Edith Ann," a five-year-old monologist who always sat perched in a wildly oversized chair to tell us her latest story. Unfortunately, this inspiration had hit me only the day before the shoot, which was to take place in Orlando the very next afternoon. And even in New York, there were no chairs to be had that would fit him, let alone dwarf him.

At the time, I enjoyed a "carte *semi*-blanche" rela-tionship with *GQ*, which allowed me a pretty free hand to conceptualize and realize my photographs. So I put in a call to the most incredible model maker I know in the business, a magician named Christo Holloway. He had created many astonishingly realistic pieces for me over the years, both oversized and miniaturized. He said if I brought him a director's chair by 5:00 p.m. he'd have the oversized version faithfully executed in wood and canvas (and able to support 350 pounds!) by 5:00 a.m. He didn't say how much it would cost. I didn't ask.

When my assistants and I swung by Holloway's studio on the way to the airport early the next morning, the Big Chair was already built, broken down, packed, and ready for shipping. This is part of the magic of this crazy profession: if you can think of it, it can be done, and done on a handshake.

When Enormous O'Neal took one look at our enor-mous chair later that day, he broke into an enormous grin and asked, "Can I have it?"

THOUGHTS ON TECHNIQUE

Strangeness. Disquietude. Something not quite right. How to convey such a sense? Playing with scale is one way. A very big man in a very, very big chair looking very small is a good start. But playing it straight with

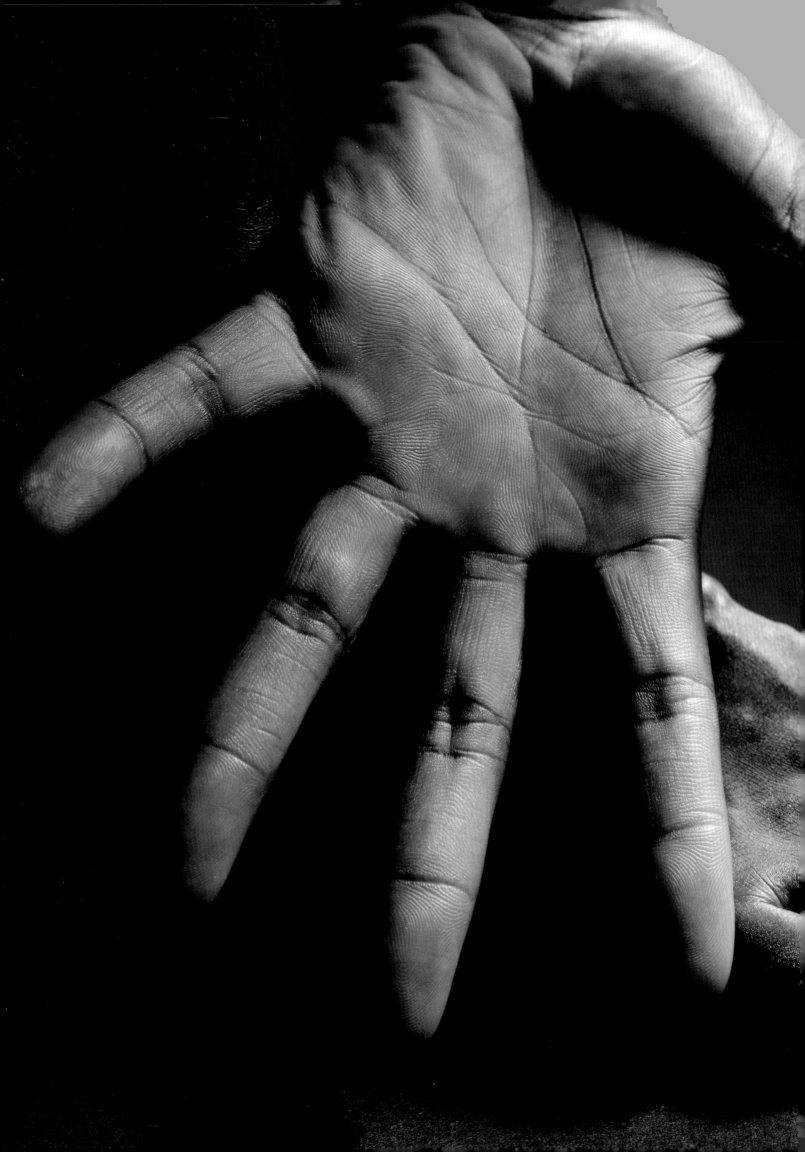

light would be too literal an interpretation and would undercut the ambiguity. The light needs to be a bit strange so that the viewer questions whether the image is real or an illusion, so it should come from two different sources that don't quite jibe.

The eye unconsciously always wants the light to make sense so that the brain can keep its bearings in an incredibly complex world. Shadows tell us what's up and down. Intensities indicate what the source might be: Is it sunlight? Moonlight? Window light? Artificial light? Direction offers a clue as to the nature of the source, especially with artificial light. Is it from a streetlight? A table lamp? A computer screen? A cigarette lighter? But when these cues are contradictory, the eye becomes disoriented and questions the reality it sees.

The light in this image of Shaquille O'Neal doesn't make sense. It seems surreal. The overall image is dimly illuminated by something—a light up high, so there are cast shadows of the legs of the chair. But where they meet the floor, the image goes a bit out of focus, making the chair seem peculiarly small.

O'Neal is sharp. His face and torso are anchored in the real world, caught in a crisp spotlight. His legs and feet fade into unreality as they blend into the softness and dimness of the rest of the image. Where's his spotlight coming from? Such lights are usually up high, like in a theater. They cast a shadow down onto the ground. This one's casting a shadow *up* behind O'Neal, so if it's high, he must be *even higher*. Of course, it's just on the floor, but it does its job. The light implies that he's *really* huge indeed. But he looks so *small*. Big and small, high and low, soft and sharp. Disorienting, disquieting. All mixed up.

These belong to Shaquille O'Neal. They're reproduced life-size, so you can compare yours to his.

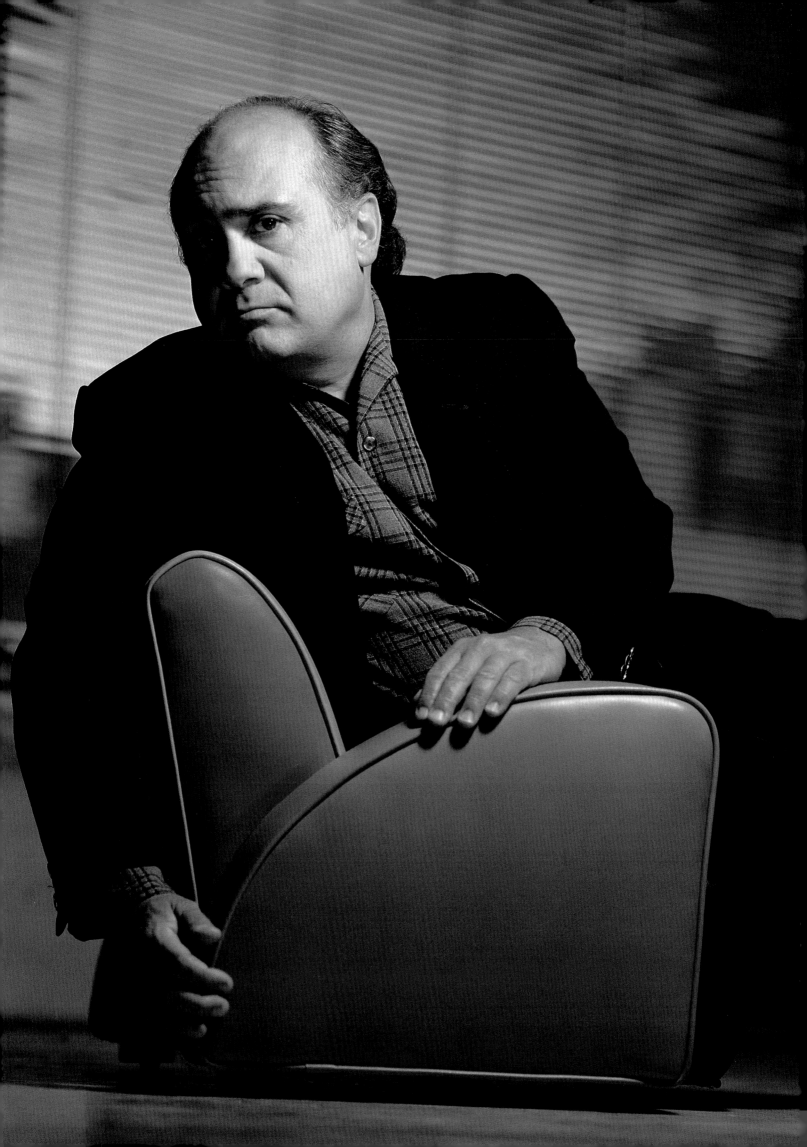

8

DANNY DEVITO

The camera was on the floor. *I* was on the floor. The chair was a child's chair. Danny DeVito loomed large, filling the frame. I was shooting him for a profile for the *New York Times Magazine* that focused not on his comedic career as a diminutive, irascible caricature but on his new career as a formidable film director.

It was early morning in a rented storefront studio in Los Angeles. The assistants and I were drinking coffee and figuring out our day. I had decided not to shoot DeVito on a plain paper background, fabric backdrop, or cyclorama wall. I wanted him to be *someplace.* So I chose to use the studio as a real location, as if we were in his home or production office. I looked around the place; there wasn't a whole lot to work with. All the seating options would only make him look that much smaller: director's chair, a large leather sofa, and a tall makeup stool. (The director's chair wouldn't be an option anyway; in his case it would have been too much of a cliché.)

There was no stylist and nobody available to go prop shopping, so I went. I didn't mind; when I'm out looking around, I often stumble upon something that I'd never have considered or known to ask for. Plus, it gives me some time on my own to mull over the day's possibilities.

I hit some of the vintage furniture shops nearby on LaBrea. There were some terrific pieces, but they were *too* good; they'd draw attention away from my subject rather than focus the viewer's attention on him. Then I spotted it: a two-tone reproduction art-deco club chair. A *child's* club chair. Half-size but not kiddie-cute; it looked like a sophisticated piece of furniture, just smaller. So I negotiated a rental fee, threw it in the car, and ran it back to the studio.

When DeVito showed up, he saw the chair sitting all alone in the studio, surrounded by lights; it was obvious this was to be his little throne for the afternoon. But he got it. He saw that it wasn't a cartoon.

He is, in his own way, a big man: stocky, barrel-chested, thick. He more than filled the chair. When he sat straight-on, he hid it. So I spun the chair sideways and tried a Hitchcockian profile. Too corny. He rolled on his hip, flung his arm over the back of the chair, and turned to face me. Now the picture was dynamic, all angles. His shoulders were a counterpoint to the blinds in the background. His black suit offered an imposing silhouette, particularly from my low angle. He swiveled his famous head, gazed down at the camera, and gave me *the look*.

*In this portrait, flattery wasn't the top priority.
I didn't want him to not look good, but it
seemed more important to get past the familiar
funnyman, to evoke a sense of the auteur.*

THOUGHTS ON TECHNIQUE

Broad lighting. Short lighting. Rembrandt. Butterfly. Clamshell. These are all terms used to describe various lighting schemes for portraiture. Unfortunately, some, like broad lighting, are discouraged, while others, like Rembrandt lighting, are often preferred. I'm an equal-opportunity illuminator. I'll use whatever works.

Broad light is when all the real estate on the broad, or near, side of the face turned toward the camera is illuminated, nose to ear. Short lighting, on the other hand, is when the light falls on the narrow, or short, side of the face turned away from the camera. In short lighting, the subject's nose is pointed *toward* the light. This is thought to be more pleasing, slimming, and flattering. In broad lighting, the subject's nose is pointed *away* from the light, which is thought to result in a less favorable portrayal, because it tends to broaden the face and make it look heavier.

But there are really no set rules about this sort of thing. It's always a judgment call. Painters for centuries have used broad lighting to create portraits with great character. (The work of John Singer Sargent comes to mind.) Yet it's always Rembrandt whose praises are sung in the lighting department. It's really not fair. Seminal portrait photographers like Irving Penn and Arnold Newman often used broad light to great effect.

In this portrait, flattery wasn't the top priority. I didn't want him to *not* look good, but it seemed more important to get past the familiar funnyman, to evoke a sense of the *auteur*—a side of DeVito that his public hadn't seen, a potentially darker side, certainly more serious than what they were used to.

One characteristic of broad lighting is that it throws the front plane of the face into partial shadow, creating a sense of the *not quite known*. Combine it with a turn of the head and the subject can look wary. Things are left *unseen*, which can be a bit disconcerting in a portrait. There's nothing wrong with disconcerting; in fact, sometimes it can be just the ticket.

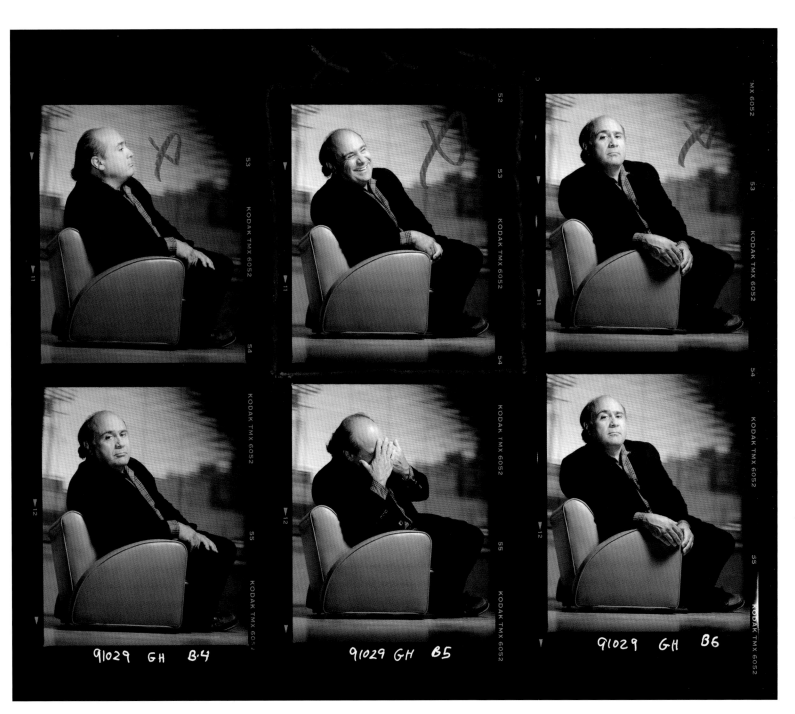

In this contact sheet, DeVito goes from Hitchcockian to hilarious to imperious.

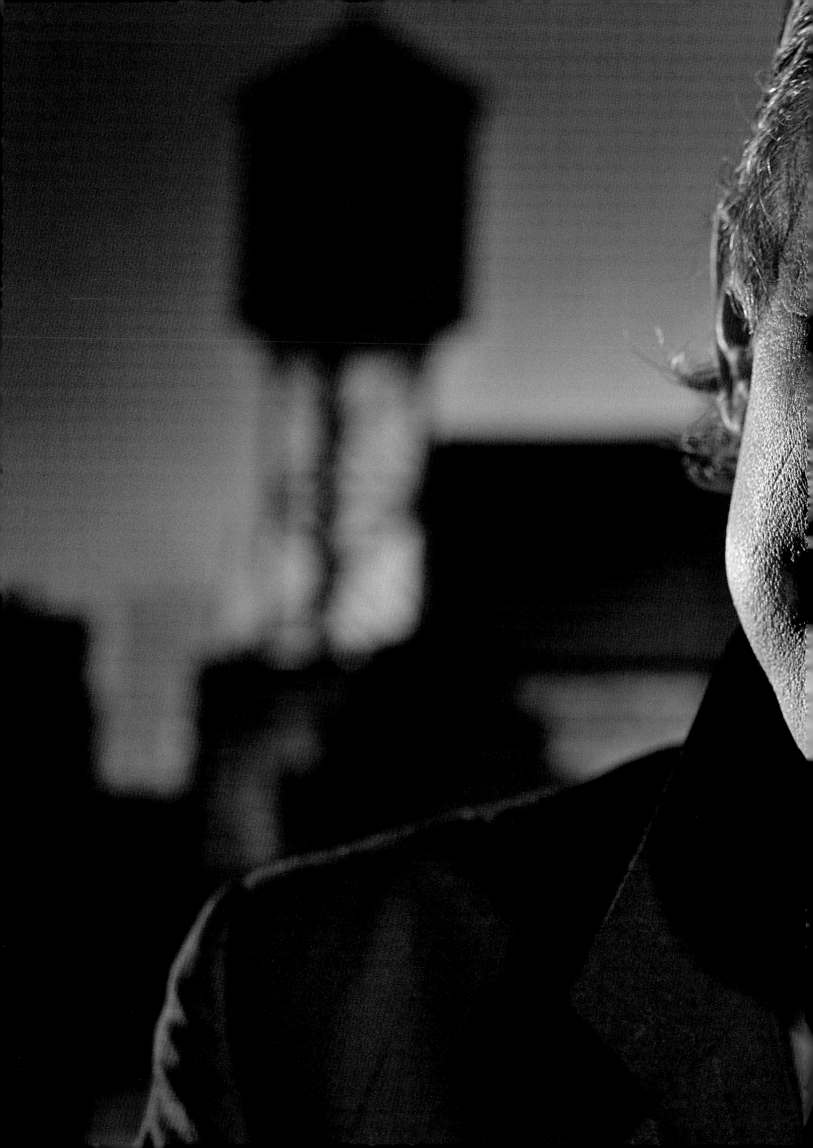

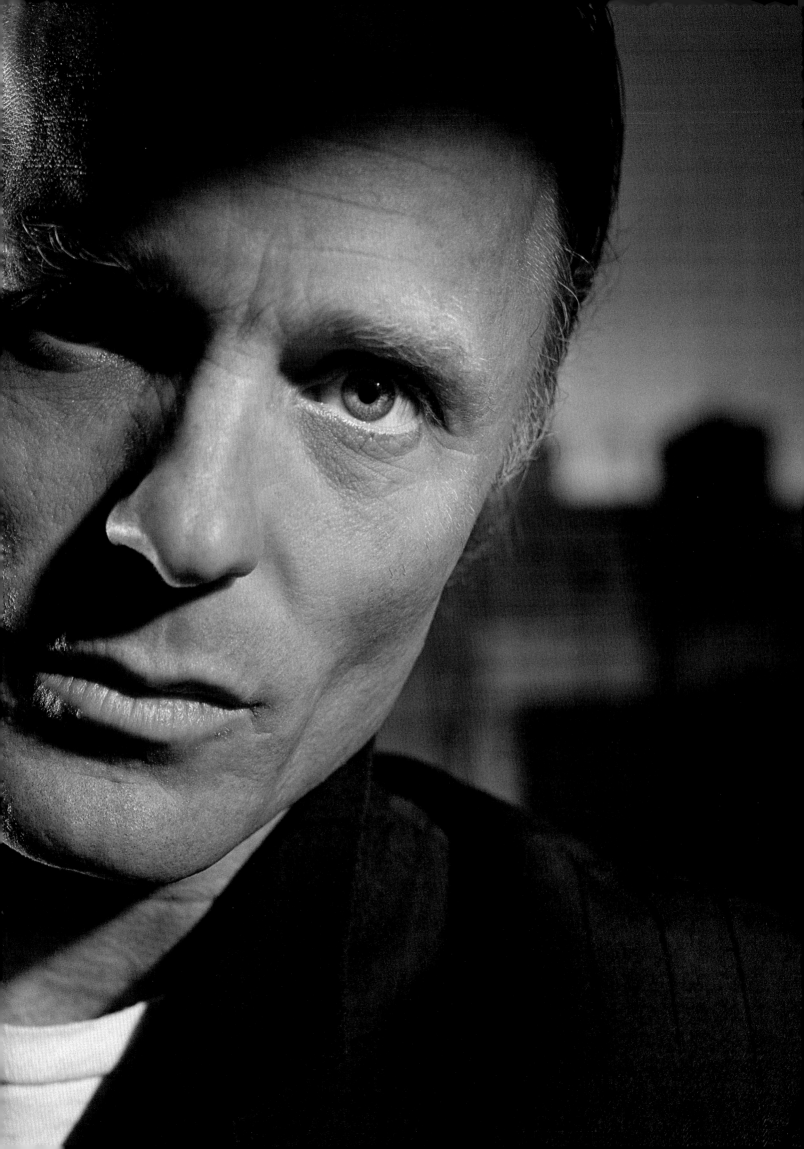

ED HARRIS

There is no rooftop. It's not even nighttime. Ed Harris and I are standing on the front lawn of his house overlooking the Pacific Ocean in Malibu. I'm photographing him because he's starring as a Hell's Kitchen gang leader in the film *State of Grace*, set in New York City. There's nothing in or near his home that will convey a sense of his role or the movie. The house, a sprawling, comfortable ranch, couldn't be sited more perfectly, with a sensational view of the sun setting over the water. But what I need is a thoroughly believable nighttime New York City rooftop. A little touch of grime on the Malibu coast.

Of course, since I'm in LA, there is just the place to satisfy such a requirement, a place that rents things called "translites." At the time, that was the term for large-scale photographic backdrops, or "backings." These are literally photographs, generally scenic panoramas like skylines, blown up to gargantuan proportions, some more than twenty feet tall by well over a hundred feet wide. They are transparent, so they can be illuminated from the rear and glow with lifelike reality. In movies, they're often used to complete the setting on a soundstage as the view out the windows of an office or apartment, and they are absolutely convincing.

At the time, they still had old black-and-white translites from the noir era, and I chose one that was

not too big, maybe ten by twenty feet, and dragged it out to the coast. It was a real beauty, a dark urban rooftop view, nondescript save for some silhouettes of the ubiquitous water towers endemic to New York. It was just enough to place him.

I constructed some shadowy lighting that looked like it belonged on an urban rooftop, lighting that, in the words of my old photography teacher, "reveals yet conceals." I needed Harris to seem intense, threatening. In the movie, he's charismatic and scary; he also kills his own brother. I wanted to see his eyes but be unable to look into them, to read them. So while I moved in close with my camera, the lighting kept him at a distance, shadowy and hard. Though I was right in his face, it remained unreadable, opaque.

THOUGHTS ON TECHNIQUE

In your face. What's the difference between a regular portrait that's just cropped tight, an actual close-up portrait, and a portrait that's truly in your face? As it happens, quite a lot.

In a portrait that has been cropped, there are several issues that affect the feel of the image. First, it's

OVERLEAF **Ed Harris**

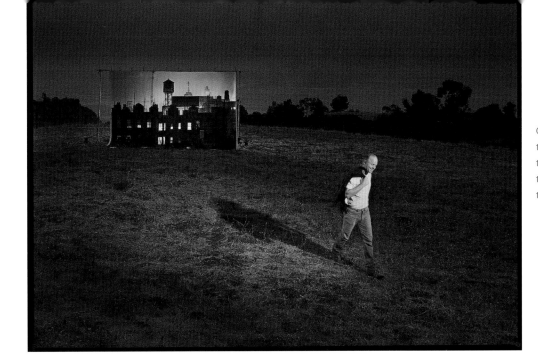

Our subject lets us in on the Hollywood illusion: the Malibu coast serves as the unseen backdrop for the backdrop.

likely that the photographer was never physically very close to the subject, which is why the picture needed to be cropped in the first place. This manifests itself as an emotional distance in the portrait, since the closeness is phony—an after-the-fact manipulation of the image, suitable for surveillance pictures but not much use in portraiture.

A close-up picture is a different story, yet it may share some of the characteristics of the cropped image. The question becomes: did you get close with the lens or by using your feet? If you got in close by using a telephoto lens, then all you did was crop the picture in the camera rather than later. But, in a sense, you still cropped it—and stayed at a safe distance from your subject. While this may, in fact, be necessary for wildlife pictures, it's less interesting for human subjects. It brings us close enough to get a good look at people, but we really never get to *see* them. There's still that emotional distance.

This is somewhat ironic, since most so-called "portrait" lenses are, in fact, in the telephoto family. They keep you at a distance from your subject. There are benefits to this. One is that you and your subjects are likely to feel more comfortable, since you are not invading their space. Another is that the slight distance

results in a generally pleasing, natural perspective to the picture. Many, if not most, portraits are made using lenses that are "longer," or slightly telephoto, because they deliver consistently flattering results.

But there is an *immediacy* to portraits made with "shorter" lenses, such as this one. These lenses require you to be physically closer to your subject. The dynamic changes. Engagement is unavoidable. The resulting portrait may be less traditionally pleasing, but it's often a whole lot more *interesting*. There's a *vibe*, a charge that gets communicated in the photograph. It's exciting.

The other thing that shorter-focal-length lenses do is enhance, or force, the sense of perspective in the picture. Close things seem closer; farther ones recede. The effect can be subtle or quite dramatic. In portraiture, it can be slightly unsettling or downright startling; it's a matter of degree. What it does is "pop" the subject out of the background and bring it front and center. Which is why Harris's intensity comes through so powerfully. The water towers recede, but he's right up in your face.

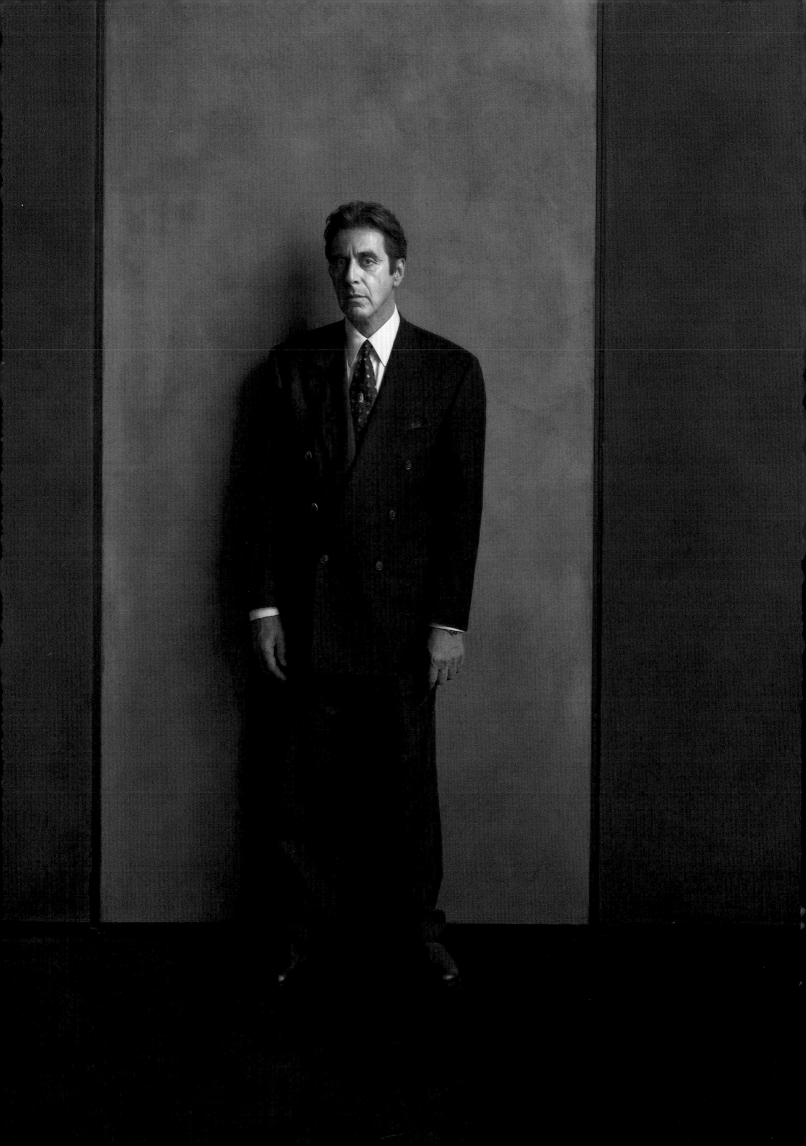

10

AL PACINO

The brief opportunity presented itself during a break. I was photographing Al Pacino and Keanu Reeves for the movie poster and advertising art for the film *The Devil's Advocate.* I had brought along my then-favorite camera, a big 11x14-inch wooden number, hoping that I might have a few moments to make a simple portrait of Al Pacino for myself at some point during the relatively brief time he'd be in the studio. The moment came when Keanu Reeves was whisked back into the dressing room for a wardrobe change. A tall gray dividing wall with a suede-like texture illuminated by a row of tall windows had caught my eye as a possible backdrop for the portrait.

Advertising shoots can be a game of options and variations. To satisfy the simplest concept, it is not uncommon to shoot many variations to provide the creative team at the advertising agency with different choices. There may be changes in wardrobe. Or make-up and hair. Or props and furniture. Or background. Or lighting. Or angle. Or even the models themselves. Then there are the endless subtleties of expression and gesture. Even once a specific visual has been identified, it is not unusual to shoot it in different croppings and orientations to accommodate the myriad layout formats the images will need to fit: horizontals for billboards, verticals for posters and newspaper ads, and so on. It

can be exhausting for the actors or models, required to maintain their concentration (and, hopefully, good humor) for hours on end.

This is why I'm usually loath to ask anything extra of my subjects. Usually. But this was Al Pacino. The carrot would be that I'd only ask for a few frames, a minute or two at most. No clothing changes; no makeup touch-ups. No variations. I could sense that he wasn't dying to do it, but he graciously consented. The layouts for the movie called for medium shots and close-ups; I wanted to finally see him head to toe. The camera was already set; I had hastily framed up the image with my assistant as a stand-in. Pacino silently walked over to the wall and, still in his character's slightly malevolent mode, turned to face the camera. Arms at his sides, without seeming to do anything, he projected serious-as-a-heart-attack gravitas. I said nothing. He was giving me a gift.

Many years earlier, I had photographed the Japanese president of Toshiba America, the US subsidiary of the giant electronics corporation. I had a terrible time trying to get him to relax for his portrait. He just stood there, solid and erect, hands at his sides, seriously facing the camera. Try as I might, I could not coax or cajole him into a more casual pose. He was friendly but, I soon realized, quite determined to appear just as he

Arms at his sides, without seeming to do anything, he projected serious-as-a-heart-attack gravitas. I said nothing. He was giving me a gift.

was and no other way. Sensing my frustration, he walked over to me and explained: "In Japan, body language conveys a strong message, especially for an executive; a very different message than it might carry in the States. If I fold my arms, it is seen as being defensive. If my legs are crossed, I appear weak and lazy. My hands clasped in front of me appear to be hiding something. And if I put them in my pockets, I just look sloppy. So when I am like this," he continued, resuming his straightforward stance, "I am businesslike and strong."

Whenever I look at this image of Al Pacino, I wonder if he was aware of the power of that posture. I am also reminded of the work of Michael Disfarmer, who, for more than forty years, made portraits of the citizens of Heber Springs, Arkansas, in his little studio, many against a Mondrian-like wall not terribly unlike this one. He didn't pose them; he just let them be and present themselves for the camera. As my subject here similarly confronted the camera without any posing or direction,

we are left to wonder if he did so as Al Pacino (whoever that may be) or as an accomplished actor in the role of John Milton, an embodiment of the devil himself.

THOUGHTS ON TECHNIQUE

Certain cameras allow you to see the quiet. Just as there is a distance from the camera to the subject, there is a distance from the photographer to the camera. When one works with a DSLR (digital single-lens reflex) or rangefinder camera, there is literally no distance; the photographer's eye is mashed right up against the viewfinder in an attempt to literally see right through the camera to the subject, to make the camera disappear. When one employs a view camera, there is a distance. The photographer has to actually back away from the camera to get a good look at the inverted image on the ground glass; otherwise, it's like trying to watch TV with one's nose pressed against the screen.

This distance serves several purposes. For one, it allows the photographer to appreciate the two-dimensional image, just as it will be rendered as a photograph. More important, it allows the photographer to *assess* the image, to step back and really have a good look, to take a few minutes to carefully study the picture before it becomes a picture. It slows down the picture-making process so that it becomes more deliberate. It also becomes more thoughtful and quiet. The camera itself does not disappear, quite the opposite: it makes its presence felt on both sides of the lens. It's a mutual standoff with a machine in the middle. It's a barrier, yes, but in a way protecting both subject and photographer from each other, giving both a bit of room to collect their thoughts and grow quiet. It is this very quietude that is reflected in the finished photograph.

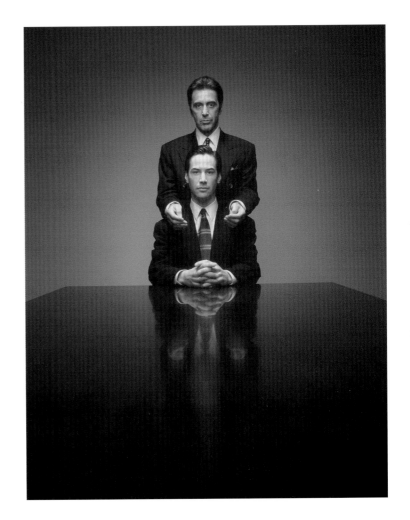

A variant of the picture I was hired to shoot for the movie poster of *The Devil's Advocate,* with my subjects fully in character.

HUGH GRANT

"Just *do* something!" This time I was the model, posing with legendary portrait photographer Arnold Newman for a magazine story on mentors. A few frames had been made. We looked at each other in stunned silence. We were side by side in the typical "guy pose" men seem inevitably to adopt: arms down, hands clasped protectively in front of the privates.

"Come on, guys, just *do* something, okay?" This was no way to cajole two nervous subjects out of their self-consciousness. We stood there in the light's glare, looking out into black space, searching for the source of that voice. Somewhere there was a photographer with his tripod-mounted camera, assistant hovering nearby. The fan on the light made an irritating clacking sound, like a stick being dragged quickly across a picket fence. I gamely tried to "do something": I leaned my elbow on Arnold's shoulder. The flash popped; a picture had been taken. Next Arnold and I posed back-to-back, arms crossed in front of our chests. Pop, pop, pop. Then nothing. Desperate for feedback, I slipped off my shoes and knelt into them, arranging my pant cuffs like José Ferrer playing Toulouse-Lautrec. Now Arnold leaned on *my* shoulder. Pop, pop, pop, pop. Again, nothing from the darkness; no prompts or encouraging words. I shielded my eyes to find the photographer. While his assistant reloaded the camera, I spotted him standing off to the side, smoking a cigarette and mumbling into a phone! We were being treated like a vase of flowers or a bowl of fruit: a still life, nothing more.

"What do you want me to do?" That's the first question every portrait subject inevitably asks the photographer. You can't reply, "Just be yourself." Self-consciousness reigns. It's even worse for actors, who spend their entire careers going to great lengths specifically to become someone else. They're never "just themselves," certainly not in front of a camera. So, as the photographer, you have four choices: (1) be satisfied with whomever they show you; (2) tell them exactly what to do (this can be dangerous); (3) distract them with music and chitchat; or (4) just do nothing and silently bore them until (hopefully) something natural happens.

For this cover shoot of Hugh Grant, part of a fashion essay in *GQ* magazine, I had started with option three. Grant had been responsive, even, as he said, "a bit hammy" for the camera. It had been a mutually beneficial relationship: he had happily played to the camera, and the camera had loved him for it. But then, while waiting for the next lighting setup in the now-defunct Cheyenne Diner in midtown Manhattan, I found myself staring at option four. He was alone in a booth sipping coffee, killing time, distractedly tapping his teaspoon. It was an authentic moment sandwiched between many

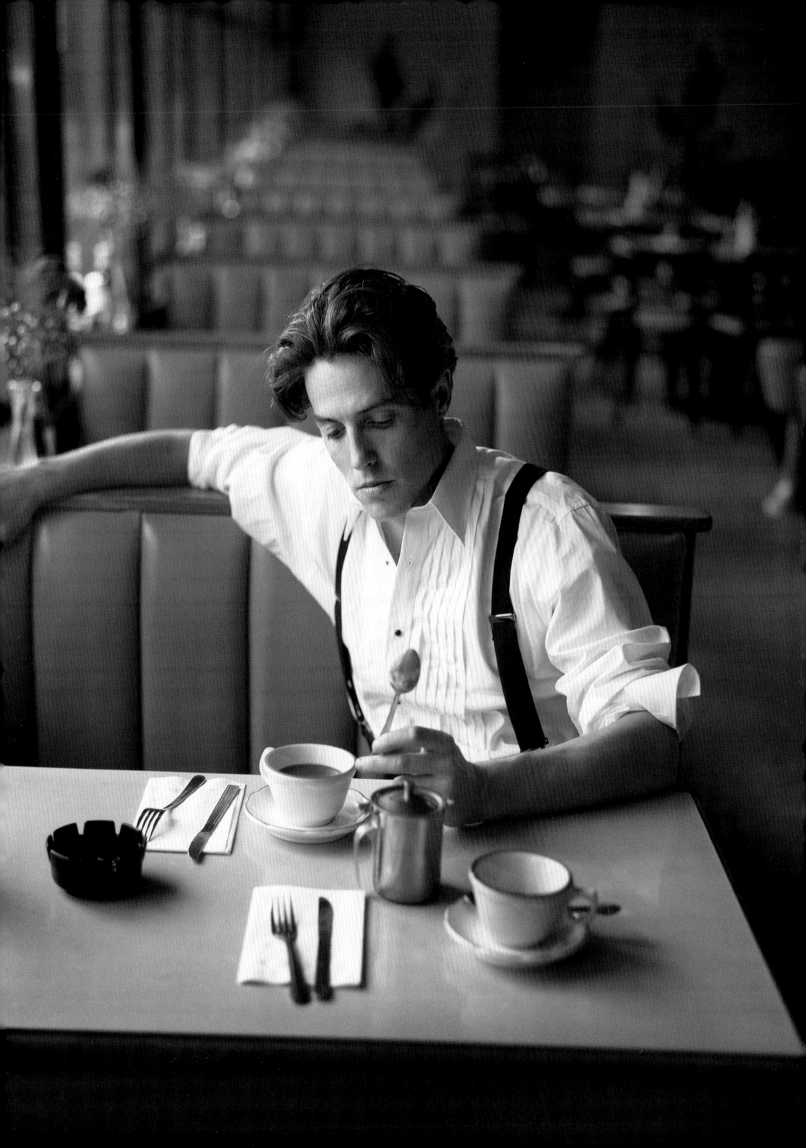

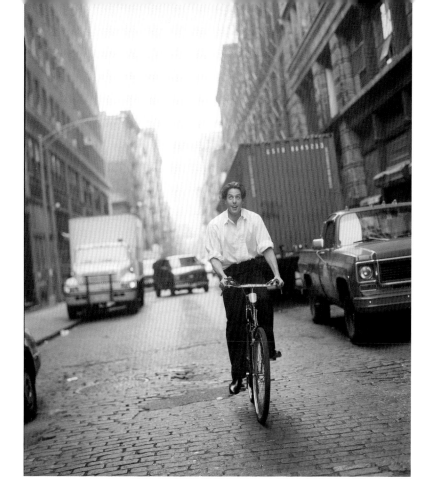

not-so-authentic moments. Picking up my 4x5 camera for a handheld shot, I slipped into the next booth and motioned for my assistant to step outside and walk around to our window with a little battery-powered light. Grant seemed truly lost in thought, because he took no notice of the activity around him (a skill no doubt acquired on countless film productions, where set and lighting changes can take hours). I said nothing, fumbled with my camera for a few minutes, silently watched, made a few exposures, and then left him to his coffee.

THOUGHTS ON TECHNIQUE

I love using light I can *see*. With continuous light sources—tungsten, fluorescent, HMI, and even LED— you can readily evaluate their effect without using light meters, Polaroids, or digital test shots; you can see it with your eyes. You can pay more attention to your subject, since half of your head isn't hurting with numbers you have to rely on (because you can't see what you're getting). This allows you to make large and very small, subtle changes on the fly during a shoot. It's actually quite enjoyable to fine-tune visually rather than be completely dependent on light meter readings and test shots. If the desired effect is late-afternoon sunlight pouring through a window, it actually *looks* like late-afternoon sun pouring through the window, and for the subject standing in its warm wash, it *feels* like late afternoon sun.

Actors respond particularly well to continuous light sources, because that's what they're familiar with from working on film sets. (There are no strobes on a movie set.) I've shot on film sets, and there have been times when I've forgotten that the light coming through the window wasn't from the sun! It's surprising what a profound effect this can have. Particularly when mixed with

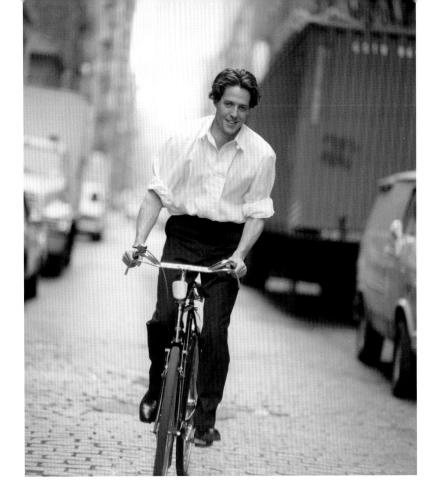

existing ambient light, continuous light sources are easy to tune out and forget. A disadvantage is that they're often not particularly bright, so "fast" lenses with wide apertures are needed to work with them at reasonably fast shutter speeds; otherwise, a tripod must be employed. Surprisingly, however, there are advantages to their not being very bright. They tend to integrate well with interior lighting sources such as window light, fluorescent light, and lamplight, so it becomes easy to organically and naturally blend them with the existing ambient light. And because they necessitate using wide-open apertures on fast lenses, beautiful, believable focus effects are easily achieved. Finally, they're kind to the subject, neither hot nor squinty-bright.

When mixed with existing ambient light, continuous light sources can bring a touch of sheen to a subject's skin, pull out the texture in a fold of fabric, or add snap to selected areas of a scene. In this simple portrait,

the window light was nice and soft, but a bit dead. I could have used a strobe, but its flash would have punctured the quiet mood of the moment and would have taken longer to set up. I'd have needed to stick a light meter in Grant's face and take repeated readings as I adjusted the flash intensity. And I'd have needed to snap a Polaroid or two to be certain of its effect—all of which would have wasted precious minutes and cost me the picture. So instead, my assistant popped outside, clicked on his continuous quartz light, and stood some distance away from our window, adding just a bit of emphasis to Grant by making him a tad brighter than his surroundings, defining the shape of his face, showing the folds in his formal shirt, and adding a kiss of highlight to his hair—all in a matter of seconds, without popping the bubble.

ABOVE Pedaling down Prince Street on my old English policeman's bicycle, Hugh Grant hams it up for the camera.

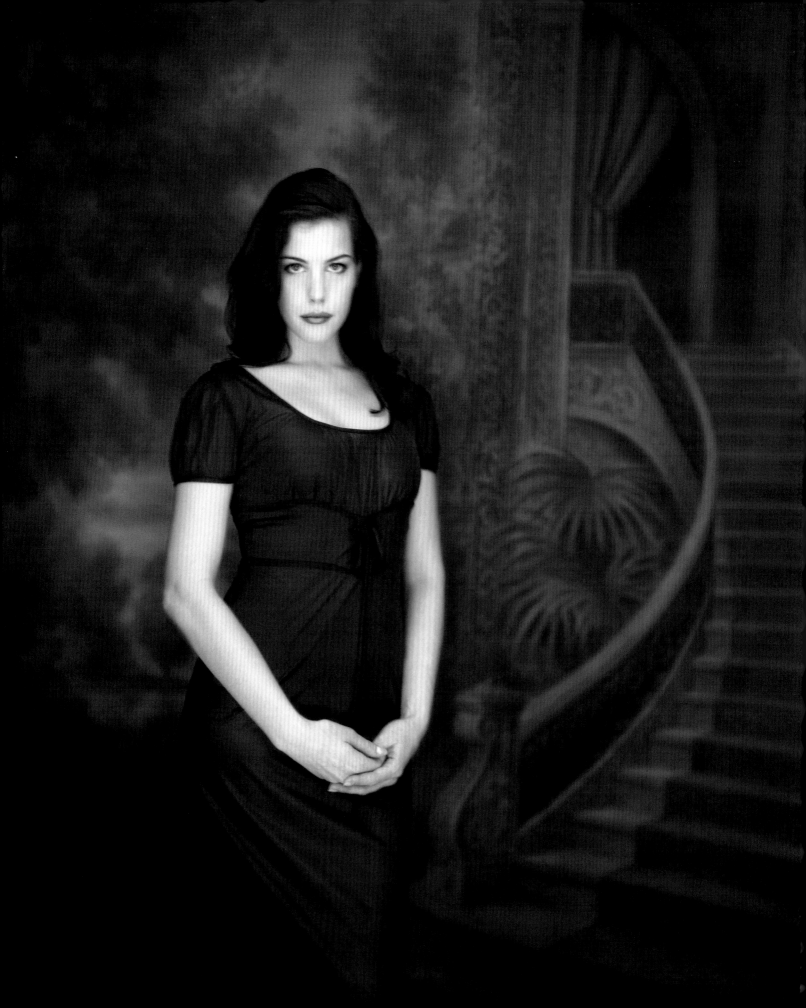

12

LIV TYLER

It's a century-old backdrop from an unknown portrait studio in upstate New York, lending an anachronistic touch to an otherwise very modern shoot. Through my lens I see lovely Liv Tyler posing before it, batting her beautiful blue eyes. (This is too easy.) I rarely get to photograph beautiful women, one of the great sadnesses of my career. It can be tricky territory, though, because it's never *not* about their beauty. Still, that can be plenty to chew on.

Yet I find that I have *more* options available to me when photographing men than women, simply because the range of what society deems attractive in a man is far broader. The clear message I've gotten from clients, art directors, editors, and writers through the years, whether they've been male, female, straight, or gay, is that men just have to look interesting but women have to look *good*. Guys can be tall, short, fat, or thin. They can be bald or bushy-haired, bearded, shadowed, or shaven. They may have big noses, prominent ears, rough complexions, and flat feet. For a photographer, this is great news. It offers tremendous creative freedom. The scrutiny of women (especially *by* women), however, is merciless. Great emphasis is placed on their beauty, which is defined very, very narrowly. For a photographer, this limitation can be terribly frustrating. In

a sense, it means that if there are a hundred ways to photograph a man, there are six for a woman. Flattery becomes the name of the game. Unfortunately, not all lenses are flattering, not all light is flattering, not every angle or point of view is flattering.

Magazines (even *news* magazines) typically hire different photographers to photograph girls than boys. This is depressing. It's somewhat understandable when the subjects earn their living largely from their looks, but even when they're politicians (or athletes, writers, scholars, or scientists), beauty, glamour, and fashion photographers are often called in to photograph female subjects, backed by a retinue of makeup artists, hairdressers, wardrobe stylists, and retouchers. Vanity trumps journalism almost every time.

Then there's Liv Tyler. She's *already* beautiful. No sorcery, or retouching, required. Stevie Wonder could photograph her. That's probably why they even hired *me*. I photographed her in a number of different setups, outdoors and in the studio, serious, seductive, laughing, and coy. I could do no wrong. In some she wore the very same dark dress, in others an overcoat and *my* black porkpie hat! She looked amazing in virtually every frame. She was cooperative, animated, and very funny. In the end, though, it was this final frame that

The clear message I've gotten is that men just have to look interesting but women have to look good.

survived the test of time. She's quietly focused on the big camera. The skylight envelops her in its soft illumination. And the old backdrop gently pulls her back into another era.

THOUGHTS ON TECHNIQUE

I've often heard and read that there are different lighting schemes for women than men, but I don't buy it; there's good light and bad light, flattering and unflattering light, but not X and Y light. It either works or it doesn't.

We had been working in a studio with a curved white cyclorama flooded with photons from an overhead skylight. For one of the setups, it had been our bright white background. At the end, after all of the required shots on the shopping list had been made, I asked for a few moments to try one last idea.

Jay Maisel has many commandments (I'm sure there are at least ten), admonishments to fellow photographers. One that rang in my head on that day was, "If the light looks good, turn around!" So instead of shooting *into* the white wall, as one always does in this type of studio, I turned my back to it. It became the light source, a glowing twenty-foot wall of light. And instead of hanging my vintage painted backdrop against the white wall, I hung it *opposite* the wall, facing it head-on. I positioned Tyler in front of the backdrop as if she were in a nineteenth-century daguerreotypist's studio, standing stock-still.

Not still enough, I later learned. The light was beautiful but the exposure wasn't. What had seemed

like a waterfall of illumination was but a drip-drip-drip to my old camera with its slow lens. While the exposure was a fraction of a second, it was a *long* fraction of a second, long enough for her to shift ever so slightly. Her body was still, her nested hands steadying each other, but her face was alive, and it moved. Just a bit, just enough to airbrush her baby-smooth skin with a supersoft glow. Sharpness isn't everything; creaminess counts, too. Even though it's risky, sometimes you make the best shot of the day with your back to the wall.

A sweetly coy variant of the magazine's cover image, photographed with the opposite tool: a 35mm camera for spontaneity and a tilt/shift lens to skew the focus and emphasize Tyler's beautiful eyes.

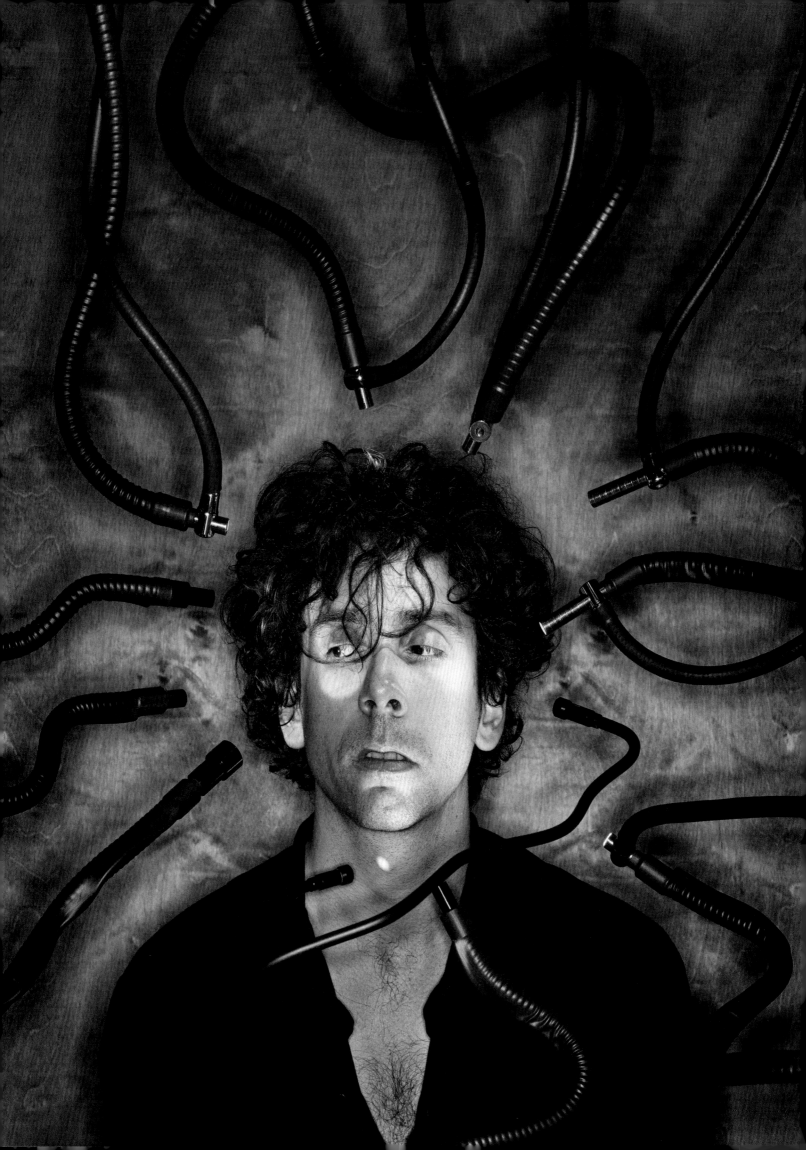

13

TIM BURTON

I had just returned to my Los Angeles studio from the shop where I'd be getting the rental gear for an upcoming shoot with director Tim Burton. While there, I had become fixated on a gizmo I had never seen before: a fiber-optic wand. It was a slender, snaky, rubberized tube that attached to a strobe in order to project a tiny, tight beam of light. It was flexible and could be contorted into all sorts of strange shapes. The contraption I had seen sported several of these wands slithering out of a dome that attached to a strobe like the tentacles of an octopus. I was enthralled.

What if these wands weren't only used to light my subject but could *be* the subject, as well? For some reason, they had the unsettling quality of many of Tim Burton's visuals. I could have imagined them in one of his films (or sprouting, Medusa-like, from his head); they almost looked *alive.*

Back at the studio, we arranged these wrigglers using a stand-in to allow space for our subject. For a background, I chose a 4x8-foot sheet of plywood for two principal reasons. The first was that when photographed in black and white, it lost its "plywood-ness" and became abstracted into an organic-looking surface with lots of random movement that echoed that of the "tentacles." The second was that it was available, handy, and free (sometimes it just works that way). When Burton

arrived at the studio, I showed him a Polaroid test shot of the image using the stand-in. He liked what he saw enough to agree to insert himself into our strange setup.

Nowadays, one could share this intention by showing the subject the image on a computer screen. But it's not something I do as a matter of practice, because it has advantages and disadvantages. On the plus side, it can be incredibly helpful, especially if the combined effect of the props, set, and lighting isn't readily visible. It can bridge the creative gap and let the subject or client in on the process. But on the minus side, this sharing is not always a good thing, depending on the power hierarchy and various personalities involved. It can put some people at ease, because they can see what the finished picture will look like, while others will pick it apart. Subjects also use it as a mirror to see how they look, all but disregarding the creative concept of the picture. Even worse, this "mirror" is unreversed, which can be a real problem. Our entire sense of what we look like is based on a lifetime of seeing ourselves reflected in mirrors. Backward.

We all know that the human face is, at best, somewhat asymmetrical. We all have "good" and "bad" sides, but we become blind to them over time. When we are confronted with our likeness in a photograph, however, this imbalance strikes us like a cold slap; our face is

Our entire sense of what we look like is based on a lifetime of seeing ourselves reflected in mirrors. Backward.

suddenly backward, and we see it with a fresh eye. For most people, it's a rude awakening.

One of my first jobs was shooting high school yearbook portraits of faculty and graduating seniors for a company engaged in that specialty. I was a real novice, barely twenty, and listened carefully to all the pointers I was given by the more experienced photographers. One day in the darkroom, the senior member of the staff shared with me the secret of his success, as his portraits vastly outsold those of the other photographers. When the paying customer was someone other than the subject, like a parent or a corporate client, he'd print the pictures normally. But when the client was the subject, he'd print the portraits *backward*. His customers loved them! At long last, here was a picture that looked *right*. "Of course," he confided with a smile, "to their friends and relatives something about the pictures always looks a little funny, but in the end they can never quite put their finger on it."

THOUGHTS ON TECHNIQUE

Broadly speaking, photographic lighting falls into two categories. There is lighting that is inspired by and emulates ambient illumination, replicating it for the technical requirements of the camera. While much of the lighting I do falls into this category, every now and again I'll make an image that falls into the other category: lighting for its own stylish sake, lighting that isn't necessarily anchored in reality but that just looks cool and feels right.

In 1990, I was working on an advertising campaign in which I had to make studio portraits of several well-known designers, including a graphic designer and an interior designer. For the graphic designer's portrait, I had wanted the image to look as two-dimensional as possible, since that was the nature of his expertise. Back in my assisting days, I had seen a few photographers work with an unusual light source that I hadn't encountered before: the ring light. It's a doughnut-shaped light fixture that fits right over the lens, surrounding it like a ring on a finger. Originally developed for medical macro photography, it produced crisp, shadowless light that seemingly emanated directly from the lens of the camera, perfect for photographing close-ups of surgical procedures, gaping wounds, and various orifices. The resulting pictures showed every detail, free of distracting and obscuring shadows. Fashion photographers had since appropriated it for the way it snappily, stylishly highlighted the apparel.

The ring light had always been used as a "key" or main light, providing the principal illumination for the subject. Because its light radiated from all around the lens, though, it seemed to me like it would be the ideal "fill" light; being essentially shadowless, it would have no directionality, seeming like it came from everywhere and nowhere. It would establish a foundation of illumination, making the subject visible but leaving the directional shaping to the main light, which would define the character of the image. Best of all, when used in this way the ring light had a beautiful strangeness to its look, imbuing the picture with a somewhat disquieting, illustrative quality. Depending on the proximity of the sitter to the background, it also left a quirky telltale fingerprint: a ring-like penumbra surrounding the subject. I set up a test with my assistant as a stand-in for the designer and we marveled at the result.

But I suffer from lighting ADD; once I hit on a new technique or solution, I get bored with it and need to move on to the next one. Consequently, I've only re-used the ring light sporadically, when it seemed appropriate. This, however, was one instance when it worked like a charm, lending Burton's portrait the unsettling feeling found in his films.

I asked Burton to draw a picture on the white backdrop that he could inhabit; this was his response.

14

LIAM NEESON

Liam Neeson showed up grumpy. Not altogether un-friendly, just grumpy, like he wasn't feeling very well. He seemed less than thrilled at the prospect of having his picture taken. Cajoling and friendly banter weren't working their magic, so speed seemed like the best ap-proach. Fortunately I had rented a "daylight studio" for the shoot, a white envelope flooded with natural light from a full glass ceiling, that would allow me to work quickly with a minimum of supplementary lighting.

Having finished a cover image of our hero in loos-ened black tie nursing a whiskey, it was now time to shoot something for the inside of the magazine to ac-company the profile. These images are my favorites, as there's much more creative leeway. By contrast, the covers are generally fairly close up and simple, to al-low for the logo and headlines, or "slugs." Robert Priest, the gifted art director of *GQ*, always granted me a free hand in my work for the magazine. There was no par-ticular agenda for these inside images, except that they should be stylish, the subject should look good, and the photograph would hopefully provide some insight into person depicted. I was usually allowed to work in black and white for these images, which opened a world of expressive possibilities.

What is so appealing about black and white? Well, first of all, it's unshackled from color, unfettered by the burden of wrangling the randomness of color as it ex-ists in the world. By its very nature, black and white abstracts the image from reality and forces us to engage with it anew. Even the phrase "documentary black and white" is a bit of an oxymoron, because a black-and-white image is anything but an accurate record, being one enormous step removed from reality. But this frees up the photographer to see the world and re-create it in a fresh way, shifting the image from "how it *looked*" to "how it *felt*." Depending on the photographer's in-tent, the black-and-white image can be symbolic or specific, a subtle statement or a sledgehammer. It can't help but be a more subjective, more right-brained communication.

As an example, this image doesn't have a *reason* to exist. It's not his house. Nor is it the set of a movie he's working on. He has no reason to be sitting on a rooftop in pricey duds amid a collection of detritus, smoking a cigarette. I hastily assembled the pile of ob-jects and arranged them in a graphically ordered way, and then quickly sat my cranky subject down. I slowly fiddled with the big camera while he got a little bored, a little preoccupied. The rusty textures, dagger-like scraps, dark tones, and turning wheel seemed to echo his brooding state of mind. I'm certain my wheels were turning, as well, as I unconsciously searched for ways to

find visual equivalents to what I was experiencing and seeing. This is when my unconscious, benevolent auto-pilot kicks in; I begin making decisions I'm not entirely aware of, and a picture suddenly begins to take shape before my eyes.

THOUGHTS ON TECHNIQUE

Some black-and-white pictures are all about tonality, about describing the shapes and textures within the photograph as eloquently as possible using the range of grays that comprise the image. The complex tonality of this one gives the eye a lot to sink its teeth into, satisfying as a Chunky chocolate bar. On a sunny day, the contrast between Neeson's pale Irish skin and the tar-paper wall would be too great and the wall would sink into solid black. But there are no harsh shadows here; the soft, overcast sky bathes all the forms and shapes in a gently revealing light, allowing the closely related medium and charcoal grays to play off one another. Also working in our favor is the size of the large 11x14-inch negative, because of its ability to faithfully separate subtleties that a smaller negative would sacrifice for size and run together.

The microcontrasts within any image that determine such tonal relationships are controlled in large part by the way the negative is developed. Some methods suppress those contrasts, while others reveal them. Certain developers hold more detail in the shadow areas and highlights. Others offer greater acutance, or sharpness, as their strength, often at the cost of increased,

peppery grain. Still others minimize the grain, offering a "creamier," smoother look to the image.

Because this negative is so large that no further enlargement is necessary, graininess was not a consideration. So I used a special two-bath developer (Kodak D-23) to bring out the subtlest nuances of tone. The exposed negative was first immersed in a developing solution that acted fairly quickly to bring out highlight structure. The development was then arrested with water, and the second developing solution was introduced. This one worked more slowly, building up detail and tone in the darker areas of the image. How long the negative is allowed to remain in each of these solutions determines the balance of contrasts in the finished negative.

I generally aim for a negative that yields the most tonal information in all areas of the image, from the darkest to the lightest, because it allows me the greatest freedom to interpret the image in the final print. I can print it with more contrast to obtain a gutsier, bolder iteration, or I can print it with less contrast for a quieter, subtler feeling. Because this negative offered complete tonality, either version was possible, while a negative with tonal deficits dramatically narrows the options available in the printing stage of the process, often forcing the image down a very specific and sometimes undesirable road in order to yield even a marginally satisfactory print. So this juicy negative allowed me to play in the darkroom rather than engage in damage-control drudgery. I was able to explore to my heart's content and discover the most evocative and satisfying expression of the image.

What do you do with a grumpy subject? Take him to the corner bar and relax him with a scotch and a cigarette.

ORLANDO DIAZ-AZCUY

What if a piano had 500 keys (and you had incredibly long arms)? Imagine that the lowest and highest notes were exactly the same but that there were 498 keys between them. This instrument would have the same range but so many more in-betweens. Now look at this picture. The ends of its range are still the same; pure black is still black, and pure white is still white. But it doesn't just have white; it has a whole palette of whites. Sparkly whites, creamy whites, smooth whites, linen whites, cotton whites, silk whites, white-hair whites, almost whites, and very, very whites. It's one of those things that, on occasion, photography does extremely well and that is especially satisfying to see. It makes me glad I have eyeballs.

This image was made just after I had finished shooting a relatively straightforward commercial advertising assignment in a rented studio in Greenwich Village. I was so taken with interior designer Orlando Diaz-Azcuy's impeccably assembled attire, its carefully coordinated textures and barely discernible hues, that I felt compelled to record them as faithfully as I could. Flattered, he was happy to linger for a few more minutes while I whipped out my big pride and joy, my handmade 11x14-inch camera. It's a camera that takes just one sheet of film that's 11x14 inches, more than a

hundred times the surface area of a 35mm frame. (I can't even guess how many megapixels that would equal.) Because the negative it produces is so big, it is comprised of that many more itty-bitty parts to accurately record the tiniest details and subtlest tonal differences. Not only that, but it looks like a camera is supposed to look. It's wooden. Big black bellows. Long shutter release cable. It sits on a large, heavy tripod and cuts a pleasingly anachronistic silhouette.

It can be slow to use, and I'm positively miserly with the film because I only have ten sheets of it at a time—ten exposures, ten clicks' worth. It's not like a 35mm camera with thirty-six shots to a roll or a digital camera that can continuously shoot hundreds of pictures to a single memory card. So I'm deliberate and painstaking. It can be a slow process for my subjects. But that can be good, because they tend to relax a bit as they watch me fumble with my cumbersome camera. In this case, I was making a portrait of Diaz-Azcuy's clothing anyway, more than his face. I generally tend to really focus in on the eyes, but this picture's not about expressive eyes, and here they are obscured by his characteristic glasses and the turn of his head. We don't linger on his face; the eyeglasses say enough. Instead, we move down to the luscious linen and silk and

Is he in the sunlight? I'd like him to be. But it was cold outside. And raining. It was late November in New York City.

enjoy the way the light falls on the close-toned fabrics, rendered in exquisite detail by my slow, cumbersome, anachronistic, 500-key camera.

THOUGHTS ON TECHNIQUE

Interior designer Diaz-Azcuy looks refined and splendid. Every perfect thread of his beautiful linen suit is lovingly rendered as he sits in the crisp, white, tropical sunlight.

Or is he in the sunlight? I'd like him to be. But it was cold outside. And raining. It was late November in New York City.

So how does one replicate high noon sunlight in the tropics? It's a surprisingly easy task. No diffusers, umbrellas, softboxes, or reflectors need apply. All that's required is just a simple naked light, as high and far away as possible. Even better, if it's bouncing off the white walls and floor in a typical photographer's studio, then it looks like sunlight on a beach, bouncing off the bright sand.

This simplest, most eloquent light has many advantages. It looks completely natural, not like some photog-

rapher set up his fancy lights to make a picture. Its crisp brightness and sharp shadows can reveal texture beautifully. It's nice for bespectacled subjects, since there's only one tiny reflection, which looks legit and can be easily avoided or remedied. And it covers a large area with perfectly even illumination, which can be useful for large groups or moving subjects. I've shot NBA stars in this light, and it looks just like they've been caught outdoors playing a game of street ball.

In this case, though, I'm just using it to lovingly, faithfully record every subtle variation of white in my subject's clothing. But my large-format camera needs a great deal of light to do its job, so a regular lightbulb won't be bright enough unless I use a very long exposure, which I am loath to do. Diaz-Azcuy might move and blur the picture, which would defeat the purpose of using the big camera in the first place. So I substitute a powerful electronic flash for the lightbulb in the sky, but it's still unadorned, just hanging up near the ceiling—high noon on a tropical beach indoors on a rainy November day in New York City.

Man contemplates Big Boy. I made the white-on-white personal portrait (page 72) while shooting this advertising campaign.

16

BILL BLASS

He showed up at our rented studio affable and camera-ready; he had the easy confidence of a man who always leaves his home knowing that he looks good. He was a big guy who wore his age well, was comfortable in his own skin, and had a clear sense of his own style. He made sure to show just enough shirt so that we'd notice he had eschewed the cuff links as well as see his rare antique watch. It's all in the details. I hoped to make a simple image that would showcase his relaxed elegance.

But first I had to make a cover portrait with a "concept" for my editorial client. It involved having a "muse" in the background, a model as mannequin. It was a perfectly fine picture, but it was an illustration of an idea more than a portrait of a person. It was a time-consuming image to create that involved some tricky lighting and finicky posing. Unfortunately, in pictures like this my attention is largely diverted from my primary subject, because I'm forced to juggle important background elements like models or other talent who require constant attention and feedback. Luckily, Bill Blass gamely gave the camera his best while I wrestled with the background.

Many long minutes later, we barely had time for a second picture (of which I only made six exposures), certainly not enough to set up any intricate lighting. We placed a chair near a large window. He seated himself

perfectly, leaned back comfortably, brought his hand to his chin just so, and all I had to do was push the button.

No wonder it was so easy; it was a photograph I'd seen before, sort of: a classic midcentury image of George Bernard Shaw. It just didn't occur to me for several months, long after I'd developed and printed the image and spent many hours staring at it in my darkroom. We photographers frequently shoot to templates and don't realize it; it's almost impossible *not* to. If it occurs to me while I'm about to make the picture, I run screaming in the other direction. It's neither appropriation nor plagiarism; it's unconscious and inevitable. Sometimes the template is someone else's picture; often, ironically, it's one of our own.

Many years earlier, I was part of a team of international photojournalists documenting the rapidly disappearing character of old Singapore for a book project. At the end of each day, we'd eagerly gather to compare notes; each day was full of little discoveries. One evening I walked in to find another of the photographers sitting dejectedly with his head in his hands. He was an Englishman who'd had a long career of brilliant essays. Yet he was clearly, deeply chagrined. Unbidden, he recounted his day, culminating with what sounded like an absolutely beautiful, spiritual, moving portrait of a monk in his temple. He paused for a long moment,

It's depressing to realize you've taken a picture that has been made before; it's even more depressing when you realize you're the one who made it.

shaking his head. "I took the very same picture of the very same monk in the very same temple *thirty years* ago!"

The fact is that we're all swimming in an ocean of images in a constant image monsoon. As photographers we can't help but be more sensitive to them and affected by them. They all make impressions that show up in our work. Let me tell you, it's depressing to realize you've taken a picture that has been made before; it's even more depressing when you realize you're the one who made it. It's one of the things that can be most difficult when working commercially as a photographer. Clients generally hire you because they've seen a photograph of yours that they really liked. And what do they want? They want you to shoot another one *just like it*. The challenge, of course, is to bring a fresh eye to the process so that you can create something new each time.

THOUGHTS ON TECHNIQUE

Work quickly to save your subject. Here is fashion designer Bill Blass. He's sitting by a large window, illuminated by beautiful window light, which falls on the wall behind him as well. It's a simple, lovely picture, and I could leave well enough alone. But it *could* be a little better. The picture is too gray. It needs contrast. I want him to separate tonally from the background, and the light on his face to be just a little stronger. The light could be tweaked the tiniest bit, and it would make all the difference (to me). But if I spend too much time on it, I'll lose him. I've done it countless times before— paid too much attention to the light or the camera and not my subject. The result: the operation was a success but the patient died.

The key is to move quickly and do a lot with a

little. I left the middle tones, the grays, alone but added blacker blacks and whiter whites for a gutsier interpretation. A 4x8-foot sheet of black foam core set next to the window cast a shadow on the wall, creating a gradation from light to dark. A small tungsten light, known as an "inky-dinky" (or "inky" for short), placed by the window like an errant ray of sun, added a brighter, crisper edge to my subject. It's a continuous light source, like a lamp rather than a flash, so you can see it with your eyes and tweak it to taste. What I *didn't* do is destroy the low-key feeling of the picture by adding a fill light to brighten the shadows, opting to preserve the velvety blacks instead. Sometimes it's better to show less to say more.

This cover portrait of Bill Blass and his "muse" (a live, if not lively, model) took forever to capture, while the first portrait (page 76) was done in minutes.

LEE IACOCCA

You rarely see a picture of an executive smoking anymore. They do, though. Cigarettes, cigars (especially cigars). But not in pictures, and rarely for magazines, let alone magazine covers.

Facilitating a subject's characteristic, telling gesture is, however, one of the most important challenges faced by the portraitist. And habitual smokers tend to have wonderfully characteristic gestures. Often it can be difficult for smokers to find a comfortable, natural pose once they've been stripped of their prop. Their hands are suddenly purposeless—floppy appendages that have to go *somewhere* and find *something* to do. Often, they'll return to familiar perches: the smoking hand behind the back or resting on the hip. There is a lovely watercolor portrait of my father-in-law in just such a characteristic pose; though no cigarette is visible, you just *knew* he'd been smoking when it was painted. Smokers, naturally, tend to be most comfortable with their hand to their face, even sans cigarette, fingers lightly touching their forehead, chin planted on the heel of the hand. But it always looks like something's missing.

Such was the conundrum when I photographed Lee Iacocca. I had already shot several rolls of him seated in a boardroom chair in the hallway of his corporate offices. (I like having a feeling of depth in the image, even though it wasn't, strictly speaking, a place where you'd find him sitting. This usually takes a bit of explaining.) He was cooperative but uncomfortable, and I wanted a sense of his toughness to come through, though I didn't want him mugging for the camera. What was missing was the trademark cigar. It would, I felt sure, relax him and elicit the attitude that had been absent.

I find that, unconsciously, I'm often shooting pictures of pictures. I have so many images floating around in my head all the time that I simply can't escape. Photographs I've seen, photographs I've made. Paintings, posters, movies, and magazines. Imagined scenes from books I've read. Frozen vignettes from my own life. Dreams. This one is inspired by two in particular, made within a year of each other by masters of the photographic portrait: the classic image of Winston Churchill by Yousuf Karsh (this is its opposite) and Arnold Newman's photo of Max Ernst smoking a cigarette. In Newman's portrait, the smoke itself is very much a subject as it forms a solid shape he referred to as "the chicken." (As his assistant, I'd made an edition of the Ernst portrait for him and ruined many prints as I furiously "ferrocyanided," selectively bleaching its pale tones to bring out the elusive smoky silhouette.) Its

Facilitating a subject's characteristic, telling gesture is one of the most important challenges faced by the portraitist.

swirls echo the shapes of the absurdly oversized chair in which his subject is seated. The smoke also adds an air of mystery to the photograph, somewhat obscuring the sitter's face. In the Karsh portrait, he famously evoked the prime minister's personality by plucking *away* his cigar instead, eliciting the trademark scowl.

In my portrait, though, the cigar just lends a hard-boiled noirish touch. It brings a bit of movement to a static image. Most important, though, the cigar allows Iacocca's uncanny confidence to come through as he confronts the camera. It lets him relax into a gesture that's uniquely *his*.

THOUGHTS ON TECHNIQUE

Thankfully, all faces are not created equal. It's part of what makes us unique. It's also why there are no real "recipes" for portrait lighting. You have to be sensitive to the human in front of your camera. And you have to know what it is that you want to express in the portrait. In this light, it is surprising that many photographers tend to use lighting formulas that are fairly locked-in. This is distressing, because it fairly disregards the subject.

This picture strays from the formula. The broad side of Iacocca's face is illuminated like a gibbous moon, a definite no-no. (This is as compared with illuminating the narrower plane of the face like a crescent moon.) Worse yet, the front of his face has no fill light, so it's quite dark. And worst of all, he has no catchlights in his eyes to give them sparkle. This leaves him with a slightly mysterious, ominous countenance, which I quite like. You can see just enough of his eyes to discern their wariness as they regard the camera (and size up the photographer). The translucent smoke, on the other hand, likes to be backlit for greatest visibility and definition. (When illuminated from the front, it just turns dull gray or disappears altogether.) His hand, holding

the trademark cigar, is the brightest thing in the picture, and appropriately so.

But these are the finer points of studio portrait lighting—and if you crop this picture to a tight head-and-shoulders format, you get a strong studio portrait. What really makes this picture work, though, is that it's *not* a studio portrait. The lighting control of the studio has been transplanted into the outside world. He's someplace real, and his environment tells us so much more. Now he's not just a wary guy but a powerful guy (and, likely, a very rich guy). His polished surroundings imply power and wealth, and he has plenty of both. It's a picture within a picture, a studio portrait embedded in a location portrait, a story within a context.

The Perfectly Nice (stiff) Portrait: what you get without some smoke and a good cigar.

18

LESTER BROWN

Sometimes it's enough just to let the camera perfectly describe someone. The broad strokes: What they look like. How they stand. And then, something a photograph can do extremely well: give us the telling details in all their myriad combinations. The dapper bow tie on a shirt that looks like it has been slept in. The rumpled suit with missing-belt trousers. The shirt-pocketed pen peeking out. The tousled hair and bushy eyebrows framing a distractedly preoccupied face lost in thought, utterly unself-conscious. He's just let out a breath, and his shoulders slump. This is a man who probably cared about how he looked first thing in the morning, until the rest of his brain kicked in and his outside got hijacked by his inside.

This portrait of pioneering environmentalist Lester Brown, considered by many to be one of our most influential thinkers, belongs to a series of photographs I made at a symposium addressing global issues that was attended by world leaders in many disciplines. About half the portraits were close-up, shallow-focus images that riveted one's attention to the eyes and facial features of the various subjects. The rest were pictures like this one: full-length pictures against a black background that simply *described* their subject as faithfully as possible from an objective distance, drinking in every detail while isolating the whole.

There is a great tradition in portrait photography in which the figure is portrayed against a neutral backdrop, plucked out of its normal context so that it can be appreciated afresh, perhaps best exemplified by the work of legendary portraitists Richard Avedon and Irving Penn. Avedon essentially *owned* the clinical white background for his subjects, to which they were pinned for inspection like bugs. There is the widely accepted sense that the white background is *empty*, somehow devoid of visual weight in the picture; however, it has always seemed quite the opposite to me, as if the pictures were stuffed *full* of all that overwhelming white brightness, pressing in on the subject from all sides. I can't help but see all that white. Penn, on the other hand, made the best use of the neutral gray backdrop for his spare, elegant portraits, its texture and tone becoming, in a way, as important as the subjects themselves, combining with them to create a richly rendered whole.

While I've always appreciated the notion of presenting people in as neutral a context as possible in order to *see* them as clearly as possible, I've struggled to define that context for myself. I confess to having shot my fair share of portraits on white or mottled gray backgrounds in the process, and I've never been satisfied with the result; a feeling complicated by the sense that

I'm ultimately shooting a picture that was already shot (and originated) by someone else.

The black background, on the other hand, has always seemed *truly* empty to me, a void. Black is blank. It feels drained, dead neutral. It *is* nothing, literally. I see nothing but my subjects, presented for the camera as simply and directly as possible. I don't see them in relation to a backdrop or anything else. All that's left to look at is the subject. So we pay more acute attention to details: a tip of the head, clasped hands, an intense expression. While grays can be like a symphony and white always seems so *loud*, black is silent. It lets the subject speak.

THOUGHTS ON TECHNIQUE

I'm always searching for the perfect light. It's the primary tool photographers possess to portray our subjects; it's the only thing the camera is going to see. But what is the perfect light? Is there even such a thing?

Usually I'm using light *for* something. To make a point. To highlight something. To direct the eye of the viewer. Often I'm looking for *beautiful* light. To flatter a subject. To bring a landscape to life. I strive to find the right light for the subject, and it varies with the situation. In most cases, the light is something I really want you to see.

But to me, the *perfect* light would be light you wouldn't see. You wouldn't notice it, recognize it as anything special, or perceive it as inherently beautiful. It wouldn't draw attention to itself.

In a portrait, the perfect light would gently, quietly allow you to truly *appreciate* the subject. This version is probably the closest I've come. It's a simple picture. Brown looks luminous. Yet the light isn't fancy. It re-

veals every detail, yet it isn't cold or clinical. It has definite direction, but it's not shadowy. There is a strong sense of three-dimensionality. You see the flesh of his face looking like face flesh, soft and delicately modeled. You see the sheen of his silk bow tie and the tiny glint off the silver clip of his pen, the highlights in his hair and heavy eyebrows. But you probably don't particularly notice where the light is coming from; it's just sort of *there*.

Of course, it's just a *key* and a *fill*, the most basic lighting setup in any studio. It's all in the tweaks, the subtleties. It's the *kind* of key and the *kind* of fill, and the *relationship* between the two, that make all the difference. Nothing new has been invented here; the soup has merely been seasoned a bit differently.

The key or main light is a softlight, a fiberglass "beauty dish" about 30 inches in diameter. It is positioned in front of my subject and just above his head, barely out of the frame. It incorporates a small opaque disk that prevents any harsh, direct light from reaching the subject, bouncing it around inside the dish so that only soft, indirect light emerges. A silky cloth diffuser that looks like an oversized shower cap covering the front of the dish further softens the light. The important point is that this dish is *feathered* almost entirely off the subject, so much so that it is essentially aiming directly at the floor. He catches just the subtle, softer edge of the light rather than the full intensity of its beam.

The fill light, on the other hand, is neither soft nor feathered. It's bull's-eye dead-on direct: hard, undiffused light shooting straight at the subject. It's a *ring light*, a contraption that wraps right around the lens so that it casts shadowless illumination onto the subject. On its own as a main light, it would be bold yet unusual, a look that has been used to great effect by many

Another example of my "perfect light," here lovingly illuminating every fold in the robes of Samdech Preah Maha Ghosananda, the Supreme Patriarch of Cambodian Buddhism.

photographers, particularly in the fields of fashion and beauty. As a fill light, toned down and serving a secondary role, its properties lend it an unmatchable quality. Shadows no longer go black; there's a little illumination *everywhere*. But it doesn't read as a second light source. It's like a magical fill. This is the kind of stuff I spend countless hours testing and refining, the stuff I kill myself over. It makes all the difference to me.

ARNOLD NEWMAN

Photographers are always the worst subjects. We *hate* having our pictures taken. (Actually, maybe comedians are worse.) That's one reason why we're always on the *other* side of the lens. It's safe there. We're hidden.

So how do you photograph your grumpy, impatient photographic mentor? You get him focused on the lens. And take the picture. Fast. As one of the masters of the medium, Arnold Newman had been photographed plenty, by some of photography's foremost practitioners. He was a savvy subject.

All I wanted was a simple portrait to anchor a large, Mondrianesque photo-composite of Newman that I had in my head, an homage commemorating the beginning of my New York life in his studio a decade earlier. The piece had rhythmic elements and a graphically strong portrait of him shot from above in his studio, but it still needed something that would transcend the formal composition: an emotional core.

I had photographed Newman previously for an article in a photo magazine, but I had made the mistake of trying to make an Arnold Newman portrait of Arnold Newman. As he would say, it wasn't bad, but it wasn't good. I had chosen his residence as the location, a spectacular duplex apartment in one of the classic prewar artist studio buildings on West 67th Street in New York City. He was fond of saying, "Photography's 1 percent

inspiration and 99 percent moving furniture." And in true Newman fashion, I had moved a bit of furniture and rearranged some of the art. A large, thoroughly incongruous stoplight played an important compositional role, as did the centerpiece of the living room, a magnificent double-story, dusk-lit, north-light window. But it wasn't *my* picture; it was me trying to be clever, trying to be him. It didn't work.

This time, I wanted, somehow, to make a simple portrait of him that gave a window into the little piece of his personality that I had experienced. It probably wasn't what his grandchildren saw, nor his illustrious subjects. But it was my authentic experience. And not surprisingly, it was captured on the very first frame.

It happens a lot. The first frame is the winner. Everyone's fresh. Contrary to popular belief, defenses are down because real pictures haven't yet been taken. Or sometimes the guard is up, but that can be the good picture, too. In this case, I was getting *the look*. I was probably fumbling with the camera. Saying something stupid. Clever repartee's just not happening; it's like rubbing your stomach and patting your head. Half your brain is thinking "F/8 and 1/30 of a second," the other half is thinking "Move the light to the right," and the third half *should* be engaging the subject—but of course, *there is no third half.*

So you learn the hard way: *never* discard the first frame. You're often too preoccupied to notice that something unpredictable, something *unrepeatable*, has just been captured without your conscious participation. It's the autopilot, that instinctive little photographer inside, who pressed the button.

THOUGHTS ON TECHNIQUE

This was frame number one, the very first exposure. And I'd thrown it in the trash. It was a Polaroid, a test picture, taken to check the light and the focus. The actual shoot was about to begin. The good pictures were yet to be made.

Newman was impatient in the best of circumstances, and being a photographer's model only made things worse. He glowered at the camera. I was terribly nervous, thoroughly rattled by the presence of my old boss. So I rushed, hastily making a dozen or more identical exposures right in a row. I knew I couldn't keep shooting. I was done. He was more done.

I had the sinking feeling that I hadn't gotten the picture. I shot too fast, didn't take my time. I had been worried that he'd actually get up and *leave* while I was photographing him (which, of course, he didn't). I reviewed the sequence of images in my head. They didn't get any better. I just hadn't connected with him. I was too preoccupied and had forgotten about the human being sitting before my lens.

Then I remembered. The Polaroid material I had used for the test shots was Type 55, which yielded a usable negative along with the positive print. Many photographers have worked with Type 55 specifically because of the lovely qualities of its negative. I was only using it as a proofing tool that day, so upon seeing the print, I had just chucked the negative into a nearby

trash can and promptly forgotten about it. But now I distinctly recalled how cranky he looked in that first Polaroid, the very first exposure I had made. It was what had initially sent me into the tailspin. The look was one I had often seen during my tenure as his assistant, when I felt like I couldn't do anything right. I went back to confirm the image, the Polaroid print of which was sitting in the case containing the exposed 4x5 film holders. Indeed, there was *the look*, looking right back at me.

Polaroid Type 55 negatives were very fragile objects when freshly separated from their respective positive prints, still covered in the sticky developing and fixing substance that Polaroid officially referred to as "goo." In order to be preserved for later use, these negatives had to be promptly immersed in a clearing bath to remove the goo and harden the surface of the negative.

As soon as Newman left the room, I rushed to the trash can and rummaged through it. There were several Polaroids in there and several negatives, all irretrievably stuck to their paper envelopes. At the very bottom was one last negative, the *first* negative, lying facedown. I gingerly plucked it loose. It had, by that time, been resting in the trash unfixed, uncleared, and unwashed for half an hour or so, and its goo was no longer gooey, having begun to harden. There were some bits of trash can debris stuck to its face, but mercifully, it had not completely adhered itself to anything else. The emulsion appeared to be intact.

Back at the studio, we subsequently developed the sequence of images I had shot that day, but as I had suspected, not one frame conveyed a sense of the man I had known. Only one negative, resurrected from the trash bin, accomplished that feat. And pinned to the wall of my darkroom for many years was its positive Polaroid twin, glowering at me reproachfully as I'd work through the night.

The finished collage for which I had made the portrait (page 88), created pre-Photoshop on a Kodak computer that produced an 8x10-inch black-and-white negative.

20

DANIEL BOULUD

Fulfill the assignment first. I aim to please, probably to a fault. This is not a strategy I'd recommend to the next photographer, because it can curtail one's own creative impulses. As a solution, photographers sometimes shoot two variations of a picture: one for the client that addresses the assignment and one for themselves that floats their boat. It is riskier, but I prefer to put all of my eggs in one basket, so the same image satisfies the client *and* me, gets used, is published, and sees the light of day in front of the greatest possible audience. It's like the ultimate gallery show.

But sometimes the client presents a concept that's just awful, an idea that's trite, hackneyed, inappropriate, poorly thought-out, unoriginal, or altogether stolen. Unfortunately, it's ingrained in the language, the creative-speak endemic to the field. People often say they're "looking" for an idea. That's stealing. Because what they're looking *at* are other people's ideas. "Thinking" of an idea or "working" on an idea, now that's a different matter altogether. Or even seeing something as a jumping-off point, that's okay, too, because I can work them around to something fresh. But sometimes they're just stuck on a bad, unoriginal visual. It's frustrating, because they don't know how good it *could* be. While they may be good visual thinkers, they're not *photographic* thinkers; they can only envision a pho-

tographic solution in terms of an image they've already seen. That's where I draw the line.

This portrait of chef Daniel Boulud was made in response to an editorial assignment to photograph several top New York celebrity chefs. The magazine's photo editor had an "idea." She wanted animated, colorful chefs shot full-length on a bright white background. She wanted them smiling. She wanted them *juggling* food. I had already seen such pictures, and I didn't like them the first time.

I asked if we could try another approach. It seemed to me that what these gents do is very serious business indeed. It seemed they shared a deep respect, a reverence, and a visceral passion for food that far transcended what most people experienced. I wanted to somehow get that across—their relationship to the *stuff* of food. Not the finished dishes, the elaborate creations, but the raw, fresh ingredients that inspire them and turn them on in the first place. I suggested we ask them each to bring a carefully chosen example, along with a favored utensil they work with on a daily basis. I offered that black-and-white might be the way to go, as it would remove the color cues from the "still life" component of the portrait. I described the image as more of a dual portrait, as much a portrait of the raw item as of the person. The light would be directional and dramatic,

emphasizing form and shadow. The focus would be extremely shallow, highlighting the surface texture. The phone was quiet. She was thinking. "Do you have an example you've already shot that you can show me?"

The problem is that if I've *already* shot it, the last thing I want to do is shoot it *again*. I didn't have anything to show her, and I didn't want to commit to a test shoot because I didn't want to lock in the look. I wanted to improvise. After all, this was editorial work. Creative freedom was the partial trade-off for low pay. It was supposed to be *fun*.

She warily agreed to my plan, even though she hadn't altogether signed on to the concept. The chefs showed up with their goodies, game for the occasion. They appreciated the idea and had given great thought to their choices. They were quite taken by their portraits; even I was surprised by the images. Apparently so was the editor. The pictures ran, but the magazine never called me again.

THOUGHTS ON TECHNIQUE

This is a portrait of a tomato. With a guy. It's a dual portrait. You notice the guy first (we're programmed to see faces), but it's the tomato you lock on to because of its razor-sharp focus. Even the knife goes a bit soft, though it's resolved enough to reveal the juice running down its serrated edge. The tomato's the star, though. It rewards the eye with its bulbous silhouette, the sheen of its skin, its imperfect beauty. It lifts off the picture plane because of its sharpness, while Boulud takes on a supporting role, receding into second-place softness. He's heavily shadowed and "unsharp," yet we see enough to discern his slight wry smile. And we feel his firm grip, his thumb pressing hard against the blade of the knife as it impales the tomato. We know who's boss.

It's focus that tells the story here. It sets up a hierarchy of things to look at, a sequence: tomato, face, blade, hand (then back to the tomato again in a triangular tour around the picture). This photograph would suffer greatly if everything were in focus; it'd just be a nice picture of a guy holding a knife with a tomato on it. Focus and depth make all the difference. The tomato is closer to the camera than he is; that depth makes it look half as big as his head. That's one big tomato. Held in the same plane as his face, it would've seemed much smaller. And the fact that the tomato is closer allows it to float in front of his shoulder.

Heightening this effect is the "swing" of the lens, angling the plane of focus toward the tomato and away from Boulud's shoulder. To achieve this, the lens is angled from its characteristic parallel position in front of the film or sensor and "swung" like a door by turning a knob that alters its attitude. The plane of focus runs on an angle from the tomato in the foreground back toward his face and beyond. This skewing of focus makes his face a bit sharper, while keeping his shoulders soft. It's an incredibly expressive and useful technique that acts like a tour guide, telling your eye exactly where to look.

In another image from the essay, chef Jean-Georges Vongerichten balances a durian fruit on the edge of his favorite cleaver.

BILLY GRAHAM

This picture was an afterthought, hastily made in minutes. The real shoot of the Reverend Billy Graham was over; we had packed up our gear and were headed out the door of his lovely home in Montreat, North Carolina. I had already made the image I had come for: a strong cover portrait for *Time* of the evangelist on his seventy-fifth birthday. Though I felt good about it, I was still unsatisfied. Meeting him in person allowed me to see a much quieter, gentler side than I had been exposed to over the years through his many appearances on television.

He had appeared in a dark suit and tie for his portrait, which I made in a makeshift studio in a large room of his house. When I went to thank him and wish him well on my way out, he was wearing an old pilled sweater and casual trousers, looking especially comfortable and relaxed. I was struck again by his genuine warmth and humanity, which I began to feel my portrait might not have fully conveyed.

I had one last chance, but it would have to be quick. Our lights had all been taken down and were packed away. The late-afternoon sun filtered through the trees, bathing his veranda in lovely soft light. I asked if I could make one last quick portrait there before I left. He graciously agreed, seated himself in an old chair,

and watched as I hastily set up my big wooden camera, the one I brought for just such an opportunity. I had enough film for ten exposures.

I shifted his chair to use the log wall as a background (including an old wooden ladle dangling inexplicably from a rusty nail—I just liked its form) and reseated him in the light. He looked benevolent and peaceful. The second frame, with its soulful sweetness, was the one.

But it was unshowy and black and white, just an image I made for myself. At the time, the magazine rarely ran black-and-white pictures on its cover anyway; even when it did, the photographs were usually documentary photojournalism, not portraiture. The color portraits from the shoot, one of which had already been placed into the cover layout, were well received. But I was excited about the handful of oversized black-and-white platinum prints I had just processed from the sitting and wanted to show them off to the design director, Arthur Hochstein. I was surprised when he asked if I could copy one of them onto film so that it could be used in the story, and he made my year when he actually ran it as the November 15, 1993, cover of *Time* magazine.

I was struck again by his genuine warmth and humanity, which I began to feel my portrait might not have fully conveyed.

THOUGHTS ON TECHNIQUE

I don't believe I could have made this portrait with a digital camera or, for that matter, any small- or medium-format camera. First, there's the matter of focus, and the *way* things go out of focus. The Japanese term *bokeh* refers to the character or quality of the defocused areas of a picture. It's often used to describe the effect of lenses when they're used wide open or nearly wide open when the out-of-focus effects are strongest and most visible. I don't think that particularly applies here, because I wasn't going for supershallow depth-of-field effects, just a nice, natural *transition* of focus, so I wasn't shooting wide open. In fact, the lens was fairly stopped down (f/16), necessitating quite a slow shutter speed for a portrait (¼ sec.). The focus just falls off in a gentle, organic way that doesn't draw attention to itself. The focus is somewhat shallow, yet the pilling of his old sweater is still apparent, as is the fact that he's sitting in front of a log cabin. It's just enough information, but not so much that you get distracted with the details. Made with a "normal" lens for a natural perspective, its look could have been achieved only with a large-format camera.

Then there's the tonality. It, too, is all about *transitions*. The Achilles' heel of digital photography is its handling of tonal transitions, because it's a medium of absolutes, not in-betweens. It assigns whole numbers to tones without any fractional increments. Digital tones don't sli-i-i-ide into one another, they jump. Gray doesn't slide down a smooth ramp into black, it hops down the stairs, one discrete step at a time. Even if they're teeny-tiny steps, they're still steps. In this image, the pale grays of his hair slide into the soft whites; the deep grays of his sweater blend smoothly into black. This organic tonality gives the picture a gentle quality that evokes a sense of the subject's soul.

And finally, there's the ineffable quality of the camera itself. On one side of the lens, there's the photographer looking at his ground glass, seeing the image in two dimensions just as it will appear in the final print.

Looking at a computer screen is also seeing the image in two dimensions, to be sure, but it lacks the quality of looking at *life*, at a dynamic, living, breathing camera obscura image. There is a *connection* with the subject that is like no other, in which you're not just watching; you're truly *seeing* your subject. On the other side of the lens, particularly at close range, subjects are confronted with this *thing*, this large Cyclops eye staring at them, and they tend to stare right back. It can fill their field of view, so there's really nowhere else to look. Some look at the lens, perhaps seeing their own reflection, but a few, like Billy Graham with his piercing yet compassionate gaze, look right *through* the lens to something deeper, connecting with the viewer in an uncanny way.

The more predictable result was obtained when I didn't use my magical 11x14 camera.

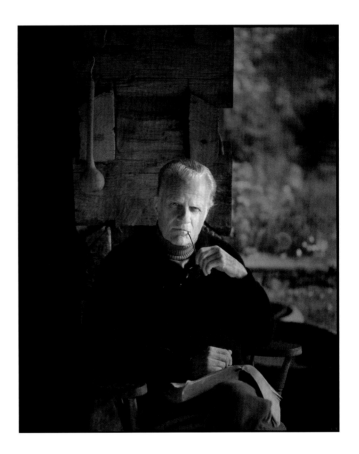

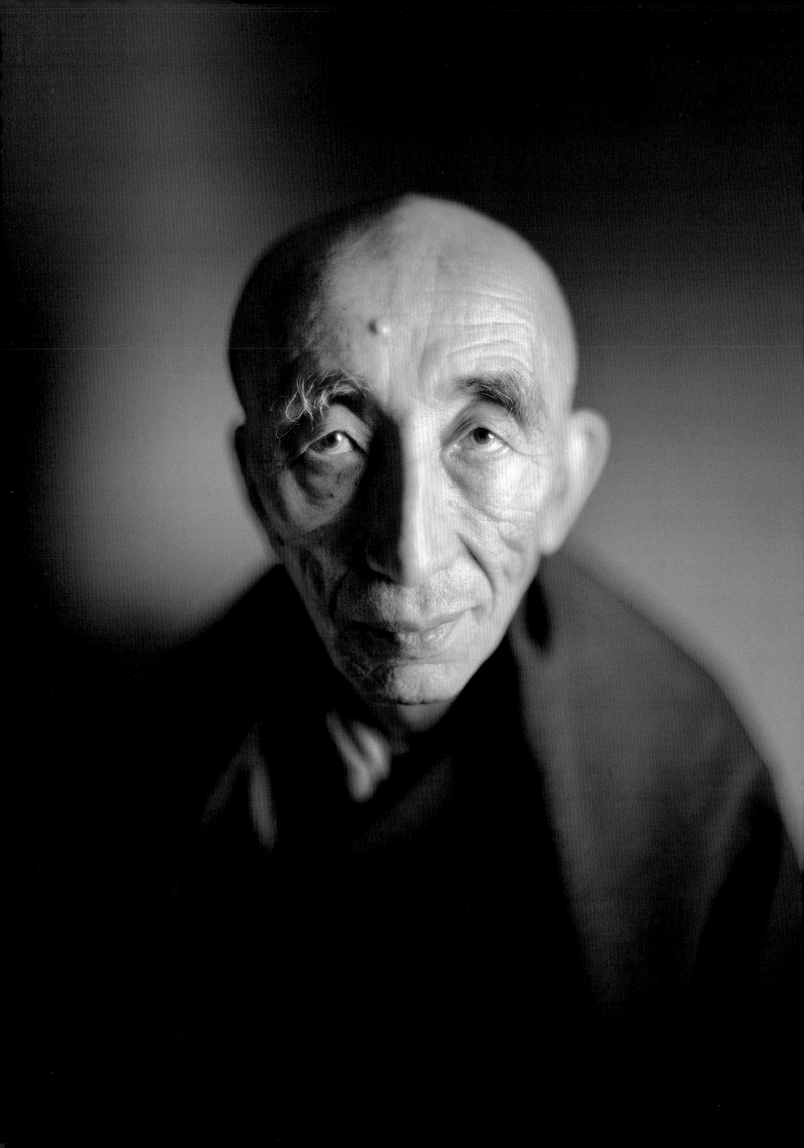

22
KUSHOK BAKULA RINPOCHE

"You want to do *what?*" The concierge was more puzzled than incredulous.

"I need to remove the bed from the bedroom," I replied, "and then the sofa and all the other furniture from the living room. They're going to be little photo studios."

The first State of the World Forum was under way in 1995 at San Francisco's Fairmont Hotel (where the United Nations Charter was drafted half a century earlier). Mikhail Gorbachev and Ted Turner, among others, had convened more than five hundred international leaders in government, religion, science, business, and the arts to address pressing global issues in a freethinking, interdisciplinary dialogue. John Balbach, the forum's cofounder, offered to cajole as many of the esteemed participants as he could into our makeshift studio. They were promised that only a few frames would be made in as brief a time as possible.

Portraits I had made at other events needed to reflect a specific time and place. I had chosen to shoot these exclusively in black and white instead for its sense of timelessness, to create portraits that would transcend the moment. There is always the argument that color is preferable because one has the option to convert it later into black and white, but I find that I need to *think* in black and white in order to *see* in black and white. For

these photographs, I didn't want to be distracted by a red necktie, green skirt, or golden sash (although in another situation it is precisely those surface details that might prove most revealing). In this case, I shifted my focus to the human inside.

I wanted these portraits not to look technical or slick; the photography needed to be invisible so that all you would be left with was a human being presented as honestly as possible. The images were made with big view cameras to provide the most tonally rich images possible with the loveliest sense of detail and to focus the attention of the sitters as quickly as possible. The 8x10-inch sheets of film would give the most beautiful sense of *skin*, of a living breathing person, to these images.

When Kushok Bakula Rinpoche, one of the sixteen disciples of Buddha, diminutive and dignified, was brought into our little hotel room, I immediately explained (through an interpreter, smiling the entire time) that I'd be making just two photographs, one full-length (I gestured to the setup before us in the living room) and the other close-up (I pointed through the open door into the "bedroom"), and that it would take less than five minutes for the whole procedure.

It took a few moments for all this to sink in, by which time he had been ushered to an X on the floor

where he was to stand for his full-length portrait. As soon as he looked into the camera, I made the first exposure. One more exposure and he was brought into our second little studio in the bedroom. Here, the entire setup occupied barely a six-foot square. He was seated quite close to the lens; in fact, the big camera probably blocked out everything else from his field of vision. The only illumination in the darkened room was the warm glow of my light inches away to his left. The atmosphere was quiet and intimate. When I motioned for him to lean slightly toward the camera, he silently obliged, and I tripped the shutter. There was still time, so I quickly made a second exposure. Then he stood, bowed, and glided out to help save the world.

THOUGHTS ON TECHNIQUE

He looks like Yoda, all-wise and serene. What gives this image its strangely intimate power is that I've used the wrong lens on the wrong camera. Lenses have several different defining, quantifiable characteristics, including focal length, maximum and minimum f-stop, angle of view, angle of coverage, and image circle. The one that technically has the most bearing on this portrait is the image circle, because it is what determines the biggest film size that can be used with a given lens. I wanted to use a large-format film for its tonality and detail. I also wanted to use a specific vintage lens for the unique qualities of its shallow focus. The problem was that the beautiful old lens was only made to work with smaller-format cameras.

Even though pictures are rectangular, lenses are round, so they project a circular cone of light that produces a circular image on the film (or sensor). Ideally, the rectangle of the picture fits inside of this circle; oth-

erwise we are left with a round image inside of a black box (as most commonly seen in fish-eye pictures). The good news is that as the lens focuses closer and closer, it moves farther and farther from the film, so the cone of light it throws gets bigger and bigger, as does the resulting image circle. Since I was shooting close-up portraits and not faraway landscapes, this would compensate for the limitations of my lens.

I could not have achieved quite the same look with a lens made for the format of film I was using, because no lenses for 8x10 cameras have as shallow depth of field as this lens (which could only cover 4x5 format at best). This shallow depth of field, combined with the quality of bokeh (that subjective character of the out-of-focus elements in the picture) of this particular lens, created the exquisite falloff of focus that makes this gentleman's face literally emerge from the rest of the image. The extremely selective focus is due to the "speed" or maximum aperture of the lens, f/2.9. Lenses made for 8x10 format cameras typically have "slower" maximum apertures of only f/5.6 or f/8, which deliver images in which much more of the image is in focus (the concept being that the larger the number of the f-stop of a given lens, the greater the depth of field or range of focus—for example, more is in focus at f/16 than at f/4).

This is but one example of the countless right brain/left brain overloads that can make a photographer's head hurt. But I couldn't have made this picture *if I didn't know how to do it.* It's a whole lot of numbers flying around, ultimately in the service of evoking a purely emotional, gut-level response. I didn't get out my slide rule to figure this one out, though. On a hunch, I just stuck the wrong lens on the wrong camera to see what would happen.

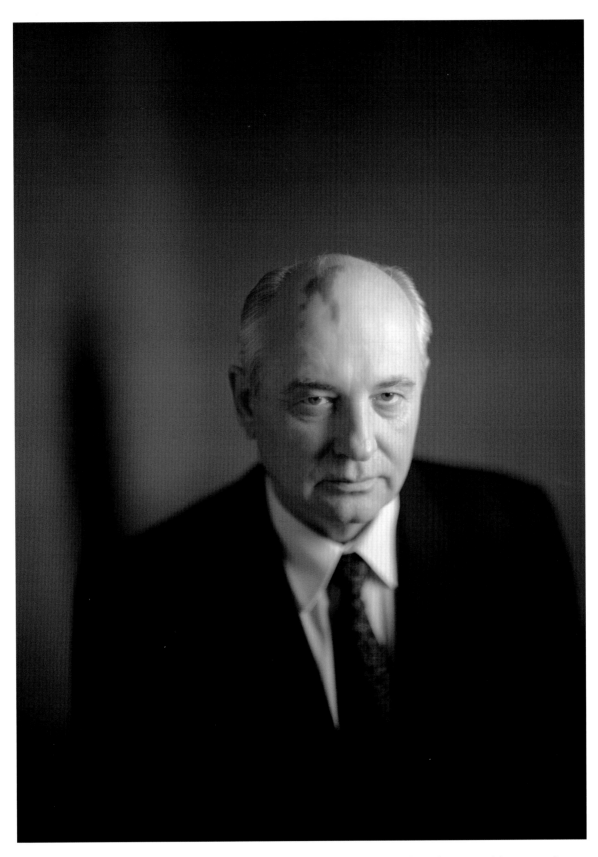

A bit impatient, Gorbachev's only words to me during our incredibly brief encounter were "Please do not extend the program."

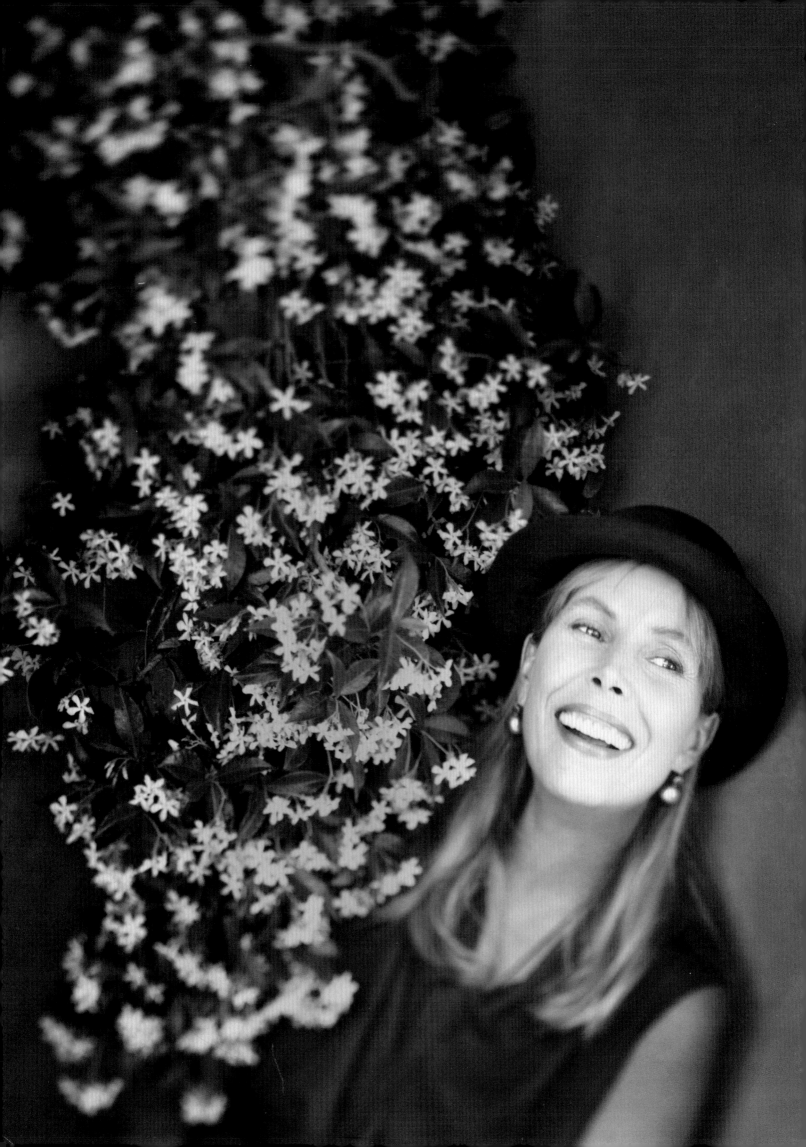

23

JONI MITCHELL

In another life, I'd have dropped to one knee and proposed on the spot. I was mesmerized, besotted. Joni Mitchell was warm, welcoming, conspiratorial, and game for our little portrait session. Oh, and did I say beautiful? *So* beautiful.

We were at her heavenly home in Beverly Hills, making portraits for *LIFE* magazine's special issue commemorating the twenty-fifth anniversary of the concert at Woodstock, New York. Although she hadn't actually performed at the event, her song had long since become its anthem, so the magazine's editors had chosen to feature her as one of the artists in the story. I had decided to take her lyric "back to the garden" quite literally and use her own lush private gardens as the setting for our portraits. Since the story was slated to run in black and white, the colorful flora wouldn't overwhelm her but would provide just the right context.

Typically, I prefer to scout around, narrow my options down, and focus in on one particular scenario that best sums up the story. That afternoon, though, I just didn't want to leave. I shot *all* of my ideas. I made many different pictures, trying disparate approaches, working with an arsenal of favorite cameras in a variety of locations in and around her home. She playfully posed among her plants, literally pranced along a garden path with her parasol, and generally flirted with the

camera shamelessly all day long. In some of the images, she was just a small figure in a sweeping verdant view; in others, she was alone in a room with her garden visible through a single window. This intimate photograph, with its cascading waterfall of fragrant Mexican orange blossoms, is the one the magazine chose to publish on its cover.

Mitchell seemed to be in no particular rush that day, offering us lunch, chatting, chain-smoking, and playing us tapes from her upcoming release. I was at my most charming, doing everything I could to elicit that deliciously radiant smile.

THOUGHTS ON TECHNIQUE

Different cameras for different pictures. Seems obvious, but it's always been a powerful part of my image-making process. Some cameras are painfully slow, deliberate, and precise. Others are fast, loose, and intuitive. Some are responsive, while others are positively dictatorial. Some make me keenly aware of the edges of my frame, while others allow me to focus first and foremost on the content. And whatever the camera, they all affect the response of the sitter in different ways. Contrary to popular myth, the camera *never* disappears, not to the subject and certainly not to the photographer. For the

photographer, it can occasionally be a marvelous tool that helps us to see more perceptively; more often, it's this confounding *machine* that's always in the way.

There's usually the right camera for the job: the one that lets you work more quickly and intuitively, or the one that allows you to study and contemplate your subject more carefully. On this occasion, I brought a selection of tools so that I could choose the one to suit my muse of the moment. For one image, I elected to

work with the Widelux, a 35mm camera that makes extralong panoramic photographs, and employed infrared black-and-white film to render her lush green garden as a dreamy sweep of snowy, luminous whites. For another, I worked with a medium-format Hasselblad for its neutral, square format.

This image, however, was made with a fairly unwieldy 4x5 large-format studio camera for several reasons. First, I wanted to use its ability to manipulate the

plane of focus. While I loved the dancing cascade of flowers, I wanted to focus on her dazzling smile; otherwise, I'd be paying more attention to the flowers than to her. And second, the sizeable sheet of film would yield a greater range of grays with which to paint her skin. Plus, since one can't look through the camera when the exposures are being made, it would prevent me from being obscured as I photographed, allowing me to interact with her as I worked. These kinds of decisions, though, were made on the fly, not worried over in advance. On this day, I chose my tools as I worked, hoping they would allow me to connect in just the right way, without getting in the way.

ABOVE Back to the garden. The magical world of Joni Mitchell, her backyard in Beverly Hills, captured with a Widelux panoramic camera on 35mm infrared film.

PETE SEEGER

I was crouched on the floor of a recording studio located in the attic of an old house in upstate New York, trying not to be a six-foot guy with a camera. I had come to listen and watch as one of my childhood heroes laid down some tracks for an upcoming album by the brilliant banjoist Tony Trischka, who had invited me along with the hope that I might have the opportunity to make a portrait of one of the true living legends of our time, Pete Seeger. There was no "purpose" for the photograph; it wasn't for a magazine or a record company. It just seemed like a rare opportunity. The only wrinkle was that Seeger wasn't aware of my desire to make a portrait; I was merely introduced as a friend who might unobtrusively take a few candids to accompany the liner notes on the CD.

I had showed up with a point-and-shoot pocket camera that would allow me to silently record the event in still pictures as well as jiggly video. In my backpack, though, were a big old view camera and a few loaded film holders, which I hoped to use for a portrait that would truly commemorate the day.

Seeger looked and sounded quite frail, singing with a whisper-soft, quavering voice. His timing obeyed rules only he knew; Tony and the fiddle player, Bruce Molsky, looked at each other, respectfully and gamely accommodating their playing to complement what they were hearing. It was a serious endeavor, yet everyone looked to be enjoying the process. After several takes, though, Seeger began to visibly tire, and as the session seemed to be nearing its end, I silently crept downstairs to set up the big camera.

It was becoming readily apparent that an actual portrait session was not in the cards and that, at best, I'd only have a few moments with Seeger on his way out the door. So I proceeded to set up my tripod in the tiny foyer, not more than six or seven feet square, and waited. He'd literally have to squeeze past the camera, and I insensitively blocked his exit with an old stool. I was desperate for this shoot to happen. As he came down the stairs, I greeted him, and Tony explained that we just wanted to make a very quick portrait before he left. He nodded but didn't look thrilled, and as he walked out to the foyer and saw the big camera waiting for him, his face grew dark. He sensed he was in for it. I asked if he'd unsheathe his trademark long-necked banjo; he sighed as he planted himself on the stool.

He fixed the lens with his incredibly piercing blue eyes and fairly grimaced as I made my few exposures. Sitting across from me was not a kindly old troubadour but the passionate, immovable, uncompromising activist who probably saw this photo as an utter waste of time.

As he made his way to a waiting car driven by an old friend, his downcast gaze was caught by a glinting piece of glass. He slowly bent down and plucked an old automobile headlight from the grass. He rose and gravely handed it to his host. "You *will* dispose of this responsibly?"

THOUGHTS ON TECHNIQUE

The Polaroid Corporation used to have an ad campaign for its "instant" cameras and film that had the tagline "The 60-Second Excitement." This photograph wasn't made in a whole lot more time than that. More like "The 60-Second Panic." Yet many decisions and judgments had to somehow still get made. Which lens to use? Where to put the camera? How high? Just how much will be in focus? What needs to be really sharp and what merely needs to be seen, its presence felt? What's the background? Where's the light coming from? Do I want to modify it? Add to it? Where should my subject be? Sitting or standing? On what? How should he pose? Where should his hands be, and what are they doing? Where will he be looking? With what expression? What will he be wearing? Do I have a choice? And on and on. Then there's the technical toolbox. What's my ISO? What shutter speed do I need? Which lights should I use? And where do they go? These are all the same decisions and judgment calls that go

into every portrait, but here they were happening at light speed.

And while this deafening din of background blather is bouncing around inside my head, somehow I'm supposed to engage in witty repartee with the subject, attuned to the subtlest nuances of expression and gesture. I tell you, it's tough. But it's *really* fun.

In this case, there was a doorway with beautiful light pouring in—which Seeger would have to pass through to exit the premises. So I knew where he'd have to be. It opened into a tiny vestibule. My studio. I grabbed a nearby stool. I guessed at the light. I quickly added a little supplementary fluorescent light near the ground to simulate sunlight reflecting off the floor onto his face. No time for strobes. Next, I unfolded the big wooden camera from its backpack and set it on its tripod.

Then I grabbed my favorite lens. This is a big deal, a make-or-break choice, for it determines what the picture will *look* like. There is no right or wrong lens. But there is, for each and every situation, a *best* lens. The one that renders the subject and the space with the proper intention. The 10 ¾ inch Goerz Golden Dagor (it even *sounds* sexy) is not dramatic or "lensy." It's just, to my eye, completely natural. People are portrayed exactly how they look at a conversational distance. They're neither stretched nor compressed, not flattered or mocked. They're just *presented*.

Now, the final decision: f-stop. How much to have in focus? I go for less. It feels more natural, less starkly photographic than when everything's in focus. Plus, it allows me another way to direct the viewer's eye. In this case, you look first at Seeger's eyes, the way their slight squint sizes up the viewer. His face emerges from the plane of the picture because the neck of the banjo beside it recedes out of focus. His outline is soft, but the details are sharp. Next, you notice the inscription on the head of his banjo (in focus), which circles around to show you his string-plucking fingernails (also in focus). Then you kind of notice the Public Radio logo on his sweatshirt (not exactly in focus), which leads you down his arm to the determined way his other hand rests on his hip (in focus). Then you bounce back up to his eyes again and notice the crisp edge of his crooked wool cap (in focus). And his razor-sharp bushy eyebrows and bristly beard (also in focus). And the firm set of his mouth, which says everything. This is a formidable, principled man.

The first two frames that I made with a silent rangefinder camera of Tony Trischka, Pete Seeger, and Bruce Molsky during the recording session.

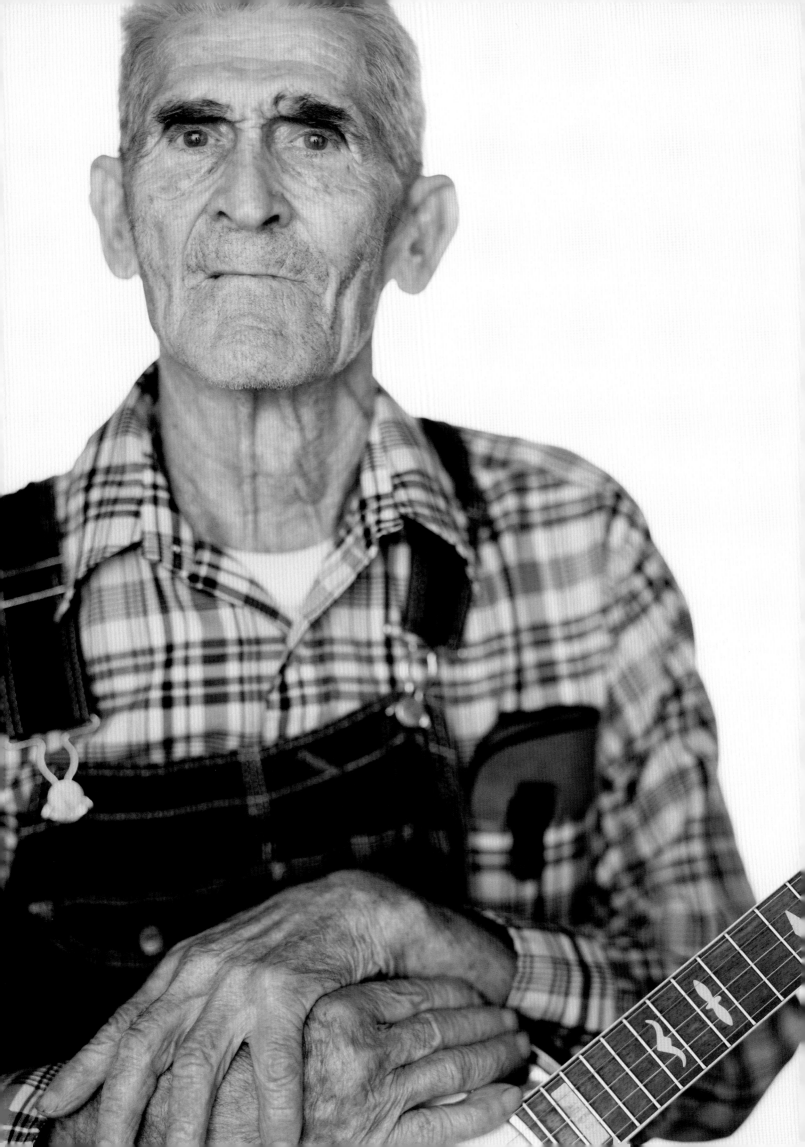

MORGAN SEXTON

I'm ashamed of this picture. I made it in 1990 at the Tennessee Banjo Institute, a gathering of banjo players, from leading professionals to unknown amateurs, who came together to listen, learn, and enjoy. I had played the banjo, badly, off and on for years, but I loved the instrument and the music, and had a special affinity for the invariably humble individuals who play it. I heard about the get-together from my banjo teacher, the legendary and passionate performer, historian, and authority on all things banjo Tony Trischka, who had kindly (and bravely) taken me on from scratch. (Imagine a novice photographer getting one-on-one lessons from Richard Avedon or Ansel Adams!) I immediately decided that I wanted to recognize and, in some way, preserve these folks, some of whom were obscure musicians from small Appalachian hill towns.

At the time, I had just gotten interested in making platinum prints of my work—big prints, which meant I was going to need a big camera. (Platinum is a "contact printing" medium in which the negative has to be the same size as the desired print.) Ray DeMoulin, the head of the professional photography division of Kodak at the time, generously spotted me a great quantity of hard-to-come-by 11x14-inch black-and-white negative film for my project.

I wanted to make photographs that seemed as if you were looking through an incredibly clear window right *at* these banjoists. It was important that nothing distract from them, so I opted for a standard solution: a pure white background. I also chose to shoot with very selective focus to direct the eye right where I wanted and to soften the feel of the potentially clinical white treatment.

The convention took place at the Lebanon State Forest just outside of Nashville, and we established our makeshift studio in an open-walled picnic shelter. We were unannounced visitors; it was a testament to the welcoming warmth of the organizers that they embraced us immediately and, with kind encouragement from Tony, did all they could to help. I set up two ministudios on the premises, one with the white background and the big camera, the other with a gray canvas backdrop and a smaller 4x5 camera.

While the shoot went well, working with the big camera was a slow process. The players patiently waited their turn, sometimes as long as an hour or more, while I painstakingly photographed their compatriots. The big camera itself established quite a serious occasion, and I believe my subjects felt flattered to have such careful attention lavished upon them. One of my

It didn't hit me until I was on the plane returning home: in all my excitement, I hadn't made a single original picture.

favorite images from the shoot is this straightforward portrait. Eastern Kentucky's Morgan Sexton didn't make his first public appearance as a banjo player until the age of seventy-seven, singing with a high and plaintive voice that echoed his simple accompaniment. He was about eighty years old when I made this picture, having worked as a coal miner for most of his life, and he passed away a few years later.

It didn't hit me until I was on the plane returning home: in all my excitement, I hadn't made a single original picture. Suddenly the white background images were all second-rate Avedons, while the canvas backdrop pictures were Irving Penn wannabes. I *did* get them out of my system, but I was suddenly so despondent I wanted to crack open the emergency exit and take a dive.

The hundreds of negatives sat undeveloped in boxes for ten years.

THOUGHTS ON TECHNIQUE

What is so appealing about a white background? Well, it's nothing, for starters, just active negative space. It has a "clean" look. And it lets you really study the subject without any distractions. The only problem is that the late, great photographer Richard Avedon basically claimed it as his own, essentially patented and copyrighted it, so that now it's all but impossible to use it without referencing his work to some degree. Yet it has its uses, so it's good to figure out a way to make one when you need it.

There are countless ways to create a white background. The first and most important step is to decide the look you desire. Will the white be almost-white, or even light gray? Or will it be airy and blown out, causing lens flare? Will it be sloppy, with the white kicking onto the sides of the subject? Or will it be sharply defined with no spill light whatsoever? It's all a matter of personal preference and technical ability.

I generally like my whites crisp and clean, so I don't use umbrellas or softboxes to light the white seamless or cyclorama (a curved wall that gives the sense of infinite space). There's no need for "soft" light; it just needs to cover the wall evenly. I simply use raw lights (strobes or tungsten lights, sometimes with a bit of diffusion to spread the light) directly hitting the surface. Usually, there are four lights, two on a side stacked vertically, four to eight feet from the background, with each pair of lights aimed at the opposite edge of the paper or cyc. This yields a very even light, within a third of a stop corner to corner.

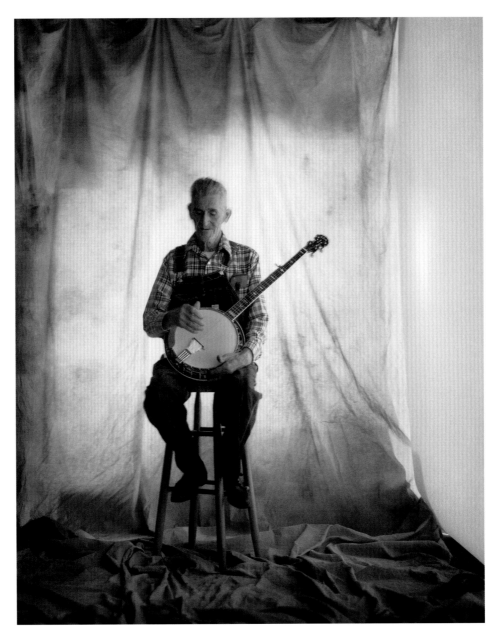

Our subject in the alternate setup, with the white seamless backdrop from the first image (page 112) now functioning as the light source.

The subject should be as far as possible (within the limitations of the studio) from the background to better isolate him or her. The next step is to "mask out" the background to prevent any stray light from hitting the subject. This can be accomplished by placing some opaque black material (anything from black foam-core boards to black velvet) like a border around the subject from behind, right to the edges of the frame. The fi-nal step is to determine the exposure. I like to have my white background only a third to half a stop brighter than my main, or key, light. This prevents any flare-causing overexposure while still ensuring a completely white tone. But as with many things, my preferences have changed over time. Today, for me, black is often the new white.

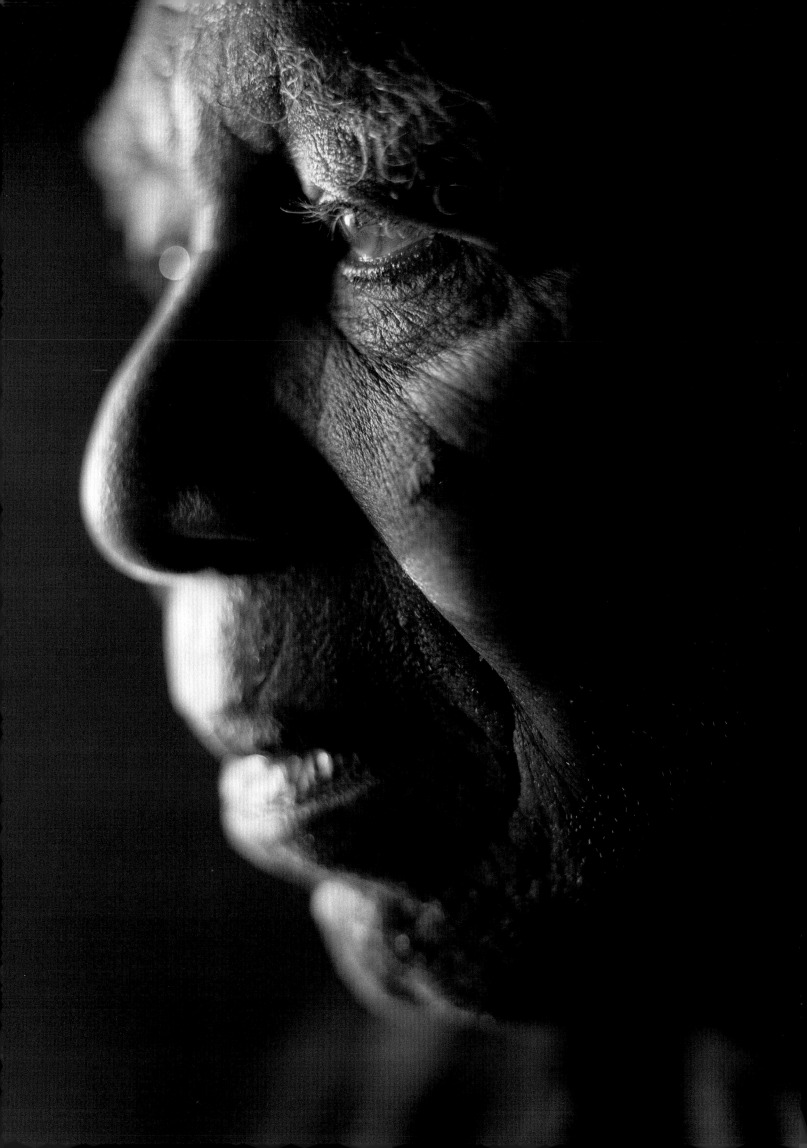

26

HERMAN SHAW

A gentle man. Guileless. Trusting. Herman Shaw was ninety years old, one of the last remaining survivors of the infamous Tuskegee Experiment. How to go about making his portrait? First of all, he barely looked a day over seventy. He spoke softly but was not frail; his firm, enveloping handshake surprised me. He lived in a small wooden house in rural Alabama, had an old pickup truck and a tired mobile home on his property.

I left my gear in the rented minivan as he took me on a little tour. I try to have my antennae on high alert, sensitive to anything that might catch my eye: a corner, a texture, a slash of light. Often I'm looking for something specific. It might be a spot to turn into a makeshift studio for the afternoon. It might be a room with a view. It's a search for the telling detail that opens a window onto my subject, helping to tell a piece of the story—like the old truck that he drove to the hospital for forty years to get his painful "checkups" (which included excruciating spinal taps to get out the "bad blood," or so he was told), the unused tractor sitting in an overgrown field, the faded, framed photo of a relative who didn't survive the Tuskegee "treatments," or the hand-carved cane

he never lets out of his sight. I walk, look, listen, and learn.

All of these are choices; each tells a different piece of the story in its own way, immediately and nonverbally. It's up to me as I search for context and meaning. If I allow too much time to pass, I'll overthink the situation. The possibilities become limitless, the potential overwhelming. I get flooded and dry up, not knowing where or how to begin.

So I wasted no time getting started and made several black-and-white images that afternoon. The first was a strong, low-angle image of him as a survivor, cast against a stormy sky. The magazine ran one of those. The second was a pulled-back picture of him walking his farm, a lone figure in the late-afternoon landscape. I also made several portraits as he sat in an old sprung sofa on his rickety front porch, some with him laughing as he told me family stories from his childhood, others more subdued as he talked of friends lost. There was even a close-up of his aged hand on the old cane. But my favorite was this simple one, because it didn't depend on context. To me, his gaze told a story of betrayed trust, hurt, and endurance.

His gaze told a story of betrayed trust, hurt, and endurance.

THOUGHTS ON TECHNIQUE

First, do no harm. I often feel that is my mantra when I walk into someone's home to make a portrait. It's not always possible. I've been on shoots and heard about many more where the photographer (or film crew) was like a bull in a china shop, if not smashing precious possessions, then ordering people around like a general on D-day, rearranging furniture, banging lights into walls and ceilings, scraping stands along polished floors, leaving coffee cup rings on furniture and even cigarette burns in the carpet. While I've certainly rearranged my fair share of furniture, it is always done with the utmost care and consideration.

Sometimes I've photographed in a house rented as a location for an advertising shoot, in which case the owner is being handsomely compensated for the incon-venience and a bit of unavoidable wear and tear; however, it's a different story when I'm photographing in the home of my subject. It's *their* space, filled with *their* possessions, *their* lives, and *their* memories. I tend to tentatively tiptoe my way around a bit when I first enter. (*Then* I start slinging furniture around. Just kidding.)

For years, I worked with small strobes in locations like these and still do on occasion. But for quite some time now, when possible, my preference has been to work with continuous low-wattage tungsten and fluo-rescent lights. They just seem far less intrusive on many levels. They're generally quite small. They don't blow fuses. They're easy to move around and hide and don't weigh much, so they don't require big, bulky stands for support. Since they aren't too bright, they blend in more easily and don't make my subjects sweat and

squint. Best of all, since they're not strobes, they don't "pop" and break the mood.

In this image, ninety-year-old Mr. Shaw was sitting on an old sofa on his front porch, speaking in a gentle voice, reminiscing about his youth in rural Alabama. I had been photographing his lovely, weathered hand gripping the equally worn old cane, but the overcast sky gave a flat cast. I longed for the glow of late afternoon, now lost to dusk. I set up a tiny tungsten light off to one side, barely brighter than the existing ambient illumination, like a ray of soft sunlight to reveal the texture of his skin. He grew quiet and reflective; as I moved up to his face, his eye came into crisp focus, and I gently pressed the shutter.

The environmental portrait the magazine ran as the opener for the story.

ALONZO MOURNING

I had photographed Alonzo Mourning some years earlier at the Georgetown University practice gym for a story in *Esquire* magazine, a simple black-and-white portrait of him standing under a backboard that bore a stenciled "No Dunking" admonition. He was younger and skinnier, and he'd had hair. Now that he was a seasoned NBA star, "Zo" was bigger, badder, and strikingly bald. This time it was for the cover of *ESPN The Magazine*, which encouraged unusual stylistic approaches and whose daring director of photography, Nik Kleinberg, allowed me tremendous creative freedom.

I ran some tests in my studio to work out a couple of lighting ideas dealing with supersaturated color. Mourning was strong, solid, and handsome, shaved head and all, and I thought he'd make an ideal canvas on which to paint. When we had finished our experiments, we made careful notes and measurements of our setups so that we'd be able to re-create them in Miami.

Our impromptu studio ended up being a cinder-block hallway ringing the floor at the American Airlines Arena. It took us about an hour to accurately replicate our New York lighting setups. When Mourning arrived, he took one look at the vibrant 8x10-inch Polaroid test shot we made of him and promptly announced that he wanted to have his head freshly shaved for the shoot. He returned two hours later looking, to me, exactly the same, but if he felt his handsomeness had been maximized, it was worth the wait.

I can't explain this picture. It's an unusual one for me, as I rarely use colored gels gratuitously. I just thought he'd make an eye-popping cover. Ultimately, while the magazine ran the alternate cover image from our second setup, this portrait was published as a two-page *vertical* inside spread, a rare use of real estate in the world of editorial photography.

THOUGHTS ON TECHNIQUE

I had an idea, a color idea. Using light as my paintbrush, I wanted to break free of the predictable flesh tones portraiture offers. There was, atypically, no real reason, no particular logic; I just wanted to wash my subject in lush color for its sheer impact. And the actual 8x10-inch original color transparency actually looked this juicy, no Photoshop needed.

The first step was to set a base color for the image: a rich, saturated blue. I wanted an overall cool feel to the picture and, from experience, knew it would translate well on his skin, whereas white guys tend to look like poached fish when lit with blues. Additionally, the blue light would amplify the blue seamless paper background. In fact, whenever I want the color of a

When Mourning arrived, he took one look at the vibrant 8x10-inch Polaroid test shot we made of him and promptly announced that he wanted to have his head freshly shaved for the shoot.

background to be really pure and strong, I light it with gels that match its hue fairly closely, rather than with white light.

Next, a contrasting color was needed to cut Mourning out of the background. Blue's complementary color, orange, would have been the logical choice and provided the greatest contrast, but red seemed like it would be hotter and more intense. We tried it, and it packed a wallop. So red it was.

But the image still looked somewhat two-dimensional, floating in a world of fantasy color. Something was needed to ground it in reality. A chromatic cue. But I didn't want an absolutely neutral and accurate skin tone. I felt that would be a non sequitur given

the image as it stood. So we went for a slightly dirty-greenish glow that would catch small areas on his body from below. Something just to provide little anchors of reality.

There was still a lingering flatness to the image. It was the solid blue backdrop. It needed some relief; it needed to breathe. But rather than adding another light with another gel, I tried "feathering" the red rim lights slightly away from Mourning and toward the blue background. The nicest thing happened—not a strong pop of color but just the coolest glow that moved from magenta through violet to blue behind him, quietly pushing the background back.

There was no logic; I just liked the way it looked.

The lighter side of Alonzo Mourning, photographed in the alternate color scheme that was used on the magazine's cover.

28

BARRY BONDS

Baseball always happens on sunny summer days. (At least in the photo moments archived in my memory.) So when it came time to photograph Barry Bonds, I felt compelled to convey the feeling of summer sunshine—but we were stuck in a hotel conference room, without access to a ballpark, bench, or even a window.

It's the "sunlight" that sets the tone in this picture. Yet Bonds's mood is anything but sunny. He's sunk in a funk, barely cradling his bat. (He had a lot to think about at the time.) The portrait isn't heroic but humble: a private, unguarded, introspective moment. I have a frame with his hat around the right way, his eyes alert and looking into the lens. It's another kind of portrait, but his guard is up and we're shut out from his world.

Often, logistical limitations force me to photograph subjects in unlikely, uninspiring places like hallways and hotel rooms. Many times, the solution is to set up a little portrait studio in whatever space is available, creating a bubble in which to make some magic. It's like a little radius of sanity and control. From locker rooms to boardrooms, I can have the sophisticated resources of a studio at my disposal to finesse the final photograph. But that doesn't mean it has to *look* like a photograph that was made in a portrait studio (although that may be the order of the day). It's possible to create anything

you want, any illusion, unconstrained by the realities of the environment: any time of day, any quality of light.

While the image that was ultimately published as the magazine's cover did look like a slick studio portrait, this one was my favorite because it's not slick; it's a "fooler." You don't even notice the lighting; it's just *there*. Its naturalness makes for a believable portrait rather than a pose. Instead, it's just an authentic, in-between moment on another sunny summer day.

THOUGHTS ON TECHNIQUE

Phony natural sunlight. It's one of my favorite light sources, though not one I employ very often. It's crisp, simple, strong. It produces nice, sharp shadows. It accurately describes a subject without looking like fancy artificial light. It feels organic and real when done right.

Grant Peterson single-handedly revolutionized commercial still-life photography in the 1980s and '90s partly through his brilliant, innovative use of the bare bulb. (I copped the idea from him.) A bare bulb is just that: a light without any reflector or modifier to attenuate, concentrate, spread, or soften its illumination. It's a small, or "point," light source. Our sun roughly mimics a point light source, which means that it casts razor-sharp

It's possible to create anything you want,
any illusion, unconstrained by the realities
of the environment: any time of day, any
quality of light.

shadows because all the light rays emanating from it are essentially parallel. As its name suggests, a point light source is usually quite small. The sun is unimaginably enormous, but since it is ninety-three million miles away, it, too, looks quite small, like an incredibly bright little lightbulb hanging way up there in the sky.

The bare bulb can be a regular lightbulb, a tiny quartz light (Peterson's favorite), or even a strobe. The key is that it is bare and unencumbered, so it radiates its illumination 360 degrees, bouncing all around the room, creating its own fill light off of any available surface. It's a distinctive fill light, coming from everywhere, because you don't see it as such; it just *exists*. It can contribute subtle secondary colors depending upon what it's bouncing off, lending, say, a cool cast to the shadows that looks like it's coming from an open blue sky. It can be very beautiful.

I've used this type of light to photograph groups of guys in ties, hockey teams, and chorus girls. I've also used it to simulate late-afternoon light with longer shadows that can be used quite expressively on single subjects. It's simple, easy, and quick to set up; it's not fussy and doesn't need to be positioned with great accuracy. It just needs to make sense, to be coming from a realistic angle. And it needs to have something to reflect its light all around, otherwise its shadows are inky black (which, with a little underexposure, can mimic moonlight).

Typically, I work with this sort of light for the character of its shadows, their shapes and sharp edges. For this portrait of Bonds, though, I just wanted the overall sunny feeling but *without* any distracting shadows. I wanted his face gently illuminated only by the soft indirect light bouncing off my big white reflector boards. So I uncharacteristically positioned my bare bulb above and *behind* him. It threw hard noontime light onto his shoulders and arms but bathed his face in a shadowless reflected glow. The result is nothing fancy, but totally believable.

Our midday "sun" warms the athlete as he gives the camera his most sincere gaze.

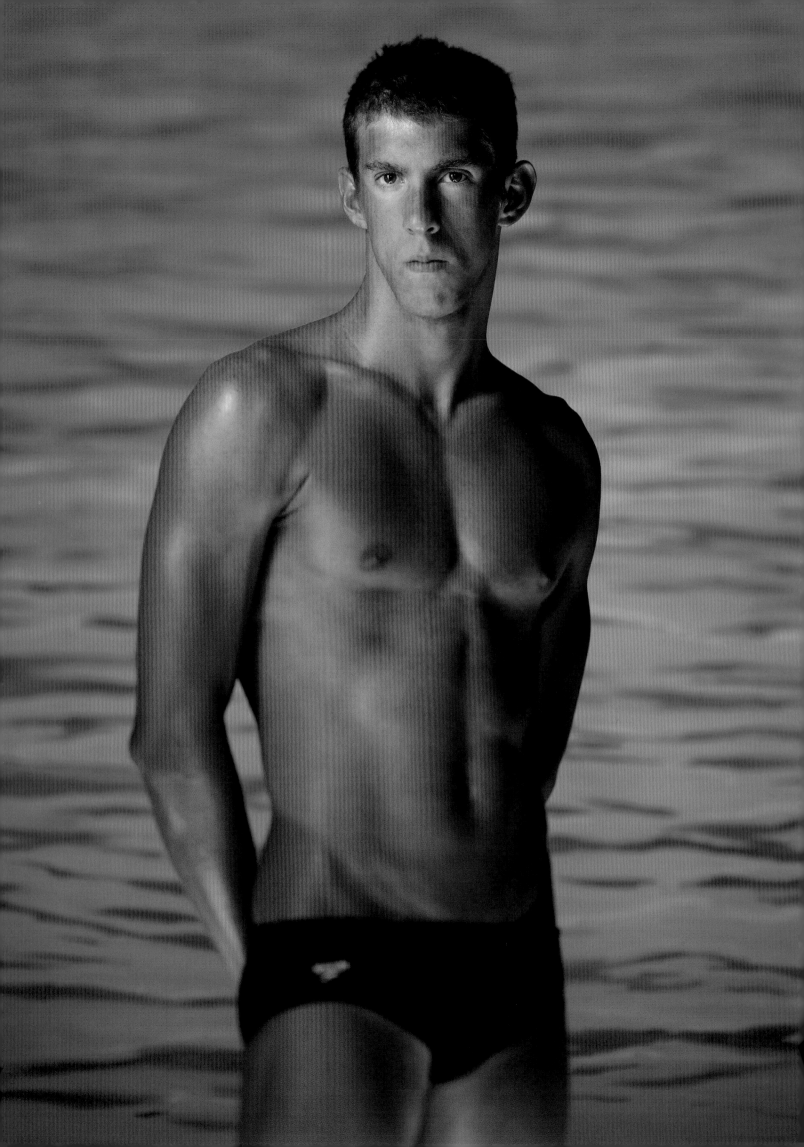

MICHAEL PHELPS

How do you photograph a swimmer without a pool (and not just *any* swimmer but Michael Phelps)? Imagine Phelps, very tall, soaking wet, incongruously padding around in front of you on the cold cement floor of a garage-like rental studio in his itty-bitty Speedo. There's no pool in sight. Talk about a fish out of water!

I believed that he needed to be shot as a swimmer, in context, with a pool. Many accomplished photographers have certainly made iconic studio portraits, many in black and white, of athletes over the years. It can be beautiful, graphic, and striking to pluck the individual out of his milieu and isolate him starkly in a studio setting. But for me, there's something about incorporating a bit of the environment that grounds and enriches the image. The challenge is that the surroundings can begin to take over the picture; they can *become* the picture. So sometimes it's better not to actually see all of it but just to convey a sense of the context, a feeling for the place.

The goal was to photograph Phelps on location at the Stanford pool where he was training for the Olympics, but it was fully scheduled and unavailable. On to Plan B. But there was no Plan B, except that he would make himself available for a studio shoot. You could make a strong studio portrait, but it wouldn't have the veracity of the real thing. You could photo-composite him into an environment, and while it might look dramatic, it simply wouldn't feel right.

I hate to rely on postproduction techniques, preferring to get it right in the camera whenever possible. (I may be fooling myself, but I believe there is an organic *rightness* when the image is achieved in camera.) More important, it's simply a different creative process. When one works extensively on the computer piecing parts together, one begins to shoot not photographs but *elements:* patchwork components that may have little photographic value independently but shine when combined into a stitched-together whole. The risk is that you can make it *too* good, too perfect, and end up squeezing all the air out of it.

When you create the finished image in camera, on the other hand, the working process is quite different. It is a thrilling process in which you see the image take shape before your very eyes, in real time, in which every decision you make affects the next one as well as the entire picture. You are responding to changing circumstances and new ideas all the time in a constant improvisational riff. It's hard to get it right, let alone perfect, so there's always a rough edge, an unexpected imperfection. But best of all, you never quite end up

where you thought you'd be. Photography's a bit like a rangefinder that's out of whack; you think you're aiming here, but you end up over there. It's the beautiful, unpredictable disparity between what you think you're going to get and what you *got*. It's always a little bit of a surprise and a little out of your control.

THOUGHTS ON TECHNIQUE

It's not water. There's no pool. Phelps is standing in front of a canvas backdrop painted with blue acrylic swirls. It looks like a watery surface receding into the distance because of a tipped lens. Phelps looks like he's illuminated by the very same imaginary pool of water through the magic of lights and colored gels. It's a complete concoction.

I knew we wouldn't have access to the pool where he was in training. I also knew I wanted a pool picture. I looked for photographs of pools that I might photo-compose behind him (even though I was loath to do it), but as I searched, they all looked too real, too specific. I was stuck with the specific skies, specific angles, specific lighting dictated by the pool photos. So I thought I'd try one step *less* real. I looked at colored seamless paper. It was blue, all right, but had no sense of reality, of a *place*, whatsoever. I started combing the catalogs for painted backdrops. They can be either really good or *really* bad. Often their success hinges on how they are illuminated in the picture. They can look either like the real deal or like a parody. This one couldn't look like

a parody. I picked several to play with under the lights. Sarah Oliphant's backdrop #1175 worked perfectly (she has created beautifully expressive backdrops for photographers for decades), but the image as a whole still wasn't convincing. While the backdrop photographed well enough, the picture still had two distinct, unmarried planes: the subject and the backdrop. There needed to be a *link* to tie them together visually.

Somehow, I needed to connect Phelps to the "pool." It struck me that he needed to be illuminated with "pool light," as if he were standing next to an underlit pool at night, with cool hues washing over his body and showing off his sculpted Olympic torso. So I knew two things: the light needed to come from below (where the "water" would be), and it needed to be blue (the color of the "pool"). Achieving this seemed simple enough, but my assistants and I worked through an entire weekend with swimmer stand-ins, through interminable all-nighters, to come up with this picture. There were challenges.

My initial thought was to simply place fluorescent lights flat on the ground beneath Phelps to provide the cool glow. Their light was beautiful, but they were too dim for my 8x10 camera. He'd have had to stand still for a 10-second exposure. No way. So I switched to strobes. I positioned three long softboxes around him on the floor to mimic the look of the fluorescent lights. They were a little too big and sat up too high, almost waist height, which meant he'd have to stand on a platform, since I was looking for a three-quarter-length portrait.

Not good. It was now well into the night on Saturday, and we had to board a plane first thing Monday morning. There was nowhere open to rent more gear from. I had run out of options. Almost.

Several hours later, we had constructed three of our own custom-made softboxes, to the perfect size that sat low on the floor, out of foam-core board and diffusion gels. We cut holes in the ends and stuffed our strobes into them. Presto! We made one more and hung it vertically from a light stand to bathe his face and torso in warm light. We shot a film test, and then carefully sliced the softboxes apart with a box cutter and tucked them into tripod cases for shipping.

There was one last tweak. The "water" backdrop still looked two-dimensional, a flat plane sitting at a fixed distance behind him. On a hunch, I tipped just the front of my 8x10 camera forward a bit to alter the plane of focus. By tilting the lens, I shifted the plane of focus. Instead of running parallel to the camera and focusing on only the subject *or* the backdrop, it now cut through *both* my subject *and* the backdrop on an angle, causing both to transition from sharp to soft. In particular, it made the surface of the "water" look like it was receding away from the camera by growing blurrier from the bottom of the frame to the top. We took down careful measurements and light readings, packed everything up, and re-created our bone-dry "pool" when we arrived in California the next day.

A sneak peek of Phelps's Olympic rings tattoo. Without our "water" backdrop, though, it loses the sense of drama and context.

30

TIGER WOODS

I'm often called upon to photograph people who've been photographed many times before. The challenge is to make not just a good picture but a *new* picture, although it's not *always* possible due to external (or internal) obstacles and constraints. I try not to do different for its own sake but to say something specific, something that illuminates the magazine story accompanying the portrait, or simply to note something that I saw or felt at the time. Well, you don't need an MFA to figure out this image: Tiger Woods is a giant among golfers, larger than life.

I inevitably seem to have little time with my subjects, often just minutes, which unfortunately can impose a certain degree of contrivance on the image. The picture has to be, to a great extent, subjectproof, able to survive no matter what mood they're in or how briefly they remain in front of the camera. It absolutely has to work. I need to create a finished image that I can *insert* my subject *into.* The picture needs to be pretty much done; the subject simply *completes* it. In this case, I had already made an unusual head shot as a possible cover for *ESPN The Magazine,* so I felt a little looser when it came to shooting this image for the inside story (though it was ultimately published as the cover).

For this shoot of Woods, I had scouted the golf course, which was beautiful, but hadn't come up with a compelling idea. Then I spotted the practice putting green. It was dotted with little half-scale red flags marking its holes. They looked cute. The green was flanked by sand traps and backed onto the actual golf course, so it looked like a real green. And it was planted with real grass, which would complete the illusion that he was on the links.

Initially, I shot from a high angle on a little stepladder to make the flag look even smaller and see more of the landscape, but then I had the idea to go low. It's a strategy that's now almost an unconscious part of my process: to think of the opposite picture to the picture I'm taking. If I'm shooting high, I go low; if I'm far away, I come close; if I'm aiming east, I'll look west; if I'm using a wide-angle lens, I'll try something longer. I've found this to be an incredibly useful approach, one that leads to discoveries I wouldn't have otherwise made and helps me avoid forehead-smacking insights that occur too late as I'm on the plane headed home.

So I lay on the grass, elbows on the ground, camera held aloft. From this angle, Woods looked imposing, towering over the landscape. The flag appeared to regain its normal height, making him look even more monumental. He didn't need a club or a ball; we know where he is and what he does. But when he looked

down at the camera, his eyes appeared closed, so I had him gaze off heroically into the distance.

My clearest memory of this whole event happened while Woods was being interviewed by Stuart Scott, the writer for the piece, and I was setting up the shot. Woods took a handful of balls and dropped them at various distances from the hole on the gently undulating green, distributing them like numbers on a crooked clock face. Then, without interrupting his conversation with Scott, he casually walked around the circle with his putter and, one by one, without the slightest hesitation or apparent effort, dropped each and every ball right into the cup.

THOUGHTS ON TECHNIQUE

The horizon is where your eye is. It follows you. If you crouch down, it moves down; as you stand back up, it rises with you. Even if you climb a ladder, it ascends, too. Whether you use a wide-angle lens or a telephoto, no matter if you're close up or far away, the horizon sticks with you like glue. This is what sabotages the outdoor snapshots of many amateurs. They inevitably take their photographs from a standing height, so the horizon follows right along and cuts through their subject's head every time. This is tragic, since the slightest crouch would have been enough to pop the subject's head above the horizon. Ken Whitmire, an eminent portraitist from Washington State, says that it pierces people's heads like a comedian's arrow and that he looks for telltale "arrows" when he critiques the work of other photographers.

In the hands of the watchful photographer, on the other hand, the horizon can be a powerful tool. It can diminish or emphasize the subject. When the horizon is placed low, the apparent stature of the subject increases dramatically; in fact, it can make a subject seem downright heroic, as here. In this portrait, I was calf height to render Woods larger-than-life. I was very close to him and used a wide-angle lens to exaggerate his towering presence.

The catch when you use a wide-angle lens to look at your subject from a high or low angle is that the sense of perspective is heightened, making foreground objects appear much larger than those in the distance. Parallel lines converge, creating an illusion known as "keystoning" commonly seen in photos in which tall buildings appear to grow smaller at the top (which would, I suppose, be more accurately termed *inverted* keystoning). While this can be employed to dramatic effect, architectural photographers more concerned with accuracy generally endeavor to avoid it (along with fish-eye lenses), preferring to keep their parallel lines parallel and their straight lines straight. To do so, they refrain from tilting their cameras up, employing special cameras and lenses that allow the *image* to be shifted

up instead while their camera remains perpendicular to the ground (and, therefore, parallel to the building). In these devices, the camera or lens incorporates a sliding mechanism that allows the lens to be shifted up and down or side to side without angling the entire camera.

And while I'm not an architectural photographer, I'm often shooting environmental portraits in which I want to see the room or building in the background, and I want to see it straight. So I don't tilt, I *shift.* Although I frequently use wide-angle lenses to create my images, I don't want to tip my hand to the viewer. I just want them to get a feeling for the space I've elected to include. I don't want my pictures to look "lens-y." Similarly, while I may want my subjects to look larger than life, I don't want to noticeably distort them in the process, so I often use the same tools as an architectural photographer to preserve their proportions.

An alternate viewpoint using a long lens.

31

DALE EARNHARDT JR.

We stood there looking at each other on the banked track in the fading light. No car. I was supposed to return with a picture of him with his iconic red racer. He had been making cell phone calls to determine its whereabouts; apparently the driver of the transport truck had gotten lost and couldn't find the racetrack. (These sorts of little wrinkles happen all the time in the world of editorial photography.) Earnhardt had only been there for a short while, so he wasn't impatient; if anything, he was being most apologetic about the disappearance of his car. It was a dreary day; the gloomy overcast sky had been threatening rain all afternoon. While the nice folks at the raceway had agreed to turn on the track lights for us, I was feeling the need to make *some* kind of picture soon if I wanted any remaining hint of sky in the frame.

I set up a couple of lights and photographed him walking toward me on the track, then just standing there. They just looked like nicely lit pictures of a guy walking on the track and then standing there. The car still hadn't arrived. Part of what I was doing was figuring out my picture by making pictures. I was also just killing time. I set my camera down on the ground while I marshaled my thoughts and paced around a bit. When I bent down to retrieve my camera, I reflexively had a look through. (It was a camera that you look down into rather than viewing at eye level.) What I saw were his two legs about three feet from the camera, angled impossibly out of the frame!

Since the camera was resting on the surface of a steeply banked racetrack, it's "level" was actually about 30 degrees from normal. Earnhardt was just standing there comfortably, but from the camera's perspective, his body seemed to be tilted at such a crazy angle that it looked like his shoes had to be nailed to the ground to keep him from falling over. I asked him to just stand in a perfect profile; then I backed up a few feet to get his whole figure into the frame. There may have been no race car, but there he was, italicized for speed.

About an hour later, the transporter finally showed up with his car and unloaded it onto the track, and we discovered, appallingly, that it was *out of gas!*

THOUGHTS ON TECHNIQUE

Day-for-night. Rods and cones.

Even though we know that colors don't really disappear when the sun goes down, we experience it as being so. Colors grow softer, quieter, less saturated, dimming to a cool monochrome as night falls. It's a funny trick our eyes play on us, all because of a shift change in the neuron department. Our retinas are jam-packed with two types of light-sensitive receptors. Surprisingly, the

Literally going nowhere fast. A strobe and a jiggly camera bring a dead car to life.

vast majority called "rods," over 120 million of them, don't see color at all. They're incredibly good at discerning subtleties of brightness and shade and can even see in the dimmest light. The ones that see color are the "cones," of which there are a paltry 6 million by comparison, but they require quite a bit of light to do their job. So as the sun goes down, as the cones hand off seeing responsibilities to the rods, our vision shifts from glorious color to measly monochrome, which we often perceive as somewhat cool in hue.

Day-for-night (or in this case, day-for-dusk) is an incredibly useful technique whereby the quality of light that exists from dusk through to dawn can be simulated or enhanced with a combination of underexposure, which magically transforms sunlight into moonlight, and bluish color rendition, which tends to drain the juiciness from those sunny reds, yellows, and oranges. Overcast days can be a blessing, as there's a more muted palette to begin with and no harsh shadows to complicate matters. Add a dash of blue, dim the exposure a bit, and you have instant dusk all day long.

What helps intensify the illusion of dusk is the sense of believable lighting on the subject. Rimming the racetrack are powerful floodlights on high poles. It only makes sense that they would illuminate Earnhardt. They're literally bare, harsh lights casting crisp, hard shadows, so it follows that my lights should have the same appearance. And they do, because even though they're strobes, I've left them as bare, harsh lights. (There are no umbrellas or softboxes at a racetrack!) And they're mounted on tall light stands to mimic not just the character but also the direction of the floodlights. So we buy the overall look.

The final step is that I made the lights extra warm in color by adding orange filters (full CTO) to them. That allowed me to make my white balance extra cool (the "lightbulb" or tungsten setting, approximately 3200°K) without turning Earnhardt into a blue-faced zombie. So I warmed up the lights and then cooled off the white balance to simulate handing off the image from the cones to the rods to achieve day-for-night.

PAGES 136–137 Dale Earnhardt Jr.

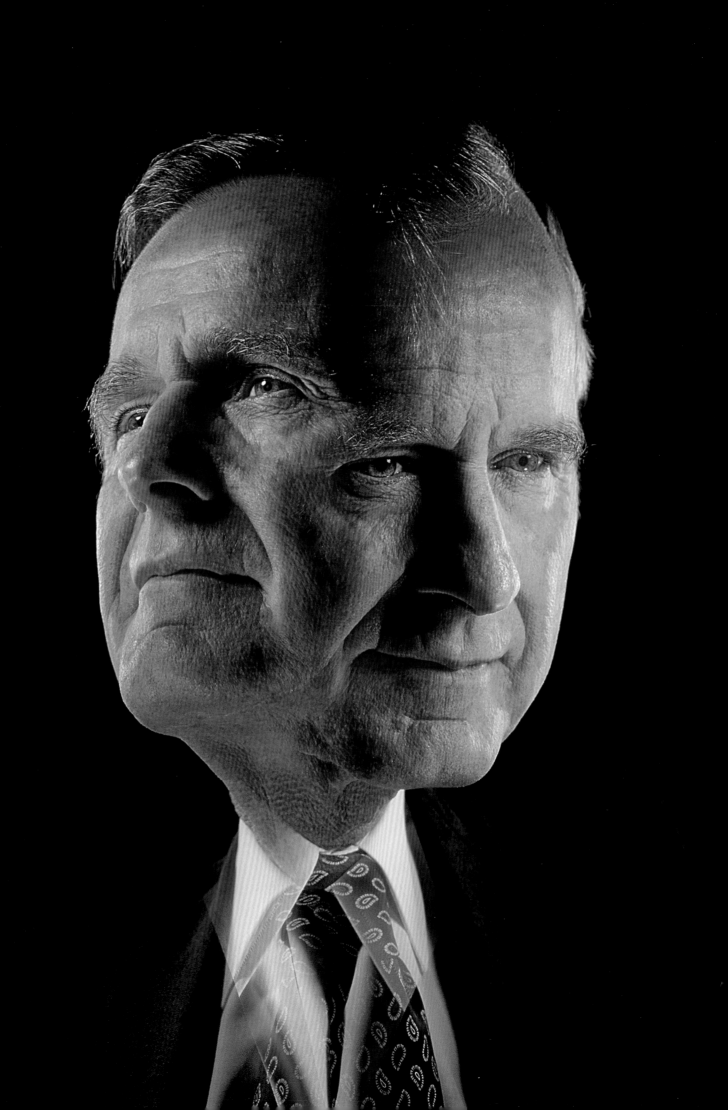

GEORGE H. W. BUSH

What does the photographer owe the sitter? Flattery? Honesty? Empathy? Or nothing at all? There is an unspoken contract, a bond of trust. It's an uneven exchange, to be sure. While both participants can affect the outcome, only one controls it. The subject is utterly vulnerable; for those brief moments, even the President of the United Stated cedes power to his portraitist.

It's a responsibility I take very seriously. The line I've drawn severely limits the kinds of portraits I can make, but it's one I can live with. It's a corollary of the Golden Rule: Photograph others as you would have them photograph you. Or: Don't take a picture of someone else that you wouldn't want taken of yourself. I feel I owe my sitter that integrity, nothing more or less.

Flattery's uninteresting, but sometimes it's part of the job. Honesty sounds good, but it can look awfully cruel. Empathy works, except when none is called for. But "I will not take a picture of you that I wouldn't want taken of me" seems fair. I might not love the picture, but I would respect its intentions and endeavor to understand it. That's part of what the sitter owes the photographer.

So what else does the sitter owe the photographer? The willingness to show up; be present and available, trusting and compliant. I have no patience for difficult subjects. I assume that we've both agreed to be there for the same purpose and we're both going to give it our best shot. After all, I don't expect my dentist to cajole me. I'll do my best to be cooperative as long as he does his best not to hurt me. That's our pact.

One crisp spring morning, about three months after I made the picture shown here for *Time* magazine, that pact was on my mind as I stood with my crew and a reporter outside the north gate of the White House on assignment to photograph the president for the *Los Angeles Times*. The security team was giving us the once-over: ID check; pockets emptied; belt, wristwatch, and shoes off; X-rayed; full body scan; then all cases opened on the pavement for another sniffing by the dogs. As I prepared for what promised to be a two-hour procedure, the cadet in the outer security booth motioned me over. "Your clearance has been declined, sir." I was incredulous. I had been there several times before, plus all of the necessary arrangements had been made in advance.

"Could I trouble you to check just one more time?" I asked.

A few moments passed. "I'm sorry, sir, but I cannot let you through. Your clearance has been pulled." We had no choice but to pack our bags and head home.

Back in New York later that afternoon, I got a call from the reporter. "Fitzwater [Marlin Fitzwater, the

White House Press Secretary] said the president was really steamed about that picture. He says you're out."

I was stunned. I imagined the president would have bigger fish to fry. The image I had created for *Time* was, I felt, elegant and distinguished, certainly anything but a cheap shot. It was a matter of context. I believed that had the cover story been about his never-ending vigilance or his uncanny ability to successfully manage domestic and international affairs, he likely would have appreciated a framed copy. But his perception of the image was tainted, because the "Men of the Year" cover story was a backhanded compliment. The idea had been to communicate his duality as a leader. Had it been an illustration, he'd have had no part in its making. Perhaps he felt that by cheerfully posing for the photographs, he had been a party to his own skewering—that he had been had.

To this day, I have no misgivings about the portrait. Great care was taken in its creation. *Both* of his faces are beautifully lit and handsomely rendered. It's a respectful image in which he looks patently heroic, yet it is unsettling. Context defined the picture, as it was meant to, and criticism comes with the territory when you're the president. While he didn't approve of the context, I'd like to think he might have privately nodded his head at a painstakingly conceived and crafted image.

THOUGHTS ON TECHNIQUE

I occupied a studio in Soho, in lower Manhattan, for more than twenty years. While I used it for hundreds of assignments, I doubt if I actually photographed more than a dozen jobs in it during that entire time. It was a playpen, a laboratory for experimentation. It did not contain a darkroom; that was located in my home a block

away. It had files for paperwork, fireproof cabinets for pictures, light boxes for evaluating and editing film, a sturdy safe, and, of course, computers. Most significant, it housed all of my lighting and camera equipment.

These were my tools and my toys. My assistants and I spent countless, truly countless, hours trying out various cameras, myriad lenses, and every variety of lighting gear imaginable. We'd experiment with colored gels and run film tests. The most important thing we did, though, was to exhaustively work through ideas for upcoming shoots, refining the lighting as much as possible before taking our show on the road. The assistants would draw detailed diagrams with precise measurements so we'd be able to replicate our setups on location. In some cases, these preparations served merely as a jumping-off point for the actual shoot, like a safety net for our high-wire act. On other occasions, constricted by time and circumstance, our tests became a tight template from which we dared not stray.

This portrait of former president George H. W. Bush is perhaps the most extreme example of this latter category. It was created "old school," made just prior to the advent of Photoshop. The president was photographed twice on the same sheet of film using two different, side-by-side camera and lighting setups. There was no time to improvise and no room for error.

We spent several days in my New York studio working out the lighting, which had to be tailored precisely for the two exposures to dovetail properly. It had to be just so, falling into shadow at just the right point on both pictures in a mirror-image fashion, allowing the two heads to merge seamlessly, avoiding the problem of an ear from one image showing up next to a nose from the other. I worked with modern 4x5 view cameras that still used sheet film yet had the ability to be finely and

FILM @ 22

*FINAL f/32 5M + *3RD.*

Assistant Paul Meyer sits in for the president in this Polaroid double-exposure test.

accurately articulated in a way that could be repeated. I carefully drew the outline and shading of the first face onto an acetate overlay on the ground glass viewing screen of the first camera to be transferred to the second camera, at which point I sketched the second face juxtaposed on the same acetate. This would be the guide for aligning the two images of the president as he posed for his portrait(s).

When we finally achieved the desired effect, we made exact measurements to document the positions of both cameras and the respective lighting setups. I took the extra precaution of renting a studio in Washington to ensure that we'd be able to re-create what we had done in New York. I also contacted the White House to ascertain the size of the room in which we'd be photographing and to request that the room be emptied of all furniture. Then, prior to resetting our gear, I decided to put down a seamless paper floor in our D.C. studio in the exact footprint of our White House "studio" to be certain that our setups would fit within the allotted space.

The D.C. practice setup went smoothly, thanks to the careful lighting diagrams and measurements we had made in New York. We shot a few sheets of film to double-check the alignment of the two exposures. But before we packed up our gear, we took the time to actually draw the footprint around every single piece of equipment right onto our paper floor. Again, measure twice, cut once. Then we rolled the paper up and brought it with us to the shoot.

Early the next morning, we killed an hour going through the X-ray checkpoint. Then we stood in the semicircular drive off the Pennsylvania Avenue entrance to the White House, our equipment cases lying open on the ground, waiting for the bomb-sniffing dogs. For another hour. So much for our two hours of setup time. Finally we were hustled into the now-empty Map Room, our studio for the day, and were told that our appointment had been pushed back by fifteen minutes to give us time to set up. Fifteen minutes!

Fortunately, we had our trusty template. We rolled out our paper floor, plunked down each piece of equipment in its precisely indicated spot, and positioned the two cameras. Just as we finished, the president strode in, sat down, and readied himself for the first portrait. I lined him up with my acetate outline and exposed exactly twelve sheets of film. He reseated himself in the second setup, I moved the ground glass to the second camera, aligned his face with my acetate sketch, and reexposed the *same* twelve sheets of film.

Not wanting to risk transporting the undeveloped pictures back to New York, I kept a local lab open after hours to process the film. Late that night, after processing one single-exposed sheet as a test, we got our first look at a double-exposed 4x5 transparency. One president, two faces.

33

HILLARY RODHAM CLINTON

Warm and cool. I was invited into the First Family's residence at the White House to make a portrait of First Lady Hillary Rodham Clinton for a *Time* magazine profile. She appeared wearing a lovely teal dress that seemed to complement her as well as the warm tones of the décor. My job was already halfway done; the palette was handed to me on a platter.

I had photographed her once before prior to the election, for a *Time* cover, at home in Little Rock. (She had baked us all delicious oatmeal cookies for the occasion, cheekily countering her "I'm not a mom who stays home baking cookies" quote.) She had struck me as authentic and engaging, asking questions and listening attentively to the answers. This time she won me over immediately. Walking into the room, hands outstretched, she greeted me with, "It's so nice to see you again, Greg. How are your daughters?" I was smitten.

As is the case for these kinds of sittings, I had prepared several setups prior to her arrival. The key was to be able to quickly slip her into the settings on the spot and see which suited her best. First up was the "grand picture," a full-figure portrait looking down the length of the great central hallway of the residence. She knew she looked good, and it showed. Much as I liked the im-

age, though, I felt she was a bit diminished by the scale of the space, like a doll in a full-sized house. Next, I tried a seated portrait of her on a long, gold sofa against one of the enormous arched windows at the end of the hallway. The sofa seemed to swallow her up when she relaxed, and when she perched on its edge, the softness disappeared. I made a few exposures and moved on.

Next to the sofa was a corner. Not a corner where anyone would linger, just a small corner in an impossibly large space. Isolated from its context, though, it felt like an intimate piece of an elegant room. There was a side chair occupying the sweet spot, but since the initial standing portrait had been successful, I opted to remove the chair. As she moved into place, she was bathed in the loveliest wash of color: the warm light of the room cast an amber tone on her skin that beautifully offset the soft, cool illumination from the large window. She fairly glowed.

But what to do with her hands? In the first standing image, they had been down at her sides as she slightly swayed and made a soft swirl in her dress. For the second, seated portrait, they had been either nested in her lap or resting on the sofa; neither looked natural. Now she stood with her arms folded. It seemed comfortable

Walking into the room, hands outstretched, she greeted me with, "It's so nice to see you again, Greg. How are your daughters?" I was smitten.

but looked a little severe. I asked her to gaze out the window. As we chatted a bit about our daughters, she absentmindedly twiddled her pearl necklace, and then softened into the slightest smile.

THOUGHTS ON TECHNIQUE

What's "correct" color? Or "accurate" color? Color perception is a highly subjective affair. If one is copying paintings or fabric swatches, then absolutely accurate color is a prerequisite. Neutral, consistent skin tones are essential for mass-produced portraits and makeup campaigns. Otherwise, dead-neutral color is just that. Dead. I've had countless images run through the "de-flavorizing" machine at publications whose production departments are dead set on dead neutral. It's terribly disheartening to have one's hard work and carefully considered chromatic choices nullified for the sake of neutrality. Ambient color doesn't exist in a vacuum in the outside world. It's messy, contaminated. It's a gorgeous, seductive cacophony. Its infinite variety is something we're not consciously aware of and often don't even see. But it absolutely enriches the way we visually experience our world. Not just how it *looks* but how it *feels*.

A touchstone image for me is one that I made many years ago on assignment in Singapore. I was walking the streets in the rapidly disappearing old section of the city when I happened upon a goldsmith seated in his tiny open-air stall. I was confronted by a "color moment." There he sat, silently working away under the yellow light of his work lamp. The rest of the room was illuminated by the weak greenish wash of a bare fluorescent bulb on the ceiling. Adding to the mix was pale blue skylight filtering into the open stall. It was a classic interplay of warm and cool hues. There wasn't a "neutral" or "correct" color to be found anywhere. It was absolutely beautiful.

I've often reflected on that palette when considering my lighting options for a photograph. Variations of warm and cool tones are probably the most commonly encountered color combinations in our contemporary world. Interior lighting is almost invariably warm. Whether it radiates from track lighting, table lamps, a fireplace, or candles on a birthday cake, warm-hued light is synonymous with indoors and triggers an instantaneous emotional response. Deep cool is the color of dusk, or of your television or computer screen at night. Slightly cool is the shade of a tree or the color of indirect skylight as it filters in through a window. Combinations of these colors occur everywhere. Picture the last orange rays of the sun breaking through slate-gray storm clouds at the end of a late-afternoon squall. Imag-

In an alternate portrait, the former First Lady sparkles in the main hall of the East Wing residence.

ine a face illuminated by match light at a bus stop from an early evening smoke.

I welcome this variety and use it as the underpinning for my color choices when appropriate. It's something I observed when working on movie sets. You hardly ever see a naked light or lens. There's almost always *something* between the light and the subject influencing the color of the scene. White light always looks to me like the fingerprint a photographer left on the crime scene of a less than fully realized image. It often happens, regrettably, that photographers who are absolute poets with natural light hamstring themselves when working with artificial light. They put their images through the deflavorizing machine between their ears.

This image of Hillary Rodham Clinton is chromatically satisfying. It's not correct, yet it feels organically right. To neutralize it would rob it of the complexity that gives it authenticity. Nature, Ektachrome, and a little light of my own conspired to create a color moment that wouldn't have existed any other way.

34

YASSER ARAFAT

You can read anything you want into this picture. When it ran on the cover of *Time* in 2002, the headline read "All Boxed In." Arafat looks trapped, cornered, maybe a little scared. The cover line certainly reinforces that interpretation. Without it, though, he might be looking imploringly at the viewer, or it could seem that he's barely containing himself, ready to explode. Are his hands clasped defensively or hiding a fist? He's definitely not indifferent to the camera, engaged by its big glassy eye staring him down.

My assistants and I had been waiting in Gaza City for days with no word on when we might be granted permission to make a portrait of Yasser Arafat. We had just arrived back at our hotel after photographing Ehud Barak, a portrait that had been precisely scheduled before we had ever left New York. That session had gone off like clockwork. The security checks were the tightest I had ever encountered (including at the White House), with hours spent combing our hired van with dogs and detectors of all sorts. Every battery had been removed from every single piece of equipment and X-rayed; the equipment itself, having already been X-rayed once, was then X-rayed again empty. Our moments with Barak were few, timed to the minute, tightly guarded and supervised in a secret location overlooking Jerusalem. He was professionally cordial.

The trip back to Gaza was a little tense. Since our vehicles were not allowed through the Erez Crossing from Israel, we had had to unload our many cases of equipment and hand-carry them across the barren zone, with automatic weapons trained on us from both sides. The crossing each way took hours, with many checkpoints and stone-faced Israel Defense Forces personnel every step of the way scrutinizing us, our cases, and our documents. We were exhausted when we finally returned to our rooms after midnight, only to have the phone ring; Arafat was ready and waiting. We scrambled back down and reloaded our cases of gear into the waiting convoy.

Apparently Arafat took meetings and did most of his work in the middle of the night. When we arrived a short while later at PLO headquarters, we were pinned by floodlights next to a long, low building as we reflexively proceeded to open all our cases on the ground for inspection. As grumbling gun-toting guards warily watched us, a soldier scurried down a flight of stairs and spoke hurriedly to one of them. "No, no!" he ordered us. "Go now!" The security inspections hadn't yet even begun, but I looked at my assistants and we promptly refastened all the cases and followed him up the stairs. As we reached an anteroom, Diane Sawyer passed us, having just completed an interview. We were told to

set up in a small sitting room decorated with large scenic photographs on one wall. There were flags, several chairs in a semicircle, and fluorescent lights overhead. This would be our studio.

As we quickly broke out our gear, the first item to be assembled was our black velvet backdrop, which provoked an immediate reaction from our handlers, who clearly found it disconcerting. Gesturing toward the flags and framed photos, they insisted that the room itself was to be the setting for our portrait. The black background, I gently explained, served no purpose other than to eliminate distractions and focus all the attention on the chairman himself. After some confusing back-and-forth, we were allowed to photograph Arafat, after which he invited the entire crew to share an improbable 4:00 a.m. lunch!

THOUGHTS ON TECHNIQUE

There are many reasons to choose a particular camera. It might allow you to react quickly to changing events. Perhaps it works with specialized lenses: autofocus telephotos for sports photography, macros for close-ups, or ultrafast lenses for low-light work and beautiful bokeh. It might be able to fire off rapid bursts of sequential shots. Perhaps it has a big ground glass back on which you can carefully consider your compositions. Or it may take large-format negatives that record incredible detail and tonality.

A primary consideration for me is how the camera will allow me to interact with my subject. While a handheld 35mm or DSLR camera will provide great freedom of movement, it's not so great in facilitating rapport. My subject can't connect with me when I've got a camera mashed up to my face, one eye squinting and

the other obscured altogether. Medium-format cameras with right-angle or 45-degree viewfinders aren't much better, as my poor subject is treated to a view of the top of my head as I look down, apparently mumbling into my shoes.

Perhaps counterintuitively, the large-format view camera can sometimes be the ideal choice for portraiture. First, it looks really impressive. Often made of mahogany and brass with a fabric bellows, it has an anachronistic appeal in this digitally dominated era. It sits on a heavy, old tripod. And there's the big, black cloth under which I mysteriously disappear to make unseen adjustments and determinations. But once that's done, I emerge and am confronted with my subject. We face each other with nothing between us. The camera sits to one side. It's silent; there's no motor or loud shutter slap. There is no button to press; a long, slender cable release rests between thumb and forefinger to trip the lens. I can choose to make the camera disappear by chatting up a storm, or I can make it very much the subject of the moment by providing no distraction. Plus, it's a special occasion. Powerful people get photographed all the time, but mostly by journalists wielding DSLR cameras. (In fact, they usually own DSLRs themselves and give them to their children as graduation presents.) They realize the large-format camera is something unique, and they typically rise to the moment. The camera marshals their attention and they focus. They *think* I'm more professional, and that I'm showing them a great deal of respect by going to all the bother and taking such great care.

I've been extremely fortunate to have my large-format portrait made by two masters of the medium, Arnold Newman and Richard Avedon. Once they got their cameras set, after considerable fiddling, they

turned their focus to me. In both cases, I was riveted by the intense attention of these two artists. I can't say the cameras disappeared, but my engagement was clearly with my caretakers, not their machines. But the machines *did* have an effect. I lifted my game. I shut up and sat straight. I paid attention. I listened.

I think President Arafat looks a little frightened in this portrait, like a child who has been scolded, sitting in a corner with his hands nervously folded. When he entered the room, he greeted everyone warmly and then grew serious when he spotted the camera. He sat in the designated chair and composed himself for his portrait. The formality of the moment (I always wear a suit and tie for such occasions) became clear as the room fell silent. He seemed somewhat intimidated by the machine, and I did nothing to dispel the mood. Without breaking his gaze into the lens, he softened a bit and quietly offered, "I've not seen a camera like this since I was a little boy."

Israeli prime minister Ehud Barak glowers at the lens in this companion portrait to Arafat's, photographed just hours earlier in Jerusalem.

JOHN GLENN

I never thought I'd see his seventy-seven-year-old head popping out of a space suit. But there was then senator John Glenn, an astronaut again, as confident and rock-steady as in those photographs from 1962, when he had beamed with pride before his first space flight aboard the Mercury *Friendship 7* spacecraft. But this isn't the *Right Stuff* portrait. It's not the heroic picture that ran on the cover of *Time*. Here he looks like he's just going about his business, another day at the office, adjusting his space suit the way an executive might straighten his tie before heading into an important meeting. His downward glance tells us he is concentrating, feeling for something he knows is there. He doesn't appear to be conscious of the camera. It's a candid moment within a completely contrived situation, one of my favorite kinds of pictures.

But the funny thing is, this was a scrap. A throw-away. A little snippet excised from the front of a roll of film, literally the first frame. When I was shooting film, I would often just knock out the first exposure as a test frame so that the processing lab would have something to develop without risking the real meat of the shoot. This was just such a frame, popped off while Glenn was distractedly fiddling with the helmet-attaching collar of his space suit as we were getting ready to take the real pictures. It wasn't until after I had processed and edited

all of the film, all of the heroic frames, that I spotted this one. It had been damaged by the metal clips holding the film during development and sported several puncture wounds near its edges. It wasn't a heroic image, to be sure, no catchlights in the eyes, but it just looked *cool*. He wasn't posing. His mind was elsewhere. It was an in-between image.

This is one of the many reasons I have always edited my own film. It's scraps like this that another person, an assistant, even an editor might discard. Plus, it wasn't even what we were after. It was an off moment. I learn the most about my images while editing them. After all, I spend far more time editing them than I ever do shooting them. For me, it's a slow process but very rewarding. I'm totally alone with my pictures. It's usually dark, as I'm either hovering above a light box or studying a computer screen. (It's usually silent, as well; I can only engage one sense at a time.) I evaluate them apart from the stresses, pressures, and distractions of the original shoot. When possible, I make an initial edit, step away for a period, and then take a fresh look at the material a while later. It can be hard for photographers to separate the experience of the shoot from the result, but I try not to succumb to that trap. And it's not that there aren't incredibly skilled editors out there or that a new, impartial pair of eyes might not find the best

images. It's just that they'll never make *my* decisions. They'll never make the same unexpected left turn. And I relish that part of the creative process.

Often, the first look is completely discouraging. The picture almost always looks like a failure. The color's not right. The exposure is off. Or, more often than not, the subject's just not with it. The first edit of the whole shoot is usually equally disheartening, because I'm seeing *all* the off moments and mistakes. (It's at this time that I silently vow never to take another photograph.) By the second round, things are looking up; the processing has been tweaked, the total rejects have been removed (but not discarded, not yet), and the shoot looks like it may be salvageable. At the end of the third go-through, things look pretty good, and it's just a matter of cherry-picking the best from the lot. And by the time that's completed and I have my "selects," my optimism has been restored and I can live on to photograph another day.

THOUGHTS ON TECHNIQUE

This is, in a sense, an incomplete picture. An alternate frame with a heroic look was published, composited with a starry background, on the cover of *Time*. But I've always preferred it like this, with simple, strong color and just a seamless paper background, because, well, I think it's already pretty clear that former senator John Glenn is an astronaut.

Setting up an effective color palette was crucial to the success of this portrait. When working with the image on the computer, I actually liked the solid background but wasn't happy with its flat, gray look, though I didn't feel the need to replace it with a field of stars, either. It seemed preferable to just alter its hue and retain the strange shadow around him. Finding the right color was the question, and its complement was the key; greener would have been too organic, and bluer would have turned it into a sky. The color I chose seemed oddly in keeping with the sterility of the image.

I initially photographed Glenn against the gray background so that it would be simpler to "silhouette" him (separate him from the background) later and plop him into a starry sky for the cover. He is lit the way he is for the same reason: the nice crisp edge would help the computer "see" where he stopped and the background started, making short work of the compositing process. The eye of the computer looks for contrast in adjacencies and tries to find the edges, either by contrasts in tone or in color.

More important, though, the edge lighting feels very white and *clean*. The fill light I'm using heightens the effect. It shows clinical detail in every shadow and produces the halo around him. It's as if he's in a sterile, high-tech environment, preparing for his final voyage into outer space.

Photo by David Hume Kennerly

A Flooter, two Hensels, an inky, and a ring: the five odd light sources that conspired to create the portrait of the senator-astronaut. I'm pointing the way to the space shuttle.

36

MICHAEL R. BLOOMBERG

The Hundred-Year Portrait. This image of New York City mayor Michael R. Bloomberg is a particular kind of portrait. It was created for permanent display in the Johns Hopkins Bloomberg School of Public Health, which had been newly renamed in recognition of a transformative gift by Mayor Bloomberg to his alma mater. (These are the folks who eradicated smallpox from the planet; their motto is "Saving lives—millions at a time.") Larger than life, the portrait has a unique mission: it must stand the test of time, of generations. It is the opposite of an editorial portrait, which is, by its very nature, of the moment. An editorial portrait portrays a person in a specific context (the story), for a specific client (the magazine), at a specific moment in time (which is what makes him or her newsworthy in the first place). This portrait also differs from a photograph taken for an advertisement, which must have an immediate impact that stops a viewer in his or her tracks. And it is certainly not the smiling likeness of a loved one that a family would display in its home. No, this is the type of timeless commission typically awarded to artists who work in oils. Yet . . . I work in film, as my client well knew, having seen an earlier portrait I'd made of former New York City mayor Ed Koch, which hangs in City Hall. As such, I wanted this portrait to evoke a painterly sensibility but without

apologizing for itself or wishing it were "real" art—or thumbing its nose at the long and rich history of portrait painting, either.

The first step was to have my subject adopt a classic pose, with one hand resting on a symbolic object. On an earlier scouting trip to the Bloomberg corporate headquarters (I had initially thought to make an environmental portrait of him there), I'd noticed a particular stainless-steel hand railing in the lobby. I had an adjustable version of it specially fabricated to suit my subject. It facilitated the pose, anchored him in space, and alluded to things modern, clinical, and cool. Combined with flattering light, the result is a polished portrait, perhaps too idealized. But I love the smooth perfection of the skin, suit, and steel. And his eyes: they glisten, eerily alive in an otherwise very still portrait. He's watching us as much as we're looking at him.

The miracle of digital printmaking enabled a second important step, allowing me to create a color print that was also a truly lovely *object*. For decades, color prints had been limited by the commercially available materials: glossy or luster surfaces not much different from those delivered by the photofinishing service at the corner drugstore. Now, however, no longer based in dyes and destructive chemicals, photographic prints could be pure pigment-on-paper,

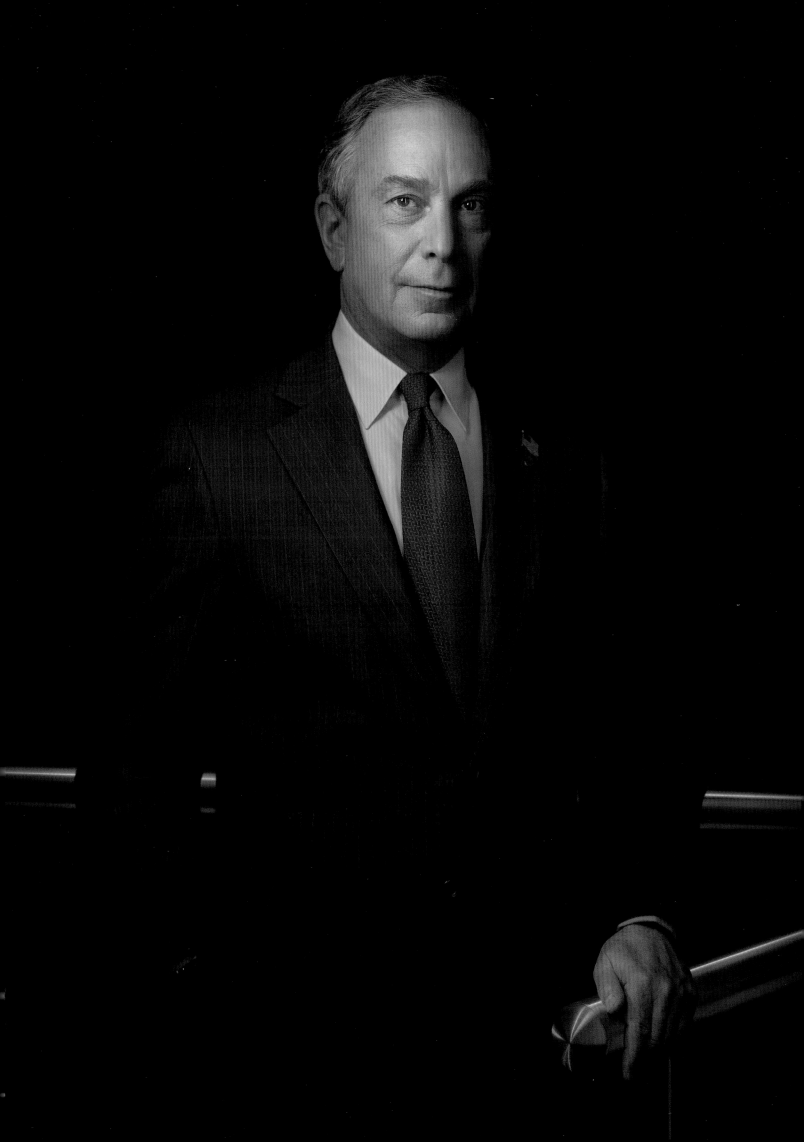

offering an incredibly wide color and contrast range as well as archival stability, particularly when printed on fine acid-free watercolor and etching papers formulated for the new process. (The print that hangs at Johns Hopkins was printed on a luscious velvety matte paper.) One could present the photographic *fact* of a person in a medium that transcended traditional photography in the way that ink-on-paper photogravures did a century ago for black-and-white images. The hard reality of a color photographic portrait could now be heightened or softened, made more interpretive and more expressive.

Ultimately, though, this image does more than merely reference the classic portrait; as a photograph, it raises the ante just a little bit. Unlike a painted portrait, the hallmark characteristic of a *photographic* portrait is its authenticity. It's not just a likeness of a person; it *is* the person. Think back to the iconic Mathew Brady portraits of Abraham Lincoln. While there are countless paintings, drawings, and engravings of the president, it's Brady's images that we all remember, because they aren't interpretations of Lincoln, they *are* Lincoln. It's his actual face in the frame. And it's this veracity that I find so compelling, so endlessly fascinating.

THOUGHTS ON TECHNIQUE

In photography, size matters (just ask Andreas Gursky, who changed the conversation with his heroically scaled, information-rich images). The ability to maintain detail in large prints can be critical. People look at photographs differently from paintings. It seems the first thing they do when they encounter a painting is to step *back* from it to get a better sense of the piece as a whole. With a photograph, viewers do the opposite. They inevitably press their noses right up to it to drink in the detail. There is a uniquely photographic fascination with the opportunity for close scrutiny of a subject or scene. Images made with a small film or digital camera can sometimes disappoint in this regard. But an image from a large format film camera never lets them down. As close as they can get, there's always more to see.

This was very much on my mind when I received the Bloomberg commission, which came at an auspicious moment during the crossover from traditional film photography to digital capture. I tried to shoot it digitally. I really did. The image was razor sharp. In fact, I actually divided the picture in half to obtain twice the resolution. I'd shoot one frame of my subject's lower half, then a dozen or more of his upper half with different facial expressions. Then another of his torso, if he shifted his weight, followed by several more of his face. While his expression would change on every frame, the rest of his body might only shift every now and again.

But it just didn't work. Maybe it was because I was too focused on my clever two-shot process. The mayor just wasn't present, and I didn't have a good feeling about what I had captured. Thankfully, I decided to shoot some full-figure frames at the end of the day with my 8x10 camera. The resulting film images had a more organic quality. The camera had perhaps captured his attention or piqued his curiosity. He seemed more engaged.

Interestingly, the 8x10 negatives proved to be less critically crisp than the digital files. Yet they were somehow more enlargeable. Unlike the digital files,

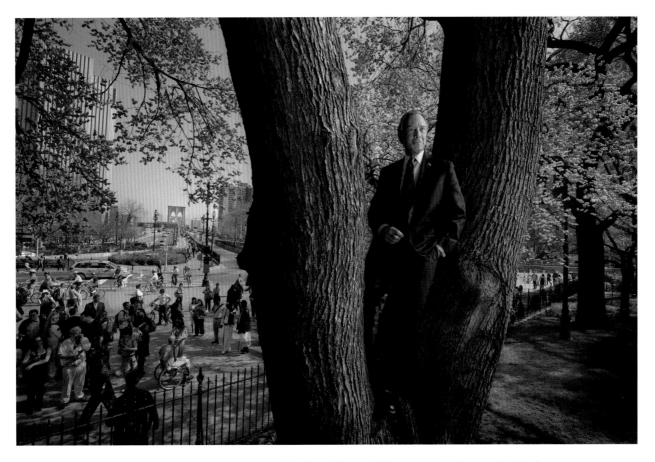

By contrast, this portrait of the mayor casually perched twenty-five feet in the air is all about context. I photographed him for a "100 Greatest Thinkers" article in *Time* magazine focusing on his Million Trees NYC Initiative.

there seemed to be no limit to how big the film could go. Eventually, the digital image would break down and pixelate, while the random grain pattern of the film seemed to soak up the magnification. I was surprised and thrilled. More important, Mayor Bloomberg's skin looked *alive* on film, with blood pulsing beneath its surface. In comparison, the digital images looked flat and pasty. His color on film was more complex, more *human*. All these subtleties emerged when the portraits were printed full size (about 40x60 inches). The first 11x14 proofs betrayed nothing. But when we pulled an 11x14 print to size of just his face, the differences were

readily apparent. The digital file just got bigger, while the film image *grew*. It became richer, more nuanced.

Having the ability to thoroughly explore this process was a real luxury. It was like getting a grant to make the Perfect Portrait, though every penny went into crafting the image and the print. I spent many long days and nights over many weeks testing, processing, and printing. (Considering all the time that went into it, I probably earned more per hour on my newspaper route as a young teenager!) But it was just so satisfying to finally, really get it *right*.

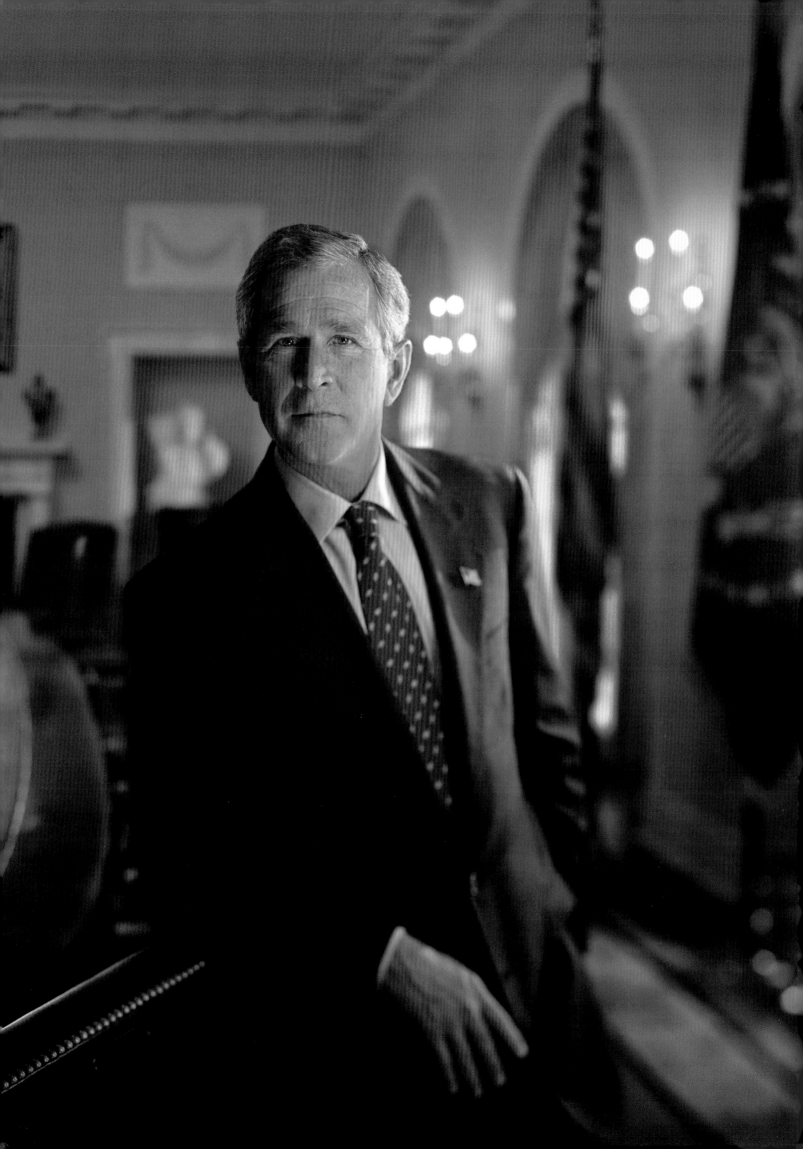

GEORGE W. BUSH

Where to even begin? Any assignment at the White House is an adventure. Even if you don't agree with the president, even if you didn't vote for him, he's still The Man: the most powerful person on the planet. To be granted a private sitting with him in his natural habitat is to be given the ultimate backstage pass. You get to see him in person. No chitchat about international events or domestic affairs, but you do get to experience the kind of gut-level response only a personal encounter can evoke. I can report that he was genuinely affable, with a quick sense of humor and real warmth.

This particular portrait was made for *USA Weekend* because former president George W. Bush was contributing a candid and heartfelt essay on the first anniversary of the 9/11 terrorist attacks. While the editors wanted quite a formal portrait, I felt that it should also have a sincerity that would echo the tone of his words. Fortunately, we would be working in the golden-hued Cabinet Room, which would help provide the palette I desired. I wanted the light to feel warm and natural, not artificial and staged. And I wanted the image to have a shallow focus, or depth of field, to place subtle emphasis on the president by separating him from his surroundings in a natural, unforced way.

Most important, though, would be the president's posture in the photograph, his pose, expression, and attitude. How does one elicit such a response from a subject? This is probably the question I'm asked most commonly. There is no one answer. It all depends on the shooter, the subject, and the situation. Richard Avedon once accurately observed, with regard to his compelling portrait of the Duke and Duchess of Windsor, that one can't evoke a response that doesn't come from a subject's own life experience. (To penetrate their practiced poses, Avedon, who knew they dearly loved their pug dogs, famously "confessed" that his taxi had run over and killed a dog on his way to the studio. Their faces fell.)

I find this to be true; if you try to force a pose, no good will come of it. The pose will look forced, your subject will write you off and become cranky, and the picture, even if it looks "good," will suffer. Even so, I sometimes resort to telling my subjects which specific body parts to move where. More often, I observe their natural body language and try to build on that. Most frequently, though, I simply adopt the expression or pose I'm looking for; usually, they'll give it back to me in a process called "mirroring." I cross my arms, they cross their arms; I cock my head, they cock theirs. When they seem to be stiffening up and I want them to relax, I'll

He gave me a perplexed, somewhat frustrated look, . . . and said with total seriousness, "You know, I've got a lot on my mind." With that, he fell into position, as relaxed as can be.

take a deep breath and they invariably take one, too. It just works.

With the president, it wasn't so easy; he's a busy guy. He was standing stiffly in the "man-pose," hands clasped firmly in front of his crotch. Not unusual, but not pretty, either. So I leaned on a chair; he did not. Then I put my hand in my pants pocket. No response. I took a deep breath to get him to relax. Nothing happened. Finally, I just asked if he could place his hand in his pocket and lean on the chair. He gave me a perplexed, somewhat frustrated look, as if I were asking him to rub his stomach and pat his head, and said with total seriousness, "You know, I've got a lot on my mind." With that, he fell into position, as relaxed as can be.

THOUGHTS ON TECHNIQUE

With characteristically prudent business sense, I spent twice as much money as I was paid for this assignment on snazzy new lights to shoot it. But it was worth it; I had a strong hunch they'd be just the ticket.

They were a sexy, compact Italian version of a revolutionary, domestically produced fluorescent light called the Kino Flo, originally developed for the feature film industry. These lights have many important qualities: They are bright enough to allow a decent exposure but not so bright that they wash out the ambient light. Their daylight color balances remarkably well with interior lighting and window light. The fact that they are not too bright means that they are easy for subjects to tolerate. They are also cool to the touch, especially compared with hot, bright quartz lights that are squinty and sizzling for the sitter. They pour out soft yet snappy light that looks great on skin. The long fluorescent bulbs emit a lovely, smooth glow, and the polished reflectors add a little kick. Plus, they are quick and simple to set up. And they look really slick.

Best of all, they are continuous light sources rather than strobes. This offers many advantages, the most significant being that you can visually judge their effect without looking at a test shot (on an LCD screen or, back in the day, a Polaroid). This is a big time saver and can really oil the creative process, since you don't have to stop and start all the time in a frustrating act of pho-

Official White House Photo

Fluorescent lights that simulate window light surround the president in the Cabinet Room.

tographus interruptus. In fact, with continuous light sources, it is possible to quickly judge the contrast in a scene just by squinting your eyes: if the shadows go totally black, there is too great a disparity between the highlights and shadows; if you can still see a little detail, the lighting ratios are probably about right. (Admittedly, this may be a bit quick and dirty, but it can be surprisingly reliable when roughing in the light.)

About twenty years ago, I picked up a small item called a color contrast viewing filter on a movie shoot. It looks like a monocle for use on a beach: a single, circular, dark gray piece of glass on a lanyard. When you quickly glance through it, before your eye has a chance to adjust, the world goes dark, leaving just the brightest areas visible. Cinematographers would use the device to quickly determine which areas of a set needed more fill light. This handy tool is only usable with lighting you can actually see, unlike strobe illumination. On a shoot like this, when you only have a few precious minutes with your subject, it can be a big advantage. With my little "beach monocle" I was able to nimbly finesse the lighting even once the president was in place.

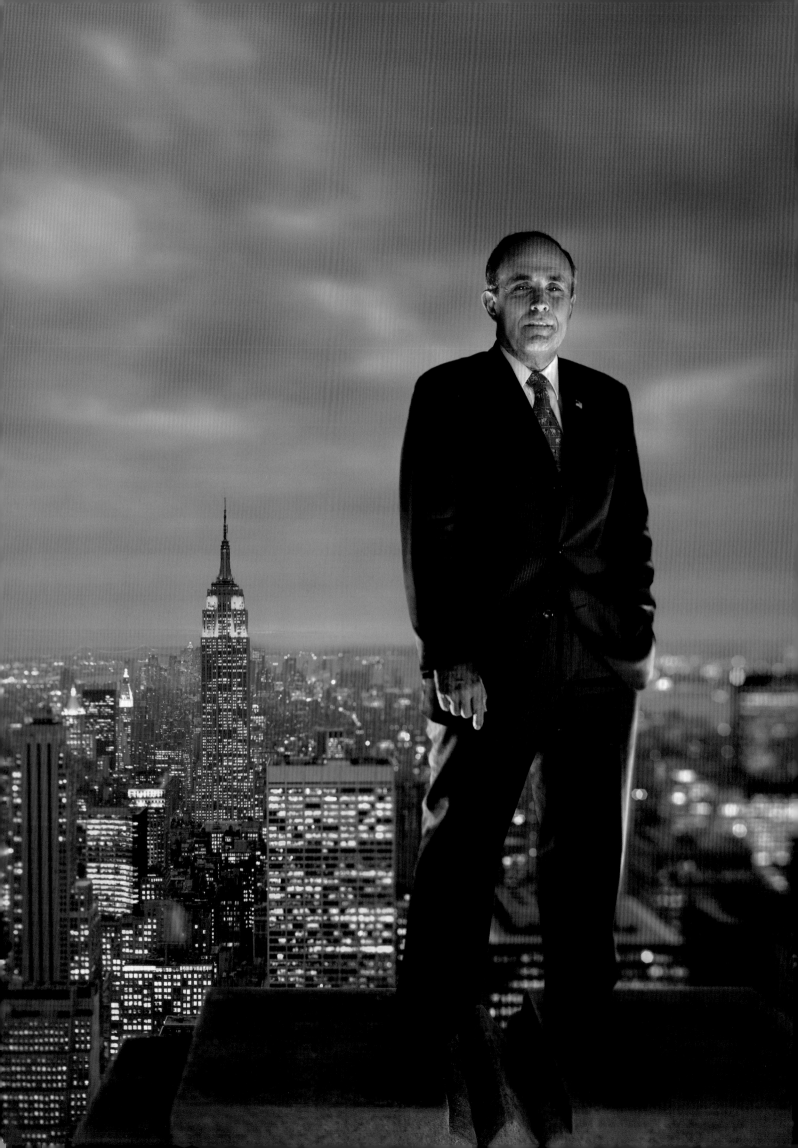

RUDOLPH GIULIANI

I had just received the call to shoot *Time* magazine's "Person of the Year" cover. The 2001 honoree was to be then New York City mayor Rudy Giuliani. He had been the single consistent media presence for the country on 9/11, that terrifying, incomprehensible day when it seemed the president was nowhere to be found. It was his reassuring, steadying conviction that helped Americans come to grips with what had just happened on their own soil, in the heart of their greatest city. This was also something that had happened in *my* world personally. After looking at the Twin Towers through my studio windows every day for two decades, I had watched out those same windows as the towers fell. This was no ordinary assignment, and I felt an especially strong obligation to say it right.

Often, the lead time for newsweekly covers is shockingly short: sometimes only a day or two, sometimes even less. I've received cover assignments on a Friday that had to be shot, processed, and edited the same day. It can be incredibly stressful and incomparably exciting. The "Person of the Year" covers are different. I am usually given the luxury of a week or more, though my time with the actual subject is still rarely more than a few minutes. In this case, there was ample preparation time but a tall order: to somehow juxtapose and anchor Giuliani to his city in a way that evoked his role and the

mood of the country at that singular moment in time. There were technical concerns, logistical challenges, and weather contingencies. There was just a sliver of availability in the mayor's schedule. In many ways, even though this was a cover portrait for a newsmagazine, it was as complex as a commercial advertising campaign. And we only had a week to pull it all together.

I began by scouting potential locations, knowing that I'd need the city as a backdrop. The mayor's office had already nixed Ground Zero, which Giuliani felt was sacred ground and refused to use for his own self-aggrandizement. We checked out the most obvious vantage points next—Liberty State Park in New Jersey, Empire-Fulton Ferry Park—but they failed to deliver. Without the Twin Towers, the lower Manhattan skyline was no longer iconic; it might as well have been downtown Milwaukee. I then considered the waters encircling Manhattan, but it quickly became clear that the mayor's schedule would not accommodate even a brief voyage off the island. Next, I explored opportunities offered by the city's street life. But the more I visualized such an image, the more it seemed too specific and small, better suited for the story within the magazine than its cover.

So I tried to imagine some synthesis of the two approaches: seeing the city as a backdrop but not as a

distant skyline, and locating Giuliani in the city but not actually on the street. An elevated position, like a terrace or rooftop, might allow me to place the mayor in Manhattan without it swallowing him up. It would also offer some privacy, eliminating the need for crowd control and increased security. And, we'd be able to keep our setup intact from one evening to the next, allowing us to test ideas and lighting in advance.

Manhattan has no shortage of rooftops and terraces with incredible views, but what looks great to your eyeballs might not work so well for a photograph. The observation deck of the Empire State building, for example, has an aerial perspective and a panoramic vista, but there's nothing to provide a sense of distance or scale; everything's so tiny and far below that it's like the view from an airplane. One of my favorite views of the city is from the midtown observation deck known as Top of the Rock. Situated high atop the GE building at Rockefeller Center, it is comprised of three floors. While the sixty-seventh and sixty-ninth floors feature outdoor terraces, the spacious rooftop on the seventieth floor boasts 360-degree views of the entire city. The other towers of the metropolis still feel within reach, as if you're *among* them, and looking south toward Ground Zero, the breathtaking vista is completely unobstructed save for the iconic pinnacle of the Empire State Building. The only problem was that the observation deck had been closed for renovations since 1986. The folks at Rockefeller Center were completely unreceptive to the idea of making the roof available, especially in the aftermath 9/11. A call to our contact in the mayor's office changed all that. Not an hour later, I received the friendliest call imaginable from someone in the corporate hierarchy of Rockefeller Center inviting us to visit that very evening.

The lower floors of the observation deck were a shambles, having not felt the kiss of a broom in more than a decade. Since the electricity had also been off for some time, our escorts guided us up the narrow stairs to the roof by flashlight. We opened the door and were greeted by a picture-perfect dusk panorama of the city.

Now that I had the location nailed down, several other specifics could be decided. The first was how to portray the mayor in the picture. Would it be a simple close-up portrait with just a suggestion of skyline? Or more a portrait of Manhattan that had Giuliani in it? Or somewhere between the two? While I often sketch out ideas in advance, the only way to really visualize the picture is by looking through the lens. In the next week, I visited the rooftop several times, accompanied by our producer, Denise Bosco, and my assistant, Mike Ehrmann. They patiently stood in for the mayor while I experimented with various camera formats and lenses, working out issues of scale, focus, perspective, and lighting. I feel strongly that these are never mere technical concerns. As the author of the image, I can't imagine delegating them. (After all, why would I let someone else have all the fun?) They're not just part of the process; they are, in fact, the very elements that will determine the essence of the image: what it will look like, how it will feel, and where the viewer will focus.

My colleagues at *Time* and I agreed that the right choice was a dusk image that silhouetted the mayor from head to toe, save for some dim illumination from below. It was an unusual decision. This was to be a dark and moody picture, while magazine covers are supposed to be light and crisp for visibility and punch. It was also going to show the mayor full-length, while magazine covers are almost always tighter portraits for maximum impact.

There was limited flexibility in the mayor's schedule, so we needed to let his office know the exact window of time before they could give us a date. To complicate matters, a storm front was blowing in. On our last return trip to the rooftop, we explained our predicament to the electrician serving as our chaperone, and he offered an unexpected solution. Three floors below was a large, high-ceilinged space that had been vacant for years and could possibly be made available. (It has since been renovated into a pricey, fancy event space ironically called the Weather Room.) As we entered the space, I couldn't believe my eyes: gray walls, windows that ran from the floor to a twenty-five-foot ceiling, and glass doors that opened onto two terraces with expansive north and south views over the city. I've photographed in countless offices of high-powered characters, and I had never seen anything like it. It would serve as our contingency photo studio.

There was one last wrinkle. For our picture to work, Giuliani would have to be persuaded to stand on an ironwork and limestone rooftop parapet. The good news was that it was only four feet high. The bad news was that it was seventy floors above Sixth Avenue. It would be solid and secure, and easily accessible with a small ladder, but I didn't think he'd go for it; when I hopped up there, I didn't like it one bit. But he needed to be up there. If he stood on the deck with us, the parapet would eat up the bottom half of the picture. We decided the solution would be to have solid stairs leading up to a large, sturdy platform constructed for the occasion that would sit just outside our frame and only a foot below where he'd be standing. That way, a nice broad "floor," just a short step away, would reassuringly fill his field of view. (Unless he looked back.)

After several weather delays, we were given one opportunity to make our picture. I quickly explained the entire scenario to Mayor Giuliani when he arrived, including the duplicate studio downstairs. There were beautiful wispy clouds in the sky, but thicker storm clouds were gathering in the west. Much to my surprise (and the evident horror of his security detail), he just hopped right up to our platform, stepped onto the parapet seventy stories above the street, and smiled.

After quickly exposing about a dozen sheets of 8x10 Ektachrome color transparency film, we hastily started to reset the camera and lighting for the dusk cover picture. It began to drizzle and then really rain. The mayor and his aides ducked inside for cover. There was no choice but to abandon the one-shot solution in favor of a composite using the indoor portrait we would immediately need to shoot. Anticipating this, precise measurements had been made of the exact angles and intensities of all the lights, as well as the position and settings of the camera and lens to replicate the rooftop setup indoors; even another platform had been constructed for the mayor. We had made several exposures from the rooftop the previous evening, so we already had the moody dusk cityscape to dovetail with the portrait from our makeshift studio. Composites become tricky when the subject actually comes in contact with an environment that has been shot separately; the matching of perspective, focus, and lighting needs to be as close as possible to convincingly marry the two.

We all scrambled down to the Weather Room. As the assistants quickly turned on our lights and readied more film, I directed the mayor to his perch on our mock parapet. (His security team breathed a sigh of relief.) But precious minutes had been spent in the transition. I focused carefully and exposed twelve more sheets of film, this time of the mayor standing on a

plywood platform in an empty room. We thanked each other, and then he and his aides were gone.

THOUGHTS ON TECHNIQUE

There are two types of artificial photographic illumination: one simulates ambient light and adapts it to the camera; the other aims for stylistic effect. In this portrait, my lighting scheme combined a bit of both. At night, with my subject seven hundred feet in the air, all of the light would have logically come from below. To complete the illusion that he was being illuminated by the city, my lights had to match not just the direction and intensity but also the color of the light coming from the buildings. Typically, fluorescent lights in office buildings are photographically rendered with a sickly greenish hue. To ensure accurate color, I normally counteract that cast by placing a magenta filter over the lens. In this case, though, I chose to allow the green to register for its unsettling effect, so I colored my lights with green filters, or "gels," to match.

I positioned strobe lights with highly polished, long-throw parabolic reflectors on the outdoor terraces a few floors below to simulate spotlights highlighting the top of the building and the mayor. A striplight sat right on the platform just below his feet to serve as his principal light source and simulate the fluorescent glow from the city. This anchored him to the space and made the image feel real. While all this green underlighting was effective and dramatic, we still needed to see his face, so I added a subtle warm softlight fill that revealed his identity without overpowering the other illumination. All of these strobes, near and far, were connected to the camera (or "synced") using FM radio transmitters and receivers. The effect of each of these lights was pre-

cisely matched in our indoor rain-contingency setup.

The resulting image, while real, was strangely heightened and theatrical, with Giuliani looking like Batman atop Gotham City. If, by contrast, we had elected to set up a big white softbox strobe at his head height, we'd have had a perfectly nice, flattering, evenly lit, and color-correct image that would have looked like someone had let a professional photographer set up his gear on the roof. Again, it's important to remember that all of this was done specifically so that it would appear as if nothing had been done at all, as if he had already been standing up there on the parapet taking in the view, turned around, and had his picture taken.

There's one other odd thing going on: the focus is a bit funny. Technically speaking, the plane of focus is always parallel to the image plane. Or at least it's supposed to be. Imagine the world as a presliced loaf of bread; the camera can only focus on one slice at a time (or lots of adjacent slices, like a "thicker" slice). It can't focus simultaneously on just part of the front slice and just part of the back slice; we know this intuitively because it's how we see, too. Our eyes can only focus on something closer or farther (or both simultaneously if a small enough aperture is used). But they can't focus on only *some* near objects and only *some* far objects at the same time.

Unless the Scheimpflug principle is unleashed. Employing the Scheimpflug allows the creative photographer to bend reality by literally bending focus. By *tilting* the lens up or down, or *swinging* it to the left or right independent of the camera, you can alter the plane of focus so that it slices through the loaf of bread at an angle, simultaneously keeping the whole loaf in focus, or only a bit of the front slice and only a bit of the back slice in perfect focus. This takes the term *selective*

Photo by Howard Bernstein

See? Giuliani really *is* standing on the edge of the building, sixty-seven stories high. At the bottom of the frame is the safety platform we constructed for the mayor's mental comfort.

focus to a whole new level. It's one of the main reasons many photographers choose to work with view cameras, which have the lens and the film on separate, independently adjustable supports joined by cloth bellows. This type of camera, which has been around since the early days of photography, allows the photographer a great range of control over focus and finesse in its application.

One of the visual problems I had been trying to solve prior to the shoot was the focal relationship of my subject to the background. I knew that I'd need to use a very wide-angle lens to capture the panoramic sweep of the cityscape behind Giuliani. Once I had decided on his full-length scale in the photograph, I became concerned that the image would lack depth. (The nature of wide-angle lenses is that they tend to have great depth of field, holding focus in *both* foreground and background.) For this portrait, my worry was that he'd look like he had been pasted onto the background—that while the picture might still be striking, it would lack depth and subtlety.

As the size of the camera format increases, the depth of field decreases. Bigger camera, shallower focus. I felt that I needed to physically see the differences as they'd appear in this exact scenario, so over several successive evenings, I brought my entire range of cameras with equivalent lenses to test at our location. My 35mm Canon with a 24mm lens. Unless it was absolutely necessary, I wanted to avoid using the larger-format cameras because they would likely require commensurately larger lighting setups with far greater complexity and cost. I thought I'd be able to get away with using medium-format, and in fact, the tests looked quite good. The 4x5 seemed to separate foreground from background a bit better yet not enough to warrant its use. But one look through the 8x10 and it was all over. On the big ground glass, the image looked positively three-dimensional, the sharply silhouetted figure literally floating in front of the soft dusk cityscape.

I needed to see Giuliani sharp. And while I didn't want to destroy the lovely soft dimensionality I had just seen, I needed some piece of the background just as sharp to make it instantly recognizable. As I studied the ground glass, I turned a small black knob at the front of the camera and the big lens began to angle slightly off to the right. The Empire State Building, and *only* the Empire State Building, came crisply into view.

39

NEWT GINGRICH

This is an unpleasant portrait. It's *too* sharp. The colors are garish. The lighting is harsh. It was all that I'd hoped for.

The year was 1995 and newly minted Speaker of the House Newt Gingrich was riding high, spearheading the Republican party's sweeping success in the congressional elections and coauthoring their *Contract with America*. *Time* magazine had just chosen him to be "Man of the Year," because in their estimation, having led the Republican Revolution, he was the person who'd had the greatest impact on the news. Yet the title "Man of the Year" was, in his case, less an endorsement than an observation. So my job wasn't necessarily to flatter the subject; rather, my goal was to try to produce a memorable image that summed up its subject in the context of the story. Was this a portrait of a man who was meek or in your face? Conciliatory or confrontational? Feeble or formidable?

I'm not one to go for the cheap shot; while I may not always flatter my subjects, I do respect them and take them very seriously. The in-your-face-ness of Gingrich suggested a close-up. But there are a thousand ways to shoot a close-up, and this one needed its own special treatment. Because it was for a *Time* "Man of the Year," it would need to look unlike any other portrait of him. Because it would exist on a newsstand, it would need to be eye-catching. The big handicap was that it wouldn't be a picture of a sexy rock star, movie icon, or fashion model but of a heavyset gray-haired white guy in a suit. Not exactly eye candy. But maybe candy-colored to offset the potency that had to be conveyed.

Backgrounds can communicate a great deal in a photograph, even studio backgrounds without depth like flat walls, painted surfaces, or paper. Their color, texture, or brightness can speak volumes—or whisper little hints—about a subject. This one needed to scream. I remembered having seen a series of painted backdrops in a catalog several years earlier that were all beautifully silk-screened gradations of color and tone. At the time, I had been searching for a backdrop with just the right subtlety for a portrait I was working on. Something warm and lovely, shading from beige to brown. I paged through the catalog, working my way from neutrals and blues through to reds, oranges, and sepias. Suddenly, I was hit in the face with an acid-green-to-mustard concoction that stopped me in my tracks. I remembered thinking, "Why the hell would anyone ever use *that*?"

Ding! The lightbulb popped on in my head as the image of that backdrop resurfaced. It was just the element of crass discordance that I needed to complete the highly saturated color scheme of the portrait in my head.

THOUGHTS ON TECHNIQUE

In photography, there exists a long and venerable tradition of techniques specific to portraiture, complete with specialized cameras, soft-focus lenses, and sophisticated lighting formulae in order to create the most flattering picture. This image thumbs its nose at all of it. Typically in portraiture, subtlety is the name of the game, yet none is in evidence here because it's not warranted. Newt Gingrich is not a subtle guy and nuance didn't get him where he was at the time this picture was made.

This is a hyperrealistic, warts-and-all portrait. I used everything I know about photographic portraiture that tells me what *not* to do to point me in the opposite direction for this image. Yet it's not a caricature; there is no fish-eye distortion, "monster" lighting, or exaggerated expression. It required great care to pull this picture off just so. It wasn't easy, and its garish lack of subtlety required great finesse.

For years, photographers had their favorite films and processing preferences, usually arrived at through rigorous trial-and-error testing. This, combined with the cameras, lenses, and lighting, hopefully achieved a signature feeling to the portrait that was uniquely their own. I was never very interested in such a "look," because I believed that the portraits should each be dictated by the subject rather than imposed broadly and indiscriminately by the photographer. So with each new assignment, I searched for a new mix, a unique combination specific to the subject. In the case of this portrait, each and every element contributed to the ultimate "in-your-face-ness" of the finished image.

I began by using the biggest camera to obtain the most detail: a large-format view camera that could yield an 8x10-inch negative. But instead of using negative film, I used the supersaturated, high-acutance characteristics of a positive transparency film made by Fuji called Velvia (which was anything but velvet-like in quality) that would show the maximum resolution. It was probably the last film one would typically employ for a portrait unless the likeness was to be used for a dermatological diagnosis. Further, it was "push-processed" for heightened contrast. Since I was using a view camera, I could choose from an almost unlim-

ited selection of lenses, new and old, made by manufacturers from all over the world; the one for this job was a modern, state-of-the-art, multicoated piece of glass from Nikon that would deliver the sharpest, most contrasty image possible. So now I had the triple-threat combination of maximum detail, sharpness, and resolution; I'd be able to see every whisker in Gingrich's five o'clock shadow thrown into sharp relief.

Then there was the lighting. Again, seeking a more clinical look, I reached for the ring light, an apparatus originally developed for the medical profession that throws virtually shadowless illumination to highlight every single nook and cranny of its subject. I complemented this by employing a lighting setup normally used to copy artwork in which a strong light is placed on either side of the camera to evenly reveal every little detail and hue.

Altogether, the effect was, as my young daughters used to say, TMI: too much information, portraying an uncompromising man in a most uncompromising way.

The "Man of the Year" cover portrait. This is a black-and-white version of the frame that was actually published on the cover.

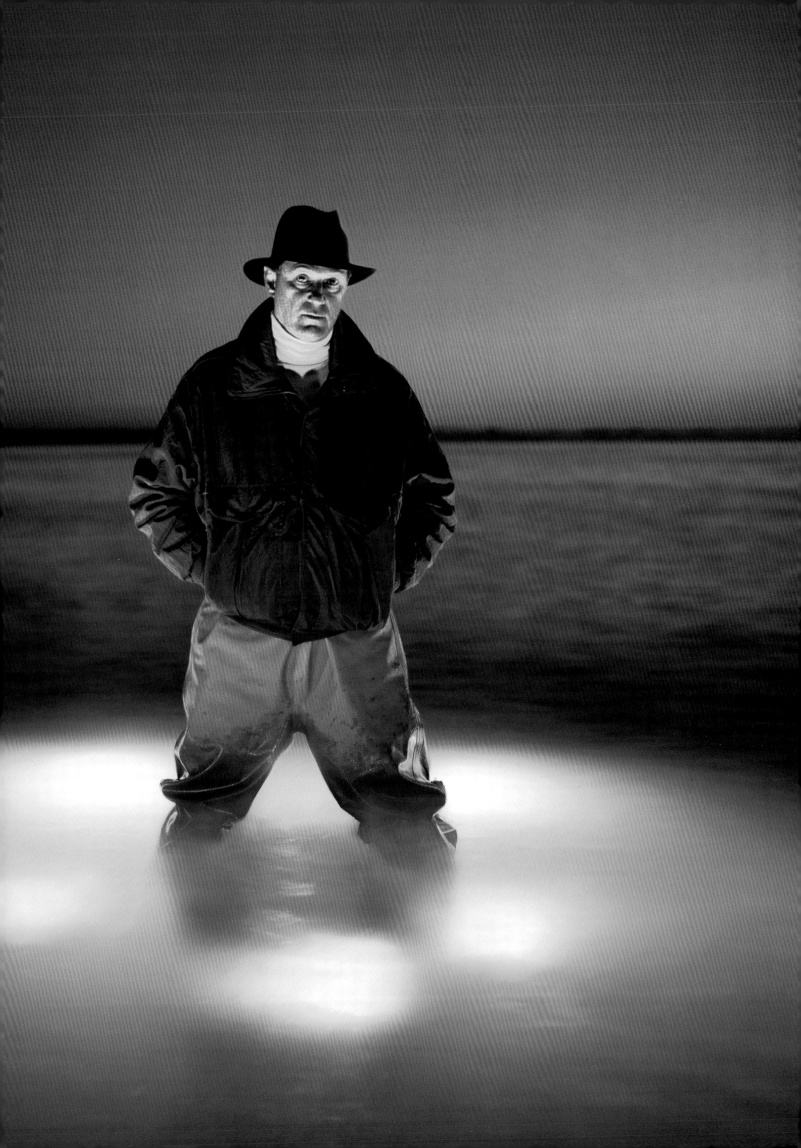

ROBERT BALLARD

This is the man who found the *Titanic* in a portrait commissioned for the inaugural issue of a new magazine called *National Geographic Adventure.* It wasn't for a science publication or a scholarly journal but for a magazine with the word *adventure* in its title. Yet I wasn't going to be able to travel to an exotic location or have access to any of the vessels used to find the legendary ship deep in its North Atlantic grave. There would be no submarines, high-tech trawlers, or remote-control robots. There would be no wind whipping Dr. Ballard's hair as he braced on the bow against the giant swells of the high seas. I wouldn't even be able to get him out on a rubber dinghy in the Long Island Sound. I would have less than an hour with the man himself somewhere in or around his home base of Mystic, Connecticut.

A number of options were presented. A selection of photographs of the *Titanic* could be made available as well as various scale models. A video from the expedition could be projected as a background. In fact, there was a whole science center in town named after him that offered myriad possibilities. And, of course, there was always his office. He could be wearing a suit and tie or perhaps a blazer and khakis. Perfectly good pictures could be made employing these elements, but none of them conjured up an image that screamed *mysterious, against-all-odds, deep-sea adventurer.*

Failing the deep-sea option, I suggested that we might at least be able to get him near open water. It was winter in the northeast, so while the idea wasn't met with a whole lot of enthusiasm, it wasn't rejected either. I thought, "If we can get him near the water, then maybe we'll be able to coax him out *into* the water." Just, like, to his knees. When they asked what he should wear, I said I wanted him to look dashing but didn't want him to get his pants wet, so I offered waders, a leather jacket, and a fedora. Sort of Indiana Jones meets the Loch Ness Monster. Fortunately, he was game.

I began to visualize him looking as if he were standing on top of an unseen, undersea robotic thingy, like one of those *Alvin*-type vessels I had read about years before. I wanted to shoot at dusk to convey a dramatic sense of the impenetrable, inky-black ocean hiding its secrets. Dusk also makes things less specific, silhouettes suggesting shapes, fading light leaving room for the imagination.

But how to light him? What would make sense? I remembered *Alvin.* A short while later, when Ballard saw the ring of green lights submerged out in the water, he raised his eyebrows, smiled, sloshed his way into their center, and turned back to face the camera: the great undersea adventurer personified.

OVERLEAF Robert Ballard

THOUGHTS ON TECHNIQUE

I wouldn't say that lighting is everything. It's the *only* thing. After all, *photo-graphy* literally means "light-picture" or "light-writing." So it's no overstatement to say that a big component of a photographic image is the light. It's something I pay a great deal of attention to and is often a defining characteristic of my work.

I will usually begin thinking about an image I'm about to make in terms of the light and build from there. Where is it coming from? Why? What would make sense as a source for the illumination in the picture? I'll look for cues in the scene to tell me where the light might originate. If someone is standing outdoors at night, for example, what possible sources could there be? A streetlight, perhaps, or car headlights. The orange glow from their match if they're lighting a cigarette.

So unless I've just decided to light a picture for my own selfish, stylish satisfaction (which, admittedly, does happen on occasion), I begin by looking for logic in my lighting, because I want my picture to make sense. I want it to have an authenticity and a believability, a kind of visual integrity. (Which is not, in any way, to disparage pictures that make no sense, that raise questions that don't add up. Often, they can be powerful, even disturbing images that linger in the mind. That's just not the kind of image I'm addressing here.)

So here we have a man standing out in the water at dusk. Logically, there is no justified source for any lighting in the picture. I could have simply set up some light that looked nice, like a big softbox. But you don't see softboxes as light sources out in the ocean, or anywhere else, for that matter. Yet they are often the go-to solution for photographers, because they're easy to use and they always look okay. That's an awfully low bar.

And it's a big reason why so many location portraits look the same. More important, they feel like a synthetic solution simply because they have no reason to be there. They're not *justified* by anything in the picture.

As I thought about my picture, an image popped into my head. What about the floodlights you always see on those undersea remote robotic exploration vessels, like the ones Ballard employed that illuminated the remains of the *Titanic* with their eerie greenish glow? What if one of those robots was just barely submerged, dramatically lighting *him* from below? Even though this image would have some pretty strange lighting coming from an odd place in a strong color, it'd be conceptually justified. It would intuitively make some sense.

I rented some underwater floodlights (like the kind that makes a swimming pool glow at night) and attached green gels to them with rubber bands. The trick was getting them to aim straight up and stay that way on the sandy bottom, as they were constantly being buffeted by the shore waves. We'd have no time to reset them, as there would be a window of just a few minutes when the intensity of my lights would match the brightness of the darkening sky. My tripod was anchored in the water, and I cautioned Ballard to hold extremely still for what would likely be a long exposure as the dusk light waned.

All was ready when the lights unexpectedly dimmed and went dark. A thicket of seaweed had suddenly knocked over some of the lights and smothered the others, choking off all illumination. My intrepid assistants cleared and reset them as quickly as they could, only to have them swamped again by the next wave. This happened several more times as the last light drained from the sky. As my opportunity was rapidly expiring, I squeezed the cable release, silently counted off the many seconds, and hoped for the best.

GEORGE DAVID

Light. Color. Gesture. According to renowned photographer Jay Maisel, these are the primary components of a photograph. I spent years trying to master light and color but was a latecomer to gesture. It had just never been a priority. I was entirely preoccupied with how the picture looked more than with what the subject did. Plus, the prevailing protocol was to have the photo ironed out in advance, a subjectproof image that would work no matter how little time one had with a potentially uncooperative sitter.

I had the picture perfectly framed up in my camera. The overhead lights were already turned off. The reflected silhouette of the helicopter glistened on the floor of the huge hangar. But where to place my subject? George David, the then CEO of United Technologies, was being featured in a cover story for *BusinessWeek* with Marine One, the president's helicopter, at the Sikorsky plant in Stratford, Connecticut. This was to be the "opener," the picture that would kick off the story inside the magazine. A tighter portrait would likely be on the cover, so there was no need for another close-up. I had room on this one, some license to have fun with scale.

The image framed in my camera was a strong horizontal. If I left enough room for type, it would probably run across two pages: a classic "double-truck" opener. I'd have lots of real estate to play with, so even if my subject were relatively small in the image, he'd still have enough size on the page to be recognizable. But I just wasn't sure what to do with him.

I had to force myself to move beyond the direction of an Arnold Newman portrait. In the "Newman version" of this image, my subject might be placed squarely in the foreground, arms folded confidently. But that image, while powerful, would look static. This was one executive who was always on the move, shuttling all over the world. A static picture wouldn't do.

I thought about Maisel and about gesture. Gesture applies to inanimate objects as well as people. Not just gesture as gesticulation, but as that expressive bit of movement, of line, that brings a picture to life. The knobby reach of a tree branch, the curve of a leaf. Power lines arcing to the horizon. Breaking surf. Rotor blades. Rotor blades? Sure, they had a sense of gesture, of suspended rotation. So I had David walk. Briskly. His scissoring legs echoed the V's of the helicopter blades. The picture came to life.

THOUGHTS ON TECHNIQUE

Sometimes the best approach to lighting is to turn off the lights and see what's left.

Early in my career, with naive, testosterone-fueled conviction, I'd arrive at a location, load in my dollies

of equipment, and immediately muscle the lighting to suit my vision. In truth, I still do it today but with a lighter hand, and I usually turn off all the lights first, just to see what's possible before I dig in. This strategy has served me well countless times. It's too easy to blow into a site and set up a formulaic lighting solution. It's just not very interesting. And it largely ignores what the location may have to offer.

On this particular assignment, the entire floor of the hangar had just been freshly epoxied with glossy white paint, and the helicopter gleamed in all its olive-drab splendor. Everything was shiny and colorless. I found myself floating in an ocean of white. There was virtually no way to effectively light my way out of it without sapping the life from the picture, and I didn't want to light up the helicopter because, after all, it wasn't a portrait of a helicopter.

So I asked if the lights, all the lights, could be extinguished for a few minutes. The transformation was magical. The ungainly green machine instantly became a hulking, anonymous silhouette, its blades taking on a menacing profile. The floor turned into a watery, rippling mirror, reflecting the sky outside and doubling the bulk of the helicopter.

The trick now was to not destroy this magic by lighting up everything again. So I set up a single spot-light strobe just outside the frame to cast a small pool of light on my subject. Much easier than trying to light an entire hangar, and more effective, too. Because it was a flash, I was able to use my shutter speed to darken the sky to a dramatic level while still maintaining the spotlit effect. The rest of the picture was untouched, the rest of my equipment left in its cases. Turn the lights out to see what's left. Sometimes it's a gift.

That's a toy helicopter and a painted backdrop reflected in Marine One; only our subject knows he's sitting in a hangar.

PAGES 178–179 George David

42

LAURIE OLIN

Act natural. It's the photographer's oxymoronic imperative. People will only do what they've done before, and they'll only do it when they do it. You can't *tell* them to do it, but you can help them to get there and politely ask them to *hold it* when they arrive at something that works for the picture. As seminal portraitist Arnold Newman used to say, the gesture may be completely natural, but *holding* that gesture is not, so it rarely feels right to the subject.

Laurie Olin is a brilliant, renowned landscape architect; he's very comfortable around trees, particularly ones he has fathered. I had already photographed him in several different locations on the grounds of a recent project, the newly opened Getty Center in Los Angeles. One spot offered a small stand of orange trees. He had nothing to do except stand there with his arms folded, so I had him hold an orange. Bad idea. Forced. Contrived. But it was an icebreaker, the first picture that gets you to the second. The next image was a graphic, black-and-white attempt in the rain. This one worked a little better; he held up a black umbrella and made a nice silhouette against the stormy sky. But he still wasn't comfortably integrated into the landscape; the picture was more about a photographer playing with shapes and tones.

It's tough being a photographer's model, and I wasn't helping him all that much. Instead of telling him how to pose, I needed to put him in a situation where he could just fall into something on his own. It's possible to facilitate an organic, naturally occurring gesture by giving the subject something to work with, like a chair or a table. In this case, an orange and an umbrella didn't work, so I had to keep trying. Finally, a tree.

This third and final try was, pardon the expression, like falling off a log. He strolled into a cozy grove of birch trees, and I asked if he might lean on one. I didn't tell him *how* to lean on it, though; that's what he brought to our little collaboration. He was at ease. I couldn't possibly have told him to stand the way he stood, his weight shifted just so, like an artist's model demonstrating *contrapposto.* Naturally and effortlessly, he placed one hand in his pocket, brought his other elbow up to lean on the tree, gently curled the fingers of his left hand over his forehead, and made the shoulder line of his jacket into a perfect diagonal. Without so much as a nudge from me.

THOUGHTS ON TECHNIQUE

A kiss of late-afternoon sunlight. The picture would survive without it, but it benefits from the warm touch. It doesn't altogether make sense because it's only striking

I had him hold an orange. Bad idea. Forced. Contrived. But it was an icebreaker, the first picture that gets you to the second.

the central subject, but it could just be peeking through a little break in the branches. There are several ways to achieve the effect of late-afternoon sun, and in this case, pressed for time, I chose the quickest and dirtiest method.

Quartz or tungsten lights are generally not preferable as sources to use in exterior lighting situations. They are, first of all, the "wrong" color. Although they are ideal for matching the indoor color balance of lamps, track lighting, and other indoor practical sources, they are far too warm to match outdoor daylight. They just look too orangey in comparison to the existing light—unless the desired effect is that of late-afternoon sun, which is, after all, quite orange. Then they look perfectly natural.

The other drawback to tungsten lighting outdoors is that it's generally not bright enough to hold its own against a midday sun. But at dawn and dusk, or on heavily overcast and rainy days, it can balance beautifully. This photograph was made on just such an inclement day, made even darker by the fact that Olin is positioned in the heavy shade of a snug stand of birch trees. It doesn't *look* dark because the exposure was made for the deep shade, rendering the other areas airy and bright. And still, the little quartz spotlight had to be held as close to the subject as possible, just outside the left edge of the frame. It didn't overpower the subtle

ambient light, yet it was just strong enough to register its warm glow. If it had needed to be stronger, I'd have been out of luck.

A strobe, on the other hand, might have been the better way to go. Its color could have been readily modified with lighting gels. Its brightness could have been easily adjusted over a greater range, independent of the existing ambient light. The problem was that I didn't have one. I had already exhausted my arsenal in the earlier setups.

All I had left was a single little battery-powered quartz light, one that I generally use solely to check my focus. The bad news was that it wasn't very bright. The good news was that it was a very dark day. But the best news was that because it was a *continuous* light source instead of a strobe, I was able to see and assess its effect immediately. When it looked good, it *was* good. I was able to work quickly and intuitively. Within seconds, as Olin fell into his pose, the light was brought closer till it looked just right, and I quickly exposed a sheet of film. And because I could *see* my warm little "sun," I was able to nimbly make tiny adjustments by simply moving it closer or farther, or by subtly altering its aim. Down and dirty, just like that.

Rather than having us all duck out of the rain for this alternate image (ultimately chosen by the magazine), I decided to deploy Olin's umbrella and work with silhouettes.

43

JOYCE CAROL OATES

Beseeching. It's the word that springs to mind whenever I see this portrait. Why does Joyce Carol Oates have such a beseeching look? Is she desperate for the shoot to be over? I hope not, but the truth may be otherwise. I was feeling nervous. She was quiet, probably self-conscious. I was bumbling a bit.

She was being awarded the National Arts Club Medal of Honor for Literature, and this portrait would be on permanent exhibition at the club's historic headquarters in New York City. The shoot took place on location at Princeton University. I had explained that it wasn't to be an office portrait; it just needed to be *her*. No environment, no distractions.

I had embarked on this portrait solo because I wanted to work without any assistants, digital techs, or interns. It had worked well before, but this time I was running late. It had taken time to pin down a location for the portrait; I required a bit of space and ceiling height to set up my makeshift studio. By the time I had schlepped my gear up to a top-floor art studio, I had to rush to set up quickly on my own. Making matters worse, as I didn't have a stand-in to perfect my lighting, I had to repeatedly race back and forth between the camera and the chair like a lunatic, using the self-timer to capture my own harried likeness.

I had just read my first Joyce Carol Oates novel the week before. I don't know what I was expecting, but I was rattled by the book's candid brutality and rawness. There were few photographs of her to be found as reference; in all of them she seemed small, fragile, bird-like. I couldn't reconcile the person I saw with the words I had read. I felt something more was needed in the photograph, a small, disturbing element to offset her gentle presence. Visiting a local antique dealer near my studio in New York, I spied a cast-iron doll's hand in a display case. I rented it for the day, along with a little nineteenth-century sculptor's stand. They'd just be in the frame, unexplained, a disquieting counterpoint to her calm.

There isn't much I remember about the shoot apart from my own anxiety. I revere fiction writers and stand in awe of their gifts. Presidents don't faze me (after all, they're our *employees*), NBA stars don't intimidate me, and celebrities don't leave me starry-eyed. Show me a good writer, though, and I go speechless. I'm sure she wasn't impressed. But she was patient and allowed me to make the necessary exposures without complaint.

Ultimately, as soon as I saw her beseeching expression, the little doll's hand seemed superfluous. It was a photographer's contrivance, the one-thing-too-many

I couldn't reconcile the person I saw with the words I had read. I felt something more was needed in the photograph, a small, disturbing element to offset her gentle presence.

in the picture. The first thing I did was retouch it out. All that was needed was the subtle S of her body, the gesture of her soft hands, the craziness of her marvelous boa, and her *look*. Looking at the picture two years later, I elected to put it back in.

THOUGHTS ON TECHNIQUE

If you want light that looks good right off the bat, use the biggest light you can find. Not the most powerful, or the brightest, but the *biggest*. Surface area biggest. It will act like a big window that lets in beautiful, soft light. It won't matter if it's a strobe or a continuous light as long as it's *big*. This is the opposite of a *point source*, like the sun or a bare bulb that gives crisp, hard shadows and tiny, intense highlights. A large source radiates beautiful soft light that envelops the subject from more directions, producing soft shadows and broad, diffuse highlights.

That's why professional photographers often use large diffusers in front of their lights, such as softboxes, umbrellas, and silks: they make the light source seem bigger. I've rented silks (large translucent diffusers) that had a bigger footprint than my first New York apartment! It's why car photographers use lights and diffusers as big as trucks—because the image gets especially beautiful when the light is *bigger than your subject*. That's a luxury and rarely practical except in still-life

work, where it's pretty much the standard (and also more manageable because the subject is usually small: a can, bottle, or box).

When photographing people, such large lights can be terribly unwieldy, especially indoors in typical locations. But they look *awesome*. Head-and-shoulders portraits are easier, because the light just needs to be bigger than the person's head. A favorite light among professionals is called a "beauty dish" (because the light is so beautiful, I suppose, or because it's often used for "beauty" photography: fashion and makeup ads and the like), which is a round source about twice the size of a human head. Many softboxes run about the same size or a bit bigger, which makes them popular for portraits.

The light I used for this portrait of Joyce Carol Oates is only about two feet wide, but it's ten feet long! It's called a Rololight, a lightweight fluorescent light that rolls up tightly, like a window shade, for transport and is only a couple of inches deep, so it's surprisingly compact to set up and use indoors, even in tight spots. Its light is easy on the eyes and quite beautiful. It's so soft, in fact, that I supplemented it with a little crisp light to give this picture a bit more punch. The end result is one of my favorite kinds of light: it looks like sunlight diffused though one of those ripply-glass skylights, soft and warm but with a little kick. It's kind but still *real*.

Actor Patrick Stewart on basic black in another portrait commissioned by the National Arts Club. Gels on the big lights add subtle overtones to his skin.

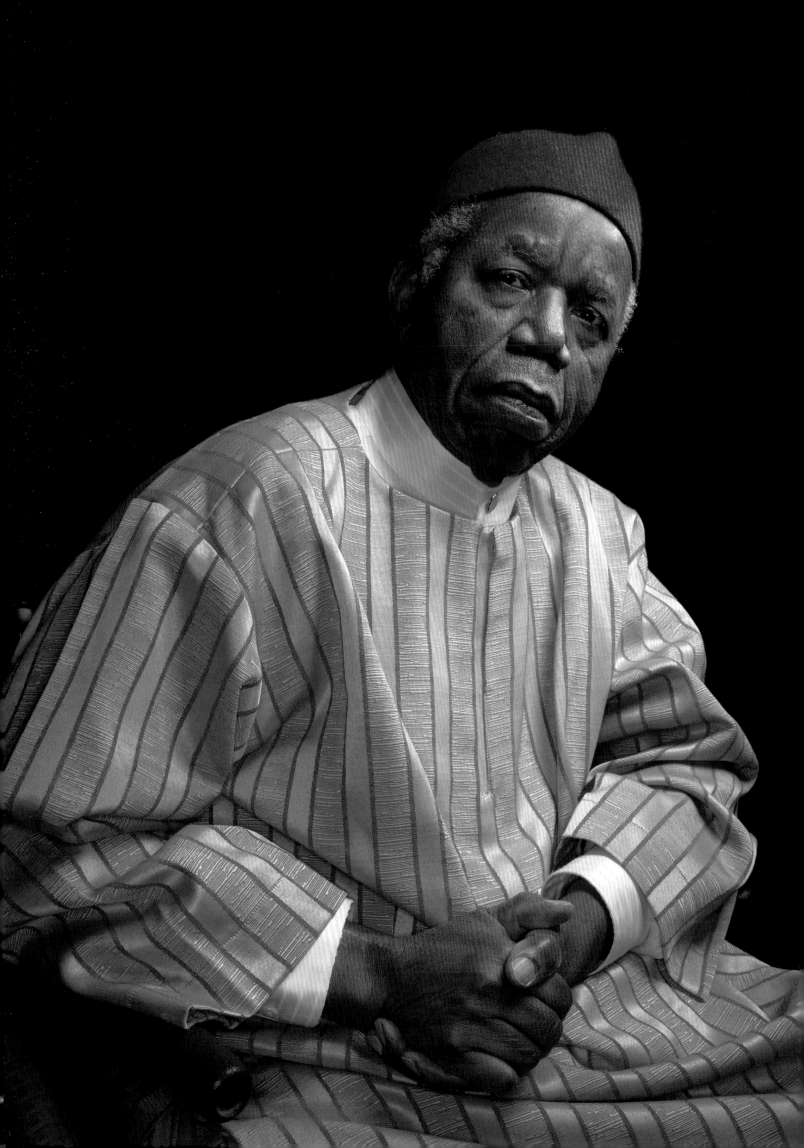

CHINUA ACHEBE

Chinua Achebe, the great Nigerian author, stares out knowingly from a deep black void. He's bathed in golden light, his eyes sparkling from beneath heavy brows. It is as if he's about to speak; it's a suspended moment. The image is crisp and highly detailed. We can feel the texture of his rich, silk garment and the soft fuzz of his red felt cap. Nothing distracts from these observations; this picture is simple. Quiet.

In contrast to the many contextual portraits I've done, this one has no outside clues. The entire image rests on the subject's shoulders. I had long since grown tired of the kind of portrait, so prevalent in editorial work for the past few decades, in which the subject is required to *do* something. Act out a role. Participate in a metaphor. Contribute to a prank. Conspire to create a picture that is ultimately more about the photographer than the subject. I had committed my fair share of such images but always felt like I was wearing someone else's clothes that didn't quite fit. I wanted to be invisible, to have the picture be exclusively about the subject.

I had also had my fill of *shoots* and *sessions* that were more like big circuses, complete with music, catered food, multiple assistants, stylists, and makeup artists, not to mention art directors, publicists, and clients, all of whom were well-meaning yet threatened the bubble of intimacy I was trying to establish with the sitter.

I longed to work simply again, without help, just me alone. Even the best, most invisible crew members still exact a toll on the proceedings. They speak, make eye contact, get hungry and tired. I know it sounds heartless, but there are times when I just don't want to *care*. Time passes differently for everyone on the shoot, especially the photographer. I tend to get so wrapped up in what I'm doing that fatigue and hunger drop away (only to reappear with a vengeance, of course, the minute the shoot's over).

The other impetus for working solo was the advent of digital imaging. For the first time since the earliest days of photography, it was possible for the photographer to personally perform every step in the creative process. I longed to experience the entire process *by myself* from beginning to end, so it would inform every decision along the way. I didn't want to delegate, to be a photo-manager of sorts; I wanted to fully be the author of my own work, from creating the palette of my "film" to pulling the final print. And this was the opportunity to try it. There was even a peculiar satisfaction to setting up and breaking down every last piece of gear; I felt like I had *earned* the shoot. In fact, as I was packing the cases back into the van, a custodian who had been sweeping the room leaned on his broom, shook his head, and exclaimed, "*Man*, you been *workin'* for a livin'!"

The sweetest moment came when Achebe wheeled onto the set. I had created a little, intimate space in the center of this big, basketball court–sized room using large sheets of black velvet. The only piece that was photographically necessary was the backdrop; the rest simply isolated us in a quiet cocoon. I know I'd never have made the same images in the middle of the circus.

After the portrait sitting was finished, I had the delicious luxury of hunkering down with my pictures for as long as I liked, taking my time selecting favorites, and then working with them on the computer. Now, I'm neither the fastest nor the best at working in post-production, but I really enjoy the process, and I feel it's invaluable. It's certainly not cost-effective, since I probably spend an hour on the computer for every minute I spent shooting. But I learn a great deal by looking at my pictures on the computer as I edit, adjust, retouch, and print them. I make decisions every step of the way—global decisions about color and contrast, as well as micro decisions about weight, luminosity, hue, and tone—that I would never have thought to communicate to someone else had I not been working on the images myself. They may not all be the best decisions, but they're *mine*.

THOUGHTS ON TECHNIQUE

I've had the misfortune to have been photographed a number of times, and I'll tell you one thing: time passes very differently on the other side of the lens. Make it a point to get photographed, really photographed. You'll see. It will be incredibly instructive; you'll probably learn what *not* to do: How not to talk to your subject. How not to pose them. Where not to put the lights. And so on. Photographers might mean well, but they don't generally have a lot of experience being the subject.

If being photographed by someone else isn't possible, be your own subject. Pretend you're Cindy Sherman or Chuck Close. You might tap into a whole new vein of creativity and strike out in a fresh direction in your own work. At the very least, you'll develop more compassion for your model.

Here's a tip: *always* stand in for your subjects to experience firsthand how it *feels* for them. Is the light too bright, too squinty? Is there a glare? Can you even see the photographer? (Being the subject is like being onstage: everyone can see *you*, but all you can see is the glare of the lights.) Are the quartz lights uncomfortably hot? Is the fan in the strobe (a veritable white-noise machine) making it hard to hear? Does the music get in the way?

The trickiest part of photographing Achebe wasn't Achebe. It was photographing *myself*. I had pulled off the test shots without an assistant to act as the stand-in or push the shutter release. Initially, I tried using the short, doorbell-button cable release that Hasselblad makes, but my arms just weren't long enough, so I resorted to the self-timer in an effort to be in two places at once. It was ludicrous, but it worked. And I noticed something I had never considered before: distractions. We had no privacy. So I erected a second black velvet backdrop *behind the camera* to create a more intimate space for Achebe. Our "bubble" was now real, physical. He could focus on the lens and me rather than be distracted by people walking by, the large windows outside, and everything else in the gymnasium-sized "multipurpose" room that was our studio at Bard College. It was like we were inside our own little tea cozy.

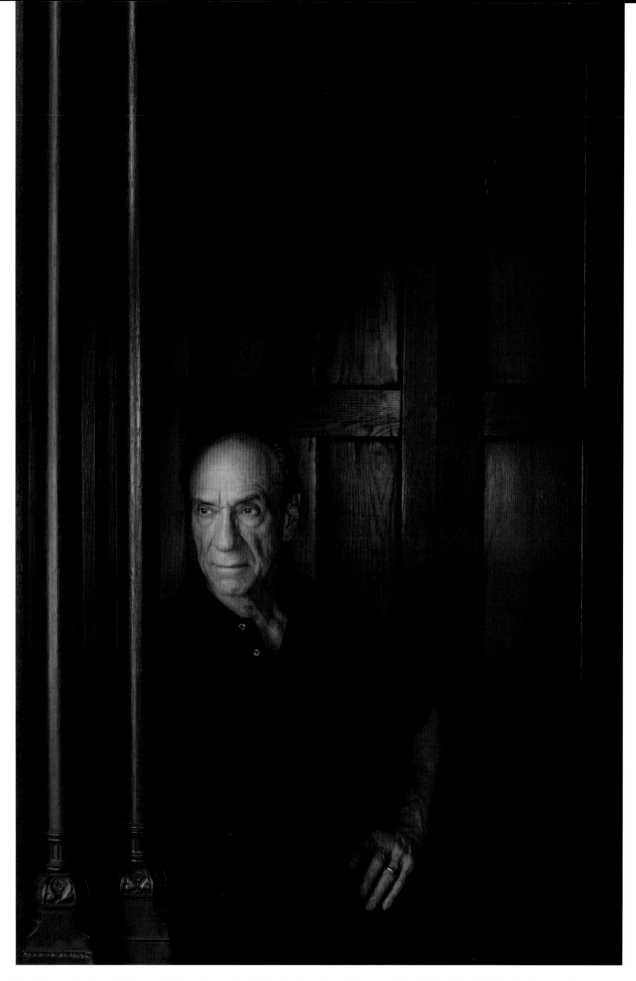

For this portrait of actor F. Murray Abraham, I opted to utilize the dramatic environment of the National Arts Club in the photograph.

MICK JAGGER
AND TINA TURNER

Yes, it's a bathroom at the John F. Kennedy Stadium in Philadelphia, backstage at the Live Aid concert on July 13, 1985. There was a ladies' room on one side, a men's on the other; this one was unoccupied, available, and not gender-specific, so we commandeered it as our studio. My assistants and I had arrived a short time earlier on short notice, having driven a van with all our gear from New York. We were uninvited and unexpected, so no one was there to greet us or help facilitate the access we required. Our fearless leader, an adman from Rochester named Vern Iuppa, had hatched the idea as a way to support photography and the mother ship at Eastman Kodak with the notion that funds might later be raised from the images. He somehow got us ushered in through the press gate; once we were inside, nobody really questioned our presence, and we were free to look around for a place to set up. The bathroom was in an ideal location; the performers had to pass right by it on their way to and from the stage. I had brought a huge gray-painted muslin backdrop for the occasion, but when I saw our surroundings, I opted to pop on a wider lens to include some of the toilet stalls as well.

The problem was going to be getting the performers to step inside to have their portrait made. *"Just one more."* It's the photographer's refrain. Always trying to wheedle another shot. It's what I dread the most. (I don't want my subject to be there one second longer than they want to be.) The carrot this time was that I'd only shoot one frame, a single exposure, and then they'd be free to go. No "just one more" cajoling to get off another roll of film. One click; that would be it.

We all took turns standing outside trying to hook people in; our "one-click" promise was a success. The notion of just committing to one image was incredibly liberating, as it removed from the interaction the whole premise of trying to squeeze in a few more shots. It was a completely fresh experience: the subjects didn't have time to be done with me because I was done with them *first*! In and out. I didn't have to entertain them or have their favorite beverage handy because they weren't there long enough. Plus they mustered their best selves, knowing there would just be one chance to get it right.

One of the few exceptions to the one-shot strategy was the *pair* of images I made of Mick Jagger and Tina Turner that day. I had exposed my one frame, but they were enjoying being together and didn't seem ready to go. It had been a serious portrait, because I'd been serious (and a little in awe) and they'd probably mirrored me. This time I think I vamped, dramatically throwing my head back. It worked: they did the same.

LIFE magazine hadn't covered the event, but when Live Aid proved to be such a huge phenomenon, the

magazine felt the need to do its own story. I presented the set of portraits I had made, and they published them as a portfolio in their September 1985 issue, opening the essay with the first image of Jagger and Turner, and using the second one as their cover (having first cropped out the bathroom stalls).

This is notable in the annals of editorial celebrity photography because of its two-for-two usage ratio. Typically, when one is shooting a celebrity cover for a major magazine, there are racks of wardrobe, countless clothing changes, endless posing variations (everything from close up to full length), myriad lighting adjustments, and facial expressions galore. This gets multiplied exponentially when there are multiple celebrities: every possible permutation is explored. In this case, in addition to wardrobe changes, they'd have been posed side by side, back to back, Turner on the right, Jagger on the right, her serious and him laughing, him serious and her laughing, both serious, both laughing . . . you get the idea. The fact that only two images were shot and both got used, *unretouched*—one as the opener, the other as the cover—was nothing short of an editorial miracle.

THOUGHTS ON TECHNIQUE

It's the littlest things that make or break a shoot.

The first hurdle was getting backstage at the old JFK (formerly Philadelphia Municipal) Stadium before the concert started. Somehow we had cleared that one. Then we snagged the only available room: a vacant lavatory with a nice high ceiling. We were so happy to have a spot for our makeshift studio that we immediately set about unpacking our gear, putting up the backdrop, assembling the view camera, popping out the softboxes,

setting up our lights, and readying the film holders. When it came time to plug in the strobes, though, we were in for a surprise. Elsewhere in the stadium there was enough juice to power a rock concert (Live Aid, in fact), but we didn't have access to any of it. There was not even a *single* wall outlet to be found in our little bathroom. I learned the hard way that people weren't using electric grooming aids in public restrooms in 1926 when the place was built.

We had come with a truckload of gear: cases and cases of strobe lighting, softboxes and other modifiers, filters and gels, large-format cameras and lenses, and all manner of grip equipment, not to mention plenty of extension cords. All of which would prove useless unless we could get some power. The concert was now under way; no one was available to help us.

Then we looked *up*. The sole source of illumination was a lone lightbulb dangling from a wire in the ceiling. *Electricity!* We began rummaging through our cases. In the trunk that held all our extension cords was a little zippered pouch. In the pouch were adapters: three-way adapters, grounded adapters, three-prong-to-two-prong adapters, European adapters, assorted odds and ends, and . . . there it was! Never-before-used, probably purchased long ago for some peculiar job that never panned out, the perfect adapter. I don't think I had known such a thing existed, let alone seen one. It had a male lightbulb screw on one end and a two-slotted female AC receptacle on the other. It was magical. I found out later that it cost seventy-two cents. We unscrewed the lone lightbulb, screwed in our magical adapter, plugged in the one cord to our one strobe, and we were in business. Without it, this picture would not exist. My kingdom for an adapter!

Other performers posed gamely for their one-click portrait. Top row: Dionne Warwick, Jack Nicholson, Daryl Hall and John Oates; middle row: Keith Haring, Mick Jagger and Tina Turner (the first exposure), Led Zeppelin; bottom row: Carlos Santana, Ric Ocasek, Peter, Paul and Mary.

46

HARRY BELAFONTE

I had been walking in circles for more than an hour, wandering through the great singer's cavernous, rambling apartment on New York City's Upper West Side. It happens sometimes; indecisiveness envelops me when I see too many picture possibilities. This was just such an instance. The warm home he had shared with his wife for decades was well lived-in, comfortable, and filled with a lifetime of memorabilia. I simply couldn't decide on a spot for my picture. The cover portrait would be a tight close-up of his elegant, handsome head, and I had already chosen the spacious living room as my "studio"—not for its environment, but because it afforded us enough room to set up all of our lights and a small backdrop. I had made the mistake of bringing too much gear: cases upon cumbersome cases stacked in the narrow hallway outside his back door. I had brought big cameras and medium cameras, big strobes and little ones. While he was a warm and welcoming host, it was clear that this felt like an invasion and imposition; whatever he had been expecting, it was not this, certainly not for a simple magazine picture. It was an experience I'm sure he had endured countless times before but never with such an onslaught of equipment and people, not in his home. I had misjudged it; the scale of my ambitions

for the picture really outstripped what was appropriate for the situation, like slinging a sledgehammer to pound in a pushpin.

My eye kept going back to what looked like a large painting hanging by itself on one wall. It appeared to be an improbably oversized etching, but upon closer inspection, it was, in fact, an expressively gestural large-scale drawing, a magnificent, almost life-sized portrait of Belafonte from 1954 by the renowned artist Charles White. I settled on it as the background for my portrait. It would be important, I felt, to show its impressive size, yet I didn't want it to compete with the man himself. If I placed him in the foreground, he would be big but the scale of the drawing would be lost. If I placed him against the piece, it would dominate the photograph by dwarfing him.

I decided to place him right next to the artwork to indicate its size. He'd be fairly small in the photograph, but since it was not intended for the cover but would run as a full page inside, there would be real estate to spare. The drawing had a wonderful feeling of animation, so I wanted him to be still and serious. Half a century older, head shaved and rather severe-looking, he acted as a terrific counterpoint to the piece.

I had misjudged it; the scale of my ambitions for the picture really outstripped what was appropriate for the situation, like slinging a sledgehammer to pound in a pushpin.

THOUGHTS ON TECHNIQUE

Big art, small person. It's a picture I had done many times before, in different environments and circumstances. My mentor, Arnold Newman, founded his career on it brilliantly, and invented the language of the environmental portrait in the process. In this image, the artwork occupied the lion's share of the space yet needed to be reduced to a secondary, supporting role to Belafonte. It was important to see him first and then notice the similarity in the artwork immediately thereafter. He was its subject, not its author.

This was accomplished with light by using its brightness and hue to set the hierarchy. I wanted him to elegantly anchor the picture, even as a relatively small part of the image. And I needed to subdue the grandly scaled artwork by pushing it back into the shadows.

Instead of walking into a location and overwhelming it with my lights, I often try to see what's already there. Usually, there's an organic logic to the illumina-tion, a quality that suits the space. Sometimes not. Then I have to start from scratch, drawing on my filed-away memories of observed light: scenes I've seen over the years under countless lighting conditions that I may or may not have photographed, which nonetheless left a lasting impression.

Here, I took my cues from the existing light in the apartment. I didn't actually use the ambient light; I merely saw its qualities as a starting point. Belafonte's was not an austere apartment of overhead track lighting, polished floors, and minimalist furniture; it was a comfortable, warmly lamp-lit, lived-in home. The blue light of dusk that filtered in through the windows had a coolness that revealed the big drawing while allowing it to quietly recede into the background, while the warm light from a table lamp highlighted his handsome face.

But the existing light was entirely too dim to deliver an acceptable exposure for my 8x10-inch view

camera; my subject would have to hold stock-still for several seconds. So I substituted my strobes for the existing illumination but molded and filtered them to render a similar mood with an instantaneous flash.

My three lights have a logic that echoes the existing sources. To capture the underlit look of lamplight, I used a bright little softbox that's about the size of . . . a lamp. It even had a very warm gel to convert the daylight color balance of the strobe to that of the incandescent bulb in a lamp. It was augmented by a larger softbox that emulated light coming in from another room onto his face. And to mimic the dim, cool window light, I employed a big but low-powered softbox the approximate size of the window and added a blue gel to the front. Taken together, my three clunky strobes all taped up with filters re-created the lovely confluence of light that revealed the mystery of that magnificent drawing when Belafonte first stood beside it.

This close-up cover image was the real purpose of the sitting, but I was obsessed with the puzzle posed by the large portrait.

BRUCE SPRINGSTEEN

We had been at Bruce Springsteen's house all afternoon, though not the house he lived in. I had hoped to shoot in his house-of-residence, because I had heard it was equipped with a complete recording studio in which he had laid down tracks from his latest album at the time, *The Rising.* But it had been made clear that it wouldn't be an option; rather, we'd be working at another house he owned nearby. I like to think it was his special "photo house," reserved exclusively for photo shoots. It was a simple, beautiful nineteenth-century farmhouse that, he had explained, he and his wife, Patti Scialfa, had fixed up for friends who came to visit. When they decided to repaint the place and started stripping decades-old wallpaper and began patching the cracked plaster beneath, they found, to their surprise, that the resulting textures and hues suited their taste, so they simply sealed them and left them in that half-finished state. The effect made for an ideal photographic backdrop.

I picked a spot at the top of the stairs. It had a beautifully aged wall as well as a window through which I'd be able to throw some light. The window, a nearby doorway, and edge of the stair railing would serve as a frame around him. He hopped up the stairs and stood in place. The setting looked great but it felt like something was missing. I asked if he could bring a guitar to place into the picture. Not to play but as a prop, as if he had just set it down for a second to have his picture taken. He obliged but then seemed unhappy with the little scene we had assembled. It was the wrong guitar.

He wasn't prima-donna unhappy, he was more I-like-your-idea-and-just-want-to-make-it-better unhappy. He's actually quite a serious amateur photographer himself and seemed to rather enjoy the process of collaborating on what promised to be a good picture. In fact, I'm pleased to report that he was one of the most likable people I've had the opportunity to photograph: sincere, curious, good-humored, and patient. He made a phone call and then explained that he had just sent someone to retrieve his favorite vintage guitar, which he had left at a nearby rehearsal venue. While he went back downstairs, I fiddled with the framing as I looked into the ground glass of my old 8x10 camera and my assistants began to set up more lights.

About half an hour later, I was ready for him and he reappeared, a happy man with his beautiful, old, prewar Gibson guitar in hand. He very gently set it down in the corner next to him to complete the picture; then he leaned against the wall, looked into the camera, eyebrow cocked, and gave me his best, most serious rocker face.

THOUGHTS ON TECHNIQUE

I'm a bad person; I don't carry a real camera with me every day. I've tried, at various times, bringing some new favorite camera to capture photo opportunities: my daughters' soccer games when they were little; fleeting "light events" (a phrase, I believe, coined by the master of such events, photographer Jay Maisel); or one of those plentiful, quirky New York street moments. But it's always unsatisfying. Once I have a camera, I'm looking for pictures all the time rather than experiencing my life firsthand, and I ultimately miss the best ones anyway because my mind is someplace else. Those torture me forever, unforgettably burned into my brain. And the pictures I do get rarely come out as I'd like because I'm not 100 percent there as a photographer; I'm still part daddy or husband or friend or on my way somewhere. Plus, in the end, I find that I'm not invested enough in the resulting pictures to want to go to all the bother of developing them, naming and keywording them, archiving them, and backing them up—let alone printing, posting, or otherwise sharing them. For the most part, I'm content to have simply had a satisfying moment of seeing. I just unconsciously click the camera in my head, save the image to use as fodder for future photos, and I'm happy, unfettered by gear or obligation.

This window light was created from a memory, a sort of "greatest hits" of window light rolled into one. It was getting on toward dusk, and the light had faded. I'm not a huge fan of softboxes; they always seem like the too-simple solution. They often, however, replicate window light. The ersatz "window light" they emit, though, is chromatically one-dimensional; it's just white. True window light can have elements that are cooler and warmer (depending on the weather, time of day, and reflecting surfaces nearby) or even greenish (if there's a brightly lit lawn outside). These are the conditions I love to subtly replicate with my lights and softly colored gels.

I lavished special attention on Springsteen's window light, because I knew my 8x10-inch color transparency film would faithfully record it. Since the light was supposed to look like it was coming from the actual window in the frame, the only place to put our big softbox was on the other side of the window; fortunately, there was an available porch roof. We taped on a pale blue gel to simulate cool north light and added a smaller softbox inside with a warming gel to echo lamplight as a fill. Taken together, they cast a beautiful, believable light that washed over Springsteen, creating subtly tinted highlights on his skin and throwing soft, multihued shadows on the wall behind him. This window light is phony, but the effect is real; only he and I, and now you, know the truth.

For this image, I used only continuous lighting to preserve the mood. It was silent, save for the soft sound of Springsteen's guitar.

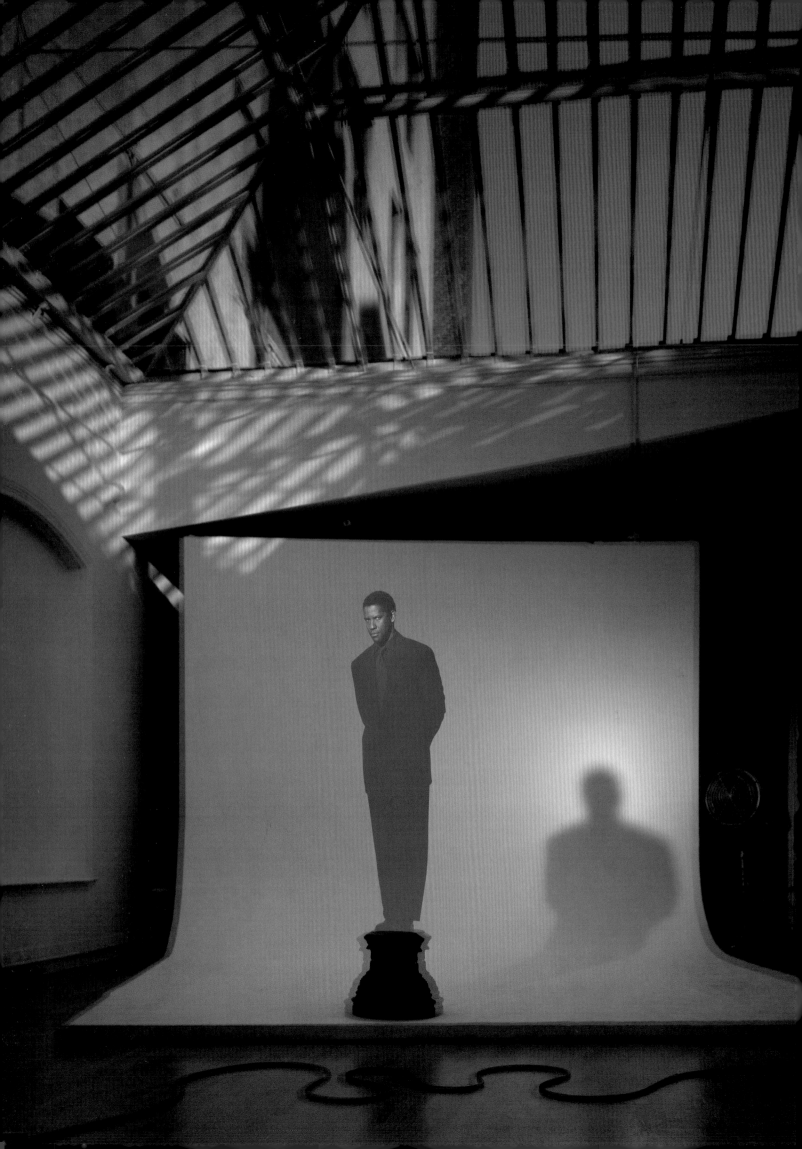

48

DENZEL WASHINGTON

I like to have a concept when I go into a portrait session. Sometimes it is quite specific, a fully previsualized image; other times it is merely a point of departure. But sometimes the best-laid plans get derailed, blown up, usually by weather, schedule changes, time constraints. They can be torpedoed by an uncooperative client or editor or a well-intentioned (or not) publicist, or sometimes even by the subject himself. I never know when it will happen, just that it will, sooner or later. It's always terribly disappointing and has nearly thrown me off my game more than once. When cajoling has proven futile, I've had to be nimble, able to turn on a dime if absolutely necessary. Thankfully, these course adjustments have usually led me to solutions and images I'd never have otherwise considered or even thought of. So I've learned to embrace these changes and run with them.

For the opening portrait of a cover story for *GQ* magazine, I had envisioned something special for Denzel Washington. He had already won an Academy Award for Best Supporting Actor for his role in the film *Glory* and had just been nominated for his starring role in *Malcolm X.* Part of the thrust of the article was going to be that even as he was transitioning from supporting to leading roles, he was so adept at disappearing into his characters that he was still essentially a chameleon.

The magazine had agreed to hire a costume designer to create a custom-made outfit for him to vanish into, to be comprised of bits and pieces of the various characters he had portrayed: the trademark fedora and glasses from *Malcolm X*, part of Private Trip's uniform from *Glory,* and so on. It was stunning, iconic, and memorable. I was so sure he'd be impressed and thrilled to wear it for his portrait that I didn't even have an alternate concept.

I was wrong. He flat-out rejected the idea and refused to even try on the outfit. I attempted to convince him of the merits of the concept, but he stood his ground. He quietly explained that once he had wrapped filming of a character, he was *done* with that character, never to reprise or reinhabit him again. He said he hoped I'd understand and asked what other ideas I had. My mind reeling, I suggested we begin with the cover image—a simple, elegant portrait of him in an expensive black suit against a black velvet background—and take it from there. He headed off to his dressing room while I scrambled for a backup plan.

While he was going through grooming and selecting his wardrobe from the vast array of black suits the magazine had provided, I scanned the studio for inspiration. I spotted the black pedestal I had procured for

*There's something to be said for ambiguity,
for not having everything in the photograph
explained.*

him to perch on in his custom character suit, and felt crestfallen. He emerged cutting a very trim and graphic figure in his all-black attire, and I was struck by the silhouette he made. I quickly moved the pedestal into the picture and asked him to stand on it.

As I looked through the camera and saw him on the white background, he took on a familiar shape but was the wrong scale. I switched lenses to get a wider view. The newly included environment meant little in the picture, but it did shrink him down in size. I took a second look and there he was: Oscar!

THOUGHTS ON TECHNIQUE

There's something to be said for ambiguity, for not having everything in the photograph explained. Washington emerged from makeup and wardrobe wearing a solid black suit. I explained my new picture idea, one in which he'd be standing on a black pedestal in his black suit, looking for all the world like an Oscar statuette. He hopped up on the pedestal, and folded his arms, and I exposed a Polaroid test with my 8x10 camera. It looked promising, but his pose and the angle weren't quite right. We shot a few more. When he had his arms folded just like the Oscar statuette, he didn't *look* like the Oscar statuette. After a few more attempts, he hit on a silhouette that clicked. He rotated his body left

and right until his cast shadow on the wall was recognizable as Oscar. But he still just looked like Denzel Washington standing on a pedestal. I wanted to take the image one step further yet wasn't sure what that step would be. The key, I felt, was to make the shadow more the subject of the picture. So I had an idea. I tried a Polaroid double exposure: one with Washington, one without. In the first exposure, Washington stood on the pedestal; the second was the pedestal alone. The result: a translucent, disappearing Denzel Washington improbably casting a solid shadow—which looked just like an Oscar shadow.

Once the test was done, the shoot proceeded apace. I exposed several more sheets of film with Washington atop the pedestal; then he hopped down, and I reexposed them all without him in the scene. The exposures with him in the frame employ a spotlight strobe to cast his shadow onto the wall of the white cyclorama, while the second exposure uses solely the ambient existing light from the large overhead skylight washing over the scene. The camera got bumped between the two sets of exposures, which accounts for the secondary, or "ghost," image that gives a funny double edge to most of the objects in the frame. While it was, admittedly, entirely unintentional, I like the zappy energy it lends to the image.

The velvety tones in this image were faithfully rendered by my trusty 11x14 camera. The magazine's cover was a color image from the same setup made with a medium-format camera and a faster shutter speed. That image was sharp and serious, but had none of the magic.

JULIA ROBERTS

What makes a picture feel natural or intimate? There is certainly a technical component to how a picture looks and feels. A big piece of the puzzle, though, is how the *subject* looks and feels. Usually, it is the bedside manner of the photographer that makes all the difference. In this case, however, it was the makeup artist who was ironically responsible for both the lateness of the shoot and the fine mood of the sitter. I was left watching from the outside as the evening transpired.

Julia Roberts arrived at six o'clock in a perfectly agreeable, businesslike mood and retired immediately to her dressing room to await the arrival of her prized friend and makeup artist, the late, great Kevyn Aucoin. Typically on a photo shoot, all crew members, including the photographer, appear well before the talent to prepare for their arrival. I had heard stories that ran counter to this but had never experienced it myself. This was not to be a typical photo shoot. After a while I checked in on Roberts to see if everything was okay, as it was she who had requested Aucoin. She put up a hand, nodded, and then returned to a phone call. (I was dismissed.) About half an hour later, I poked my head in again; she smiled and said not to worry. Clearly unperturbed, she returned to another phone call. My assistants and I fiddled with the lighting. For a very long time. More than two *hours* later, she happily reported

that he was on his way. I was astonished. It was inconceivable to me that an entire shoot, let alone one starring the world's leading female actor, could be held up for *any* crew member, including the photographer! I can only imagine that if I had telephoned to say I would be two hours late, the shoot would have been cancelled on the spot and word of my transgression would have spread like wildfire.

Aucoin finally blew in: tall, handsome, and full of warm hellos for Roberts (but no apologies; the rest of us were barely acknowledged). They then sequestered themselves in her dressing room for another *two hours* of chitchat, catching up on this and that while he did her makeup. I grew increasingly frustrated as I heard laughter from the dressing room; I feared that my subject's best energies would be expended before the photography even commenced. She emerged at last, happy and radiant, and my irritation evaporated as I felt all the delay and time spent were well worth it. Aucoin had made her look and feel terrific. With her big, beautiful smile, she came up to me and whispered conspiratorially, "This won't take long, will it? I have to meet some people for dinner." I was crestfallen; my worst fears were confirmed. Although I was livid, I matched her smile with my own and assured her that we'd work very quickly.

I wasted no time in maximizing her bouyant mood. (It is usually best to work quickly once your subject is fresh from makeup and hair to make the most of the brief window before the hair falls, the makeup hardens, and the moment is lost.) She positively glowed in front of the camera, and I shot fast. She responded to the feedback of the shutter click as an affirmation, as a "Yes, that's good, keep going, terrific!" Typically, the stylists stay near the subject, ready to dive in at a moment's notice to touch up the makeup or tousle the hair. It rankled that Aucoin was conspicuously absent from the set, having stayed behind in the dressing room making calls while we worked. Roberts seemed unperturbed by his disappearance, however, and I began to notice that it was actually kind of nice not to have anyone hovering at my elbow or near my subject. It was ultimately my good fortune that he apparently not only knew how to make her look and feel her best but also sensed how she preferred to work and left her alone to make her magic.

THOUGHTS ON TECHNIQUE

This picture was made at about 10:30 at night in a rented studio in New York City. To me, it feels like a fresh, early-morning moment in a beach house on Cape Cod. It was shot in a studio but doesn't have a "studio" look. The quality of the light and the character of the lens combine to create the illusion of naturalness and intimacy.

I'm always looking at light: how it pours through a window, bounces off a wall, falls on a surface, creates a glow. Then I file that memory away and retrieve it when I'm in the studio. Often photographers can see and use natural light when it exists in the world before their eyes, but when they walk into a studio, all that is forgotten and they're left with their softboxes and spotlights to create an unnatural reality. It's like they're two

mutually exclusive worlds. This isn't inherently a bad thing; it just limits the possibilities.

So if I'm in the studio, I might be creating a "studio" image that is unrelated to the outside world, or I might be after an image like this, in which I try to re-create a real "ambient" lighting situation as inspiration. It could be light reflecting off water, diffused through curtains, shining in a doorway, anything at all. In this case, I was after beautiful, crisp morning light streaming through big French doors opening onto a veranda just off the beach. The light pours in and bounces off a warm-toned, wainscoted wall and ivory-painted, wide-planked wood floor. So I made my lights match that. I placed a hard light source where the direct sun would be. I put warm reflectors where the wall and floor would be. And then I bounced some cool light all around to open up the image and simulate skylight.

And then there's the narrow depth of field, which can be an extraordinarily powerful tool to communicate intimacy. When we see shallow focus in an image, we immediately and instinctively make certain assumptions and associations based on our own experiences. My guess is that it begins when we're infants looking into our parents' loving gaze with our own little nearsighted eyes, the rest of the world fading off into a blurry haze. And it continues throughout our lives whenever we're physically close to the ones we love. Stereotypical soft-focus lenses claw on those heartstrings with a heavy hand. But one needn't go to such extremes to tap into the well of associations that simple shallow focus can summon.

If I had shot this image with everything in focus, say at f/22, that feeling would be lost. There are flowers in the background, but at f/2, we don't actually *see* them, we just *feel* their presence. They're not distracting, yet they're important as context. What we *do* focus on and see are Roberts's beautiful face, lovely, loose hair, and smooth, glowing skin against the soft crewel cushion on which she's lying. And that smile. Everything else just falls away. Clearly she's a terrific actor; there is no beach house. The reality is bright lights, reflectors, a mattress on a box, and assistants hovering around, not to mention a photographer with a clunky camera two feet from her face at 10:30 on a Tuesday night in lower Manhattan.

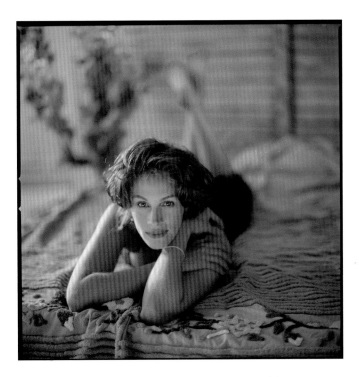

You basically can't go wrong with Julia Roberts as your model. This image is from the same roll, made moments later.

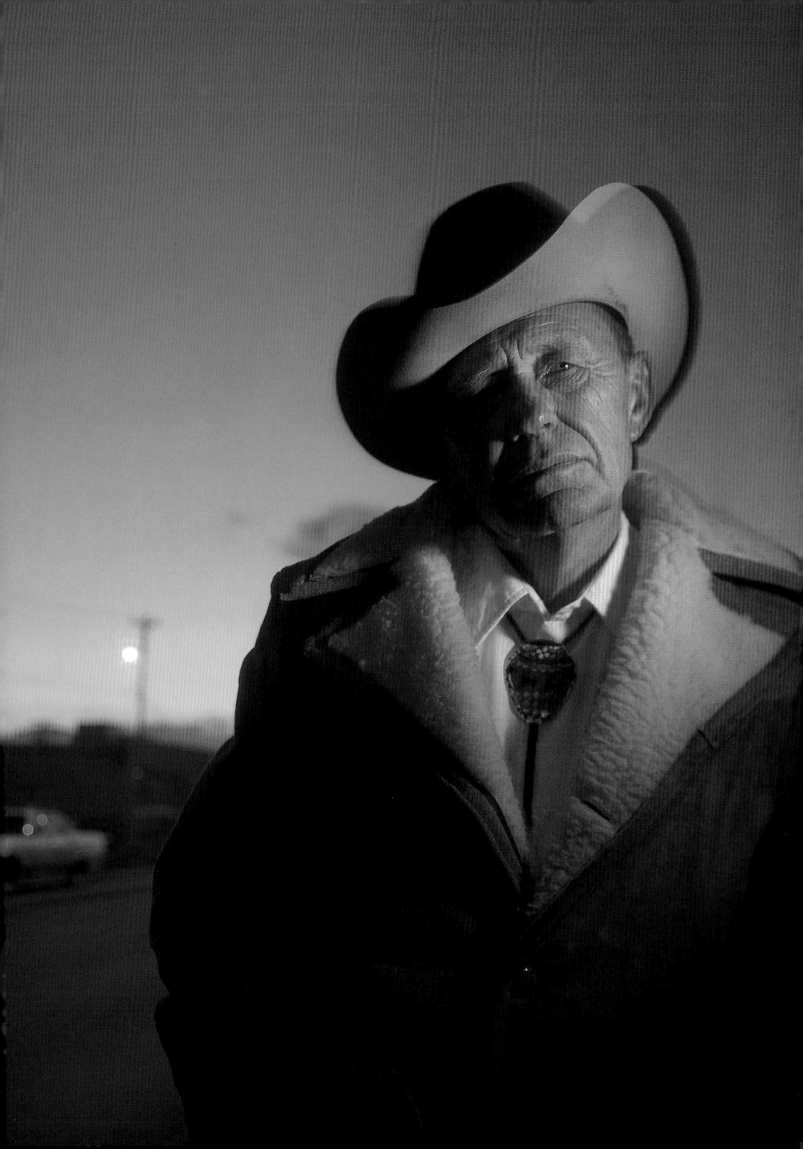

ED BELL

I shot it for a German magazine, but it was a quintessentially American story. Sheriffs. Slow-talkin', slow-walkin', cowboy-hat-wearing sheriffs. I thought the species was extinct. It was one of the few times I had suggested a story to a magazine, and maybe the only time my idea was subsequently assigned to me and published.

Sheriff Ed Bell had pulled me over. It probably looked like I had been casing the area, driving real slowly up and down the street, over and over. "You look lost. Help you find something?" he asked.

He looked like the Marlboro Man's father; to my New York eye, he was the archetypal western sheriff. I made a portrait of him in his office. Wary and sad-eyed, his face spoke of many things seen over many years. He dressed simply in the western mode yet proudly wore an elaborate Native American bolo tie festooned with turquoise inlays. He had authored several books on Native American art and craft; it was his true passion. He took me under his wing for the remainder of my stay.

I was fascinated with Bell. He didn't ride a horse; he cruised the streets in a brand-new Dodge and had a computer in his office. He had no more in common with Billy the Kid than I did. Yet he clearly saw himself, anachronistically, as a Western Sheriff. It was a romantic notion. Before I departed Grants, I asked him, "Are there more like you?" He took a drag on his cigarette (a Marlboro), smiled his shy smile and said that yes, there were; in fact, there was a sort of association of them in New Mexico. I told him I'd love to make a series of portraits, and he replied that he'd love to tag along on the shoots if that'd be okay.

Some months later, I was back in Grants, and we embarked on our little journey to immortalize these local sheriffs, with Bell making introductions in towns large and very small: Farmington, Quemado, Socorro, Pie Town, even Truth or Consequences. I worked with a little cherrywood view camera; it slowed me down and seemed to have an affinity for its subjects.

The keystone image of the series, in the end, was the very first one I had made, the portrait of Sheriff Ed Bell leaning on a lamppost across from the old Monte Carlo Café. We had arrived well before sunset to set up. I wanted to be shooting when the fading dusk light perfectly complemented the café's neon sign. There would only be a few minutes when the balance was just right, and with the old camera, there would be time for only a few exposures.

Bell hadn't yet gotten used to the glacial pace of working with the view camera, so this was a new experience for him. He shook his head as I fussed with the camera and squinted at the sky. The next day, the writer

for the story interviewed him and asked how it all went. As he recounted it, Bell sighed and said, "Well, when that young man comes to take your picture, you don't bring a watch. You bring a calendar."

THOUGHTS ON TECHNIQUE

I was sick of strobes, sick of dawn and dusk shoots. Life mostly takes place *between* those times; why can't we shoot *then*? I felt like every picture I was making was at dawn or at dusk, using strobes to light my subject. The rest of the day, I waited. Waited for the light to get better, for the sun to get lower and warmer in the sky. Midday was squinty and ugly, a good time to travel or scout locations, but unkind for portraiture, particularly in color.

With black and white, there were ways to compensate for the extreme contrasts of midday light. You could vary the development of the negative to suppress the highlights and boost the shadows. There were papers of different contrasts to suit and interpret the tonality. But in color, there were few options available.

Also, you couldn't really choose your palette like a painter; you were limited to the color characteristics of the films, which were optimized to please the eye and accurately render as many subjects under as many conditions as possible. Some films were a little juicier and more saturated with vivid color while others were more realistic, but that was about it. You couldn't really break free to create a unique chromatic vocabulary with which to interpret the world and express yourself.

In my studio, there was an odd exception to this narrowly limited world of color film choices, for I made my own dupes (duplicate transparencies of original color images). I generally used two Kodak films specifically for this task. They were extremely "slow" films with an effective ISO of around 6, neither daylight nor tungsten balanced. These films had the unusual property of *not* increasing the contrast of the image they copied.

A lightbulb clicked in my head. What if I loaded these *low*-contrast films into my camera to make original pictures in *high*-contrast light, like at noon? These films were never intended to see the light of day, so they were not color corrected. They required all kinds of crazy filtration to see color in a remotely realistic way. But the result was beautiful. It wasn't accurate, but it felt right. It had its own unique color signature.

Of course, this is the only picture from the series that was shot at dusk with flash, but ironically, it's still my favorite. Instead of heightening the reality of the moment, the dupe film subdued the seductive sunset and tamed the strength of the strobe, roping in the tones to the pleasing palette I was after.

While Sheriff Bell's face made a compelling portrait, it needed the context of the street to tell the story.

PAGES 214–215 Ed Bell

PICTURE SPECIFICATIONS

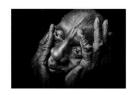

LUÍS SARRÍA

Camera: Mamiya RZ67 medium-format
Lens: Mamiya 65mm F4
Film: Kodak Tri-X black-and-white
 negative, ISO 400
Exposure: f/11 for 1/500 sec., EI 200
Lighting: Norman 150B flash, LH-2
 lamphead, taped onto a Broncolor
 Impact mini softlight reflector with
 diffuser and honeycomb grid

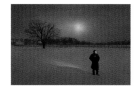

MUHAMMAD ALI

Camera: Mamiya RZ67 medium-format
Lens: Mamiya 50mm F4.5
Film: Kodak Plus-X black-and-white
 negative, ISO 125
Exposure: f/16 for 1/500 sec., EI 100
Lighting: Norman 150B battery strobe,
 LH-2 lamphead with telephoto
 reflector and bulb extender

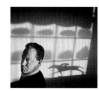

RON TURCOTTE

Camera: Mamiya RZ67 medium-format
Lens: Mamiya 65mm F4
Film: Kodak Tri-X Pan Professional
 black-and-white negative, ISO 400
Exposure: f/4 for 1/125 sec., EI 400
Lighting: Late-afternoon winter
 sunlight through window

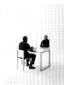

O. J. SIMPSON

Camera: Sinar P 8x10 view
Lens: Schneider Symmar-S 300mm F5.6
Film: Ilford HP-5 8x10 black-and-white
 negative, ISO 400
Exposure: f/22-3/4 for 1/60 sec., EI 200
Lighting: Elinchrom Octabank, overall;
 Fresnel spot on face

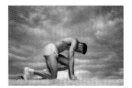

CARL LEWIS

Camera: Sinar P 4x5 view
Lens: Schneider Symmar 210mm F5.6
Film: Kodak 4x5 Professional high-
 speed black-and-white infrared (no
 recommended ISO)
Exposure: f/11 for 1/60 sec., EI 12
Filtration: Kodak Wratten #25 red filter
Lighting: Speedotron 2400 watt/
 second strobe in XL Chimera softbox
 on subject, four heads in 11-inch
 reflectors on background

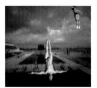

GREG LOUGANIS

Camera: Sinar Handy 4x5 handheld
 view
Lens: Schneider Super-Angulon 65mm
 F5.6
Film: Kodak 4x5 Professional high-
 speed black-and-white infrared (no
 recommended ISO)
Exposure: f/5.6 for 1/60 sec., EI 12
Filter: Kodak Wratten #25 red
Lighting: Speedotron 2400 watt/
 second strobe with 7-inch reflector

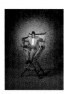

SHAQUILLE O'NEAL

Camera: Toyo 4x5 field
Lens: Nikkor-W 150mm F5.6, slightly
 tilted focus for effect
Film: Kodak T-Max 400 black-and-white
 negative, ISO 400
Exposure: f/16 for 1/60 sec., EI 200
Lighting: Speedotron strobes: O'Neal:
 10-degree grid spot on floor; overall:
 three heads with 11-inch reflectors
 bounced into white wall, diffused
 through 12x12-foot white silk

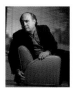

DANNY DEVITO

Camera: Mamiya RZ67II medium-
 format
Lens: Mamiya 250mm F4.5 Z
Film: Kodak T-Max 100 black-and-white
 negative, ISO 100
Exposure: f/5.6 for 1/125 sec., EI 50
Lighting: Profoto Magnum reflector
 with three layers of soft-spun
 diffusion, Profoto Zoom reflector
 with medium 20-degree grid, both
 into Profoto Pro-7 pack; daylight
 background through windows

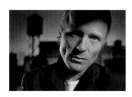

ED HARRIS

Camera: Mamiya RZ67 medium-format
Lens: Mamiya 65mm F4
Film: Kodak Plus-X Pan black-and-
 white negative, ISO 125
Exposure: f/4 for 1/250 sec., EI 125
Lighting: Two Broncolor grid spots
 on subject, four Broncolor standard
 reflectors behind background

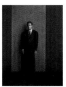

AL PACINO

Camera: R. H. Phillips & Sons 11x14
 view
Lens: Vintage Protarlinse 360mm F6.8
Film: Kodak T-Max 100 11x14 black-
 and-white negative, ISO 100
Exposure: f/11 for 1/10 sec., EI 100
Lighting: Ambient light from bank of
 windows

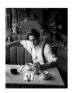

HUGH GRANT

Camera: Vintage Graflex RB Super-D
 4x5 single-lens reflex
Lens: Vintage Kodak Ektar Auto-
 Diaphragm 190mm F5.6
Film: Kodak T-Max 100 black-and-white
 negative, ISO 100
Exposure: f/5.6 for 1/60 sec., EI 100
Lighting: Bescor 250W battery-
 powered tungsten light augmenting
 window light

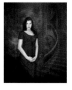

LIV TYLER

Camera: R. H. Phillips & Sons 11x14
 view
Lens: Vintage Protarlinse 360mm F6.8
Film: Kodak T-Max 100 11x14 black-
 and-white negative, ISO 100
Exposure: f/6.8 for 1/5 sec., EI 50
Lighting: Front indirect ambient light
 from large skylight bounced off
 white cyclorama, two black V-flats
 (one on either side of subject)

TIM BURTON

Camera: Sinar P 4x5 view
Lens: Fujinon-W 300mm F5.6
Film: Kodak T-Max 400 black-and-white, ISO 400
Exposure: f/45 for 1/60 sec., EI 200
Lighting: Profoto ring light, Elinchrom fiber optic strobe, Balcar fiber optic strobe, Broncolor fiber optic strobe

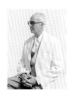

LIAM NEESON

Camera: R. H. Phillips & Sons 11x14 view
Lens: Vintage Protarlinse 360mm F6.8
Film: Kodak T-Max 400 black-and-white negative, ISO 400
Exposure: f/22 for 1/50 sec., EI 200
Lighting: Overcast outdoor ambient light

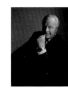

ORLANDO DIAZ-AZCUY

Camera: R. H. Phillips & Sons 11x14 view
Lens: Nikkor-M 450mm F9
Film: Kodak T-Max 100 11x14 black-and-white negative, ISO 100
Exposure: f/16 for 1/60 sec., EI 100
Lighting: One bare-tube Profoto Pro-7 strobe head on a Bogen Super boom

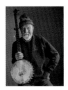

BILL BLASS

Camera: Wista 4x5 field
Lens: Vintage Protar 210mm F4.5
Film: Kodak T-Max 100 black-and-white negative
Exposure: f/4.5 for 1/10 sec., EI 100
Lighting: Window light augmented by a single 250-watt Mini-Mole Fresnel quartz light

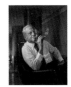

LEE IACOCCA

Camera: Mamiya RZ67 medium-format
Lens: Mamiya 180mm F4.5
Film: Kodak Ektachrome EPR 64, ISO 64
Exposure: f/4.5 for 1/15 sec., EI 64
Lighting: Two Broncolor Impact strobes with softlight grids and half CTO warming gels

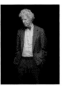

LESTER BROWN

Camera: Sinar P 8x10 view
Lens: Nikkor-M 450mm F9
Film: Kodak T-Max 100 black-and-white negative, ISO 100
Exposure: f/32 for 1/125 sec., EI 100
Lighting: Speedotron 2400 watt/second head into Mola "Euro" 33-inch softlight as key, ring light as fill

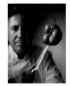

ARNOLD NEWMAN

Camera: Vintage Graflex RB Super-D 4x5 single-lens reflex
Lens: Vintage Kodak Ektar Auto-Diaphragm 190mm F5.6
Film: Polaroid Type 55 Positive/Negative, ISO 50
Exposure: f/5.6 for 1/5 sec., EI 25
Lighting: Broncolor Impact 400 into Broncolor small softlight with grid

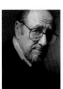

DANIEL BOULUD

Camera: Sinar P 4x5 view
Lens: Fujinon-W 300mm F5.6
Film: Kodak T-Max 400 black-and-white, ISO 400
Exposure: f/5.6 for 1/30 sec., EI 200
Lighting: Window light augmented with 250W Mini-Mole tungsten Fresnel spot

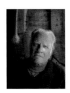

BILLY GRAHAM

Camera: R. H. Phillips & Sons 11x14 view
Lens: Nikkor-M 450mm F9
Film: Kodak T-Max 100 11x14 black-and-white negative, ISO 100
Exposure: f/16 for 1/4 sec., EI 50
Lighting: Ambient light from veranda

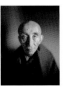

KUSHOK BAKULA RINPOCHE

Camera: Sinar P 8x10 view
Lens: Vintage Dallmeyer Pentac 8-inch F2.9
Film: Kodak T-Max 100 black-and-white negative, ISO 100
Exposure: f/2.9 for 1/125 sec., EI 100
Lighting: Speedotron 2400 watt/second head, Mola "Euro" 33-inch softlight, 1.8 (6-stops) of neutral density (ND) gels

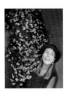

JONI MITCHELL

Camera: Sinar P 4x5 view
Lens: Fujinon-W 300mm F5.6
Film: Kodak T-Max 100 black-and-white, ISO 100
Exposure: f/5.6 for 1/15 sec., EI 100
Lighting: Ambient outdoor open shade

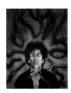

PETE SEEGER

Camera: Vintage Deardorff 8x10 large-format
Lens: Vintage Gold Dot Dagor 10 3/4-inch F6.8
Film: Kodak T-Max 100 black-and-white negative
Exposure: f/6.8 for 1/10 sec., EI 100
Lighting: Lowel Caselite fluorescent and ambient light from open doorway

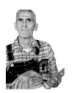

MORGAN SEXTON

Camera: Vintage Deardorff 11x14 view
Lens: Nikkor-M 450mm F9
Film: Kodak T-Max 100 11x14 black-and-white negative, ISO 100
Exposure: f/9 for 1/60 sec., EI 50
Lighting: Four Speedotron flash heads bounced off white seamless paper, two in front of the subject and two behind

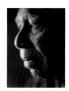

HERMAN SHAW

Camera: Mamiya RZ67 medium-format
Lens: Mamiya 110mm F2.8
Film: Kodak T-Max 400, ISO 400
Exposure: f/2.8 for 1/60 sec., EI 200
Lighting: Dedolight DLHM4300U, 150-watt tungsten light

ALONZO MOURNING

Camera: Vintage Deardorff 8x10 view
Lens: Vintage Gold Dot Dagor 10 3/4-inch
Film: Fuji Astia, ISO 100
Exposure: f/22 for 1/50 sec., EI 100
Lighting: Two Speedotron 2400 watt/second heads into two Chimera large strip softboxes with red gels, one Chimera medium softbox with blue gel, and one Chimera small softbox with green gel

BARRY BONDS

Camera: Vintage Deardorff 8x10 view
Lens: Vintage Gold Dot Dagor 10 3/4-inch F6.8
Film: Kodak Ektachrome 100, ISO 100
Exposure: f/11 for 1/60 sec., EI 100
Lighting: One Speedotron 2400 watt/second bare flash head, no reflector, two 4x8-foot white foam core reflector boards

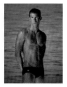

MICHAEL PHELPS

Camera: Sinar P 8x10 view
Lens: Vintage Gold Dot Dagor 12-inch F6.8, tilted for depth-of-field effect
Film: Kodak Ektachrome 100, ISO 100
Exposure: f/11 for 1/60 sec., EI 100
Lighting: Four Speedotron 2400 watt/second bare flash heads into homemade strip softboxes, three with sky-blue gels, one with full CTO gel; one Speedotron 2400 watt/second flash head with 7-inch reflector and sky-blue gel on background

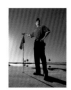

TIGER WOODS

Camera: Fuji 680II 6x8cm medium-format
Lens: Fujinon 50mm F4
Film: Fuji Astia 120 color transparency, ISO 100
Exposure: f/16-1/2 for 1/250 sec., EI 100
Lighting: Profoto 7B battery-powered strobe and Narrow Beam Reflector with one half CTO gel

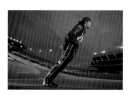

DALE EARNHARDT JR.

Camera: Fuji 680 II, 6x8cm medium-format
Lens: 65mm F4 Fujinon
Film: Fuji Astia color transparency, ISO 100
Exposure: f/5.6 for 1/15 sec., EI 100
Filter: Kodak Wratten 80A blue
Lighting: Four Profoto 7B battery-powered 1200 watt/second strobes, all with Narrow Beam Reflectors, each with one full CTO gel and one half CTO gel

GEORGE H. W. BUSH

Camera: Two Sinar P 4x5 monorail view cameras
Lens: Two Nikkor-M 300mm F9 lenses
Film: Kodak Ektachrome Professional EPN color transparency, ISO 100
Exposure: f/16 for 1/60 sec., EI 100 (both exposures)
Lighting: Two Broncolor strobes with softlight reflectors, grids, and half CTO gels; two Speedotron heads with small softboxes and half CTO gels; two Speedotron heads with 40-degree grids and full CTB gels

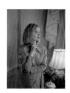

HILLARY RODHAM CLINTON

Camera: Wista 4x5 field
Lens: Nikkor-W 150mm F5.6
Film: Kodak Ektachrome Professional EPN color transparency, ISO 100
Exposure: f/5.6 for 1/2 sec., EI 100
Filter: 82A pale blue
Lighting: Window light augmented by one Broncolor Pulso head into a white beauty dish with one half CTO gel

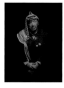

YASSER ARAFAT

Camera: Vintage Deardorff 4x5 view
Lens: Zeiss Planar 135mm F3.5
Film: Fuji Astia Readyload color transparency, ISO 100
Exposure: f/11 for 1/125 sec., EI 100
Lighting: Profoto 7B battery-powered 1200 watt/second pack, Chimera extra-small (XS) softbox

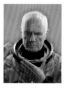

JOHN GLENN

Camera: Mamiya RZ67 medium-format
Lens: Mamiya 250mm F4.5
Film: Fuji Astia color transparency, ISO 100
Exposure: f/16-1/2 for 1/60 sec., EI 100
Filter: Kodak Wratten 82A blue
Lighting: Speedotron 2400 watt/second pack into a Broncolor Flooter Fresnel spot, full CTO gel; Speedotron 800 watt/second pack into ring light, half CTO gel; two Hensel shutter lights, no gels

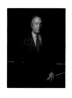

MICHAEL R. BLOOMBERG

Camera: Vintage Deardorff 8x10 view
Lens: Vintage Gold Dot Dagor 12-inch F6.8
Film: Fuji Astia, ISO 100
Exposure: f/8 for 1/8 sec., EI 100
Lighting: Homemade 8-foot, 2-bulb fluorescent light, full CTB gel; one Lupo Quadra fluorescent light, one half CTO gel; one Dedolight DLHM4300U, 150-watt tungsten light

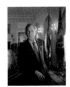 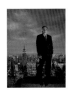 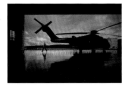

GEORGE W. BUSH

Camera: Ebony-Wide 4x5 view
Lens: Vintage Zeiss Planar uncoated 135mm F3.5
Film: Fuji Provia Readyload transparency, ISO 100
Exposure: f/3.5 for 1/30 sec., EI 100
Lighting: Window light and tungsten ambient room light augmented with four Lupo daylight-balanced fluorescent fixtures, one Mini-Mole quartz light bounced off ceiling in background, and another aimed through window onto back wall

RUDOLPH GIULIANI

Camera: Sinar P2 Expert 8x10 view
Lens: Schneider 165mm F5.6 Super-Angulon wide-angle
Film: Kodak Ektachrome EPN 100 Professional color transparency, ISO 100
Exposure: f/5.6 for 1 second, EI 100
Lighting: Four Profoto 7A power supplies; three Profoto 7A flash heads; one Profoto 51-inch medium StripLight, full plus green and half CTO gels; one Profoto 5-foot Octa softbox, full CTO gel; two Profoto Narrow Beam Reflectors, double full plus green gels on each

NEWT GINGRICH

Camera: Sinar P 8x10 view
Lens: Nikkor-M 450mm F9
Film: Fuji Velvia color transparency, ISO 50
Exposure: f/45 for 1/60 sec., EI 100, push-processed +1 stop
Lighting: Ring light with full CTB gel; two Speedotron heads with 9-inch reflectors, one with 1 1/4 CTO, the other with yellow #101 gel

ROBERT BALLARD

Camera: Sinar "Handy" 4x5 field
Lens: Schneider 65mm F5.6 Super-Angulon
Film: Fuji Astia Readyload color transparency, ISO 100
Exposure: f/5.6 for 4 seconds, EI 100
Filter: Kodak CC40M magenta
Lighting: Underwater 250-watt floodlights with Rosco moss green gels

GEORGE DAVID

Camera: Sinar "Handy" 4x5 field
Lens: Schneider 65mm F5.6 Super-Angulon
Film: Fuji Astia Readyload, ISO 100
Exposure: f/16-1/2 for 1/250 sec., EI 100
Filter: Kodak Wratten 80D blue
Lighting: Profoto Narrow Beam Reflector with one full CTO gel and one half CTO gel

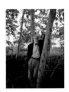 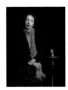 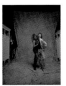 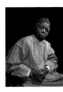 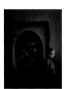

LAURIE OLIN

Camera: Sinar "Handy" 4x5 view
Lens: Schneider 120mm F5.6 Angulon
Film: Kodak Ektachrome EPN Professional, ISO 100
Exposure: f/5.6 for 1/60 sec., EI 100
Lighting: Daylight augmented by a Bescor 150-watt battery-powered quartz light

JOYCE CAROL OATES

Camera: Hasselblad H2 medium-format digital camera with Leaf Aptus 54S, 22 megapixel medium-format digital back
Lens: Zeiss Planar T* 80mm F2.8
Exposure: f/5.6 for 1/8 sec., ISO 25
Lighting: One Rololight 12x2-foot fluorescent daylight source and one Dedolight 150-watt quartz spotlight, both unfiltered

CHINUA ACHEBE

Camera: Hasselblad H2 medium-format digital camera with a Leaf Aptus 54S, 22 megapixel digital back
Lens: Hasselblad HC 50mm
Exposure: f/16 for 1/125 sec., EI 25
Lighting: Profoto Beauty Dish with grid, half CTO gel; Profoto Optical Focusing Spot, full CTO gel; Profoto RingFlash, half CTB; and Rosco Plusgreen gels

MICK JAGGER AND TINA TURNER

Camera: Sinar P 8x10 view
Lens: Schneider 240mm F9 G-Claron
Film: Kodak Ektachrome EPN 100
Exposure: f/16 for 1/60 sec., EI 100
Lighting: Speedotron 2401 power pack in extra-large softbox

HARRY BELAFONTE

Camera: Vintage Deardorff 8x10 view
Lens: Vintage Gold Dot Dagor 9-inch F6.8
Film: Fuji Astia, ISO 100
Exposure: f/11 for 1/100 sec., EI 100
Lighting: One extra-small Chimera softbox with a full CTO gel; one Chimera Super-Pro large strip softbox, no gel; and one Chimera extra-large softbox with a full CTB gel

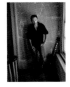 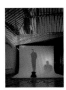

BRUCE SPRINGSTEEN

Camera: Vintage Deardorff 8x10 view
Lens: Vintage Gold Dot Dagor 10 3/4-inch F6.8
Film: Fuji Astia, ISO 100
Exposure: f/16 for 1/100 sec., EI 100
Lighting: One Profoto large softbox with a half CTB gel, one Chimera extra-small softbox with a half CTO gel

DENZEL WASHINGTON

Camera: Sinar P Expert 8x10 view
Lens: Zeiss Protar 210mm F18
Film: Fuji Velvia, ISO 100
Exposure: f/18 for 1/10 sec., EI 50 (twice)
Lighting: Available light from a large overhead skylight window augmented by a 2.5K HMI Fresnel spotlight

JULIA ROBERTS

Camera: Hasselblad 201F medium-format
Lens: Zeiss 110mm F2 T*
Film: Fuji Astia, ISO 100
Exposure: f/2 for 1/125 sec., EI 100
Filter: Harrison & Harrison low-contrast #2
Lighting: One Arri 6K HMI Fresnel bounced into white cyclorama, one Arri 1K Tungsten Fresnel, white reflector for 1K, one 4x2 Kino Flo fluorescent

ED BELL

Camera: Wista 4x5 field
Lens: Nikkor-SW 75mm F4.5
Film: Kodak Ektachrome duplicating film, no recommended ISO
Exposure: f/5.6 for 1/8 sec., EI 12
Filter: CC40Y + CC 40G
Lighting: Dusk ambient light with Norman 150B strobe in extra-small Chimera softbox, full CTO gel

ACKNOWLEDGMENTS

Gratitude. Where to even begin? On one level, photography is a completely solitary pursuit. It happens *behind* your eyes and between your ears. But this book, and the photographs in it (and all of those *other* photographs *not* in it that laid the groundwork for the good ones) were made possible only with the help and support of many, many people: clients, assistants, friends. There are people who employ you, people who support you, people who assist you, people who inspire and guide you, and people who love you.

Most important, these pictures would not exist had they not been commissioned, so first and foremost, my gratitude goes to those who assigned them. I must single out Arthur Hochstein and Robert Priest, the design directors of *Time* and *GQ*, respectively, during the time these photographs were made. They are both once-in-a-career individuals, and I've been lucky enough to have two. Without their incredible support and trust, this would have been a very skinny book indeed. Special mention must also be made of Nik Kleinberg at *ESPN The Magazine;* Michelle Stephenson, MaryAnne Golon, and Linda Freeman at *Time;* Karen Frank of *GQ;* Steve Fine at *Sports Illustrated;* Mel Scott, John Loengard, and Peter Howe of *LIFE;* and O. Aldon James of the National Arts Club. Thanks also to Alice Rose George, Barbara Griffin, Victoria Kohn, Cathy Mather, Michele McNally, Meg McVey, Karen Mullarkey, and Kathy Ryan. It takes a great leap of faith to hire a photographer to grapple with the pressures and uncertainties that face the artist/journalist on assignment, and great trust in his ability to come up with that special image. It was an honor to work with each and every one of you.

I essentially owe my entire career to two extraordinary people: Arnold and Augusta Newman, who allowed me into their studio, their city, and their lives. They handed me the keys to a photographic life. Eric Meola and John Ol-son gave me my first taste of being a working photographer. Rick Smolan changed my life forever and introduced me to the family of photographers.

The unsung heroes of the images in this book are the assistants who labored long and hard during their creation. I simply couldn't have pulled off these pictures without them. They were all my closest friends when we worked together; I spent more time with them than with my own family. We experimented, tested, talked, traveled, ate, photographed, laughed, and virtually lived together during some very intense episodes. Danielle Bock, Jeffrey Chong, David Coventry, Mike Ehrmann, Gregor Halenda, Cheryl Harmeling, Rocky Kenworthy, Michel Leroy, Frank Lindner, Paul Meyer, Frank Schaefer (who headed up all of the West Coast teams), and Howard Simmons contributed mightily to the images in this book. In addition, Frank Atura, Monica Buck, Steve Derr, Scott Rex Ely, Max Gerber, Michael Gluck, Welch E. Golightly, Stefan Hester, Hiro, Monte Isom, Jon Love, Scott Niedermaier, Tobey Sanford, Ronald Shaffer, Charles Smith, Seth Taras, Jerry Valente, Garth Vaughn, David Williams, Cameron Wong, and Anthony Woods all gave unstintingly and indefatigably of themselves on so many shoots over the years. Thanks to all of you (and to all of the freelance assistants too numerous to mention) from the bottom of my heart. And in a category all his own, big thanks go to the big man, Robert "R.P." Pattison, whose trucking kept us trucking over many years. You always went the extra mile.

Everything would have come to a grinding halt without the intelligent, unflappable, good-humored, hardworking, organized, and heartfelt contributions of the studio managers. No one put it better than Wendy Bryan, the "Voice of the Studio" for many years and dearest friend, who said she felt like both the traffic cop *and* the intersection! My thanks also go to Amy Horton and Anna Newman

for their crucial help in the early days, Diane George and Lisabeth Sierra for their unfailing patience, and Meredith Kazaras, who oversaw the studio during a critical transition time with levelheaded grace. I was privileged to share my working life with these incredible women.

The success of my studio has been due in large part to the stellar efforts of my agent, Howard Bernstein, and his staff at Bernstein+Andriulli. Thanks also to Geoff Katz and Danny Greer at Creative Photographers Inc.

Photographers dream of the special kind of support I have treasured for so many years from my friend Jeff Hirsch at Fotocare, who has, with Fred Blake and his terrific staff, enabled me to pull off so many difficult shoots by putting up with my last-minute crazy requests, always without batting an eye. And Jeff Kay at Lens and Repro has been my invaluable large-format mentor for decades. A special shout-out is needed for Paula Rubenstein, whose uncanny eye for the quirky soulful object is unparalleled. I appreciate them more than they know.

Many late nights were spent processing film for rush deadlines at US Color Lab under the care of Lali, Inder, David, and Keith. Leo Chapman and Rocky Kenworthy brought the art of digital printmaking to a new level at the studio, assisted by Liza Young.

Interpersonal skills may, in fact, outweigh the technical talents of makeup artists when it comes to working successfully with the kinds of high-profile subjects included in this book. Elicia Ho and Pamela Jenrette have artfully improved not just the appearance but also the spirits of many of the subjects herein, have been key to the success of many of the shoots, and have been an absolute joy to work with on countless occasions.

I am grateful for the continued support of Canon U.S.A. and, in particular, Steven Inglima of the Explorers of Light program (and Michael Newler, its instigator), as well as Jan Lederman and the MAC Group.

I owe a deep debt of gratitude to George Rosa. It was his vision and commitment that made possible my transition into my new professorial role as artist-in-residence at Hallmark Institute of Photography, which also afforded me the opportunity to work on this book. And to Lisa Devlin Robinson, the director of education, whose understanding and flexibility helped get the essays written on time. I must also thank Gary Camp, chairman of Premier Education Group for his continued support in that role as well as Bill Anjos, president. I am grateful to faculty member Todd Verlander for his invaluable contributions to the elegant design of this book.

This book would never have come into being without the matchmaking gifts of David "Strobist" Hobby. Thankyouthankyouthankyou, David. Julie Mazur is the gifted editor at Amphoto Books/Random House who took a chance on a first-time writer. It has been a thrilling and enjoyable educational process to work with you. Hats off to Jennifer K. Beal Davis for keeping her impeccable eye on true north in designing this book.

Photographers should be blessed with the kinds of friends who support and encourage but, more important, *push* them to do their best work. These are the exceptional individuals who inspire them and set the bar. I have had the great good fortune to have such special friendships with Jay Maisel, Mary Ellen Mark, Grant Peterson, and Rob Steinberg. I cannot count the lessons I have learned from them.

My deepest thanks to my brother, Marc, for being my brother and hero, and to my parents, Beatrice and Benjamin, for their unconditional love.

I can't look at these pictures and not think of Prudence, whose love, humor, insight, support, and good sense suffuse each and every one. When I made them, I was not home. When I was home, I was often preoccupied with them or working on them. I'm sure it was not easy, over so many years. I hope this book sheds some light on why they were so important to me. I am grateful beyond measure.

And then there's Jennifer. Your love and sound advice lifted me at every turn in the writing of this book.

INDEX